I0700795

PAINTING NATURE
in Watercolor with Cathy Johnson

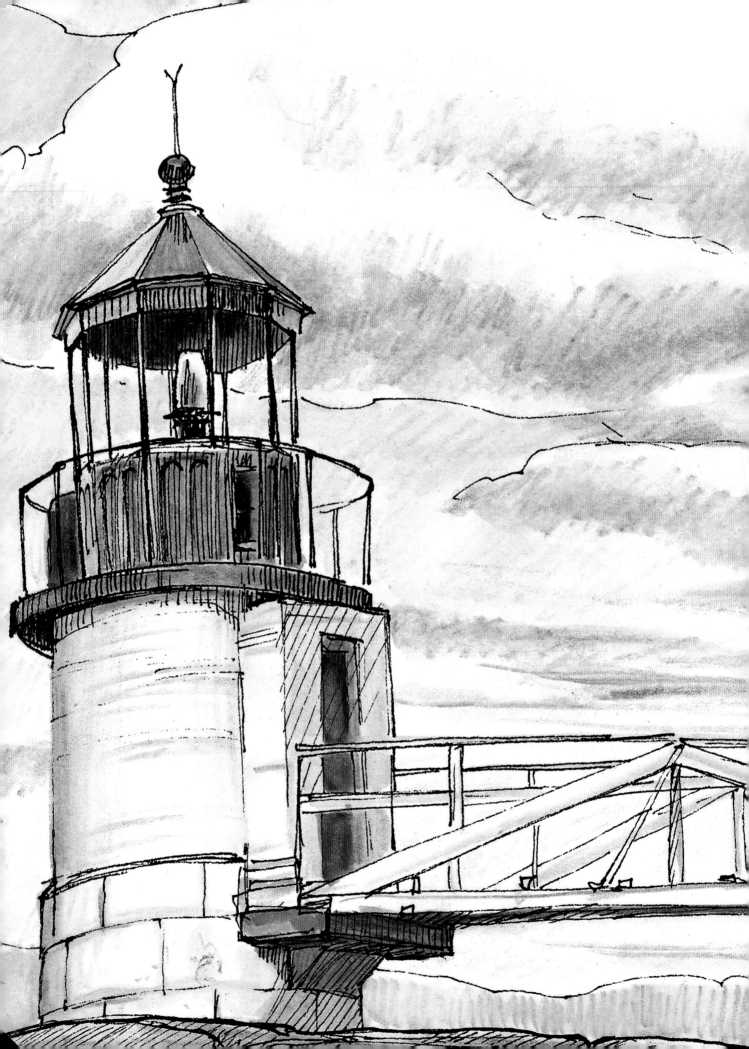

PAINTING NATURE

in Watercolor with Cathy Johnson

37 Step-by-Step Demonstrations Using Watercolor Pencil and Paint

NORTH LIGHT BOOKS
CINCINNATI, OHIO
artistsnetwork.com

Lighthouse Near Port Clyde, Maine
Watercolor pencil and ink on Strathmore vellum drawing paper
6¾" × 7½" (17cm × 19cm)

Table of Contents

Introduction

For an artist, working on the spot—in nature, *en plein air,* whatever you want to call it—can be a delight, a wonderful challenge, the ultimate high. And, yes, it is a challenge—nature sees to that! The changing light alone tests our skill and speed and our powers of observation.

Still, there are so many reasons to work outdoors: to drink in the beauty of nature; to find fresh, evocative, inspiring and challenging subjects; to spend time in the quiet places; to capture the liveliness of birds or the grace of a red fox; to learn about your environment; to perfect your skill; and just to be out where it's achingly beautiful. Whether you take a painting vacation, a field trip led by a naturalist/artist, or a trip to some exotic, untouched locale, or you find painting subjects virtually in your own backyard, you will find subjects enough for a lifetime.

Of course, it isn't necessary to complete a whole painting outdoors. You may prefer to sketch a variety of subjects with pencil, ink, colored or watercolor pencils, even mixed media with quick watercolor washes, then return to the comforts of home to do a more finished piece. You can take photos, both from a distance and close up. I'll show you how to put these resources to work!

We'll discuss the various mediums and try out the techniques together, and I'll offer some of my favorite quick tips and hints for capturing textures. We'll cover some of the basics, but also explore more specific and advanced techniques.

This book is organized by habitat. Each chapter includes the variety of things you will find in that specific habitat and hints on how best to capture these elements in your sketches and watercolors. The forest habitat chapter, for instance, will show you how to capture individual tree shapes, bark patterns and leaves as well as forests from a distance and in their varied seasons. You'll also learn to paint the wildflowers that bloom in the spring and the birds, insects and animals that frequent these places.

There is a bit of the naturalist in most of us. Painting and drawing this marvelous place we inhabit allows us to slow down and learn with our own eyes, to notice, to pay attention. The child within is still curious about that big moth or the tiny, brightly colored mushroom that grows along a fallen log. How better to explore than to observe and draw or paint?

Perhaps Baba Ram Dass was not thinking of artists when he said, "Be here, now," but that injunction certainly applies to painting in nature. We look, we see, we pay attention, we learn … and we delight in it!

Whether you love an aromatic, crackling campfire, a mountain stream, the robust wildflowers of summer or the calligraphy of tracks in the snow; whether you find time for canoeing, fishing in the early morning, watching the birds that frequent your locale or stealing silently almost within touching distance of a deer and her fawn, you will find magic in this natural world. As an artist, getting it down in concrete form is to capture those moments forever, golden as a fly in amber. Your paintings and sketches will have the power to return you to that moment in time. No matter how busy and frenetic your everyday life, these tangible evidences of time in nature will transport you back to those magical moments.

WHAT YOU NEED

SURFACE
Arches hot-pressed watercolor paper
dark toned pastel paper
Fabriano cold-pressed watercolor block
Fabriano cold-pressed watercolor paper
Fabriano hot-pressed watercolor paper
Strathmore cold-pressed watercolor block
Strathmore cold-pressed watercolor paper
Strathmore rough watercolor paper
toned warm tan drawing paper

WATERCOLORS
Winsor & Newton unless otherwise noted:

Burnt Sienna, Cadmium Red Medium Hue [Daniel Smith], Cadmium Yellow Medium Hue [Daniel Smith], Cobalt Blue, Dragon's Blood [Maimeri Blu], Hermatite Burnt Scarlet [Daniel Smith], Manganese Blue Hue, Minnesota Pipestone [Daniel Smith], Olive Green, Payne's Gray, Permanent Alizarin Crimson, Phthalo Blue [Daniel Smith], Quinacridone Burnt Scarlet [Daniel Smith], Quinacridone Gold, Raw Sienna, Sedona Genuine [Daniel Smith], Titanium White, Transparent Yellow, Ultramarine Blue [Daniel Smith], Vivianite (Blue Ochre) [Daniel Smith], Yellow Ochre

WATERCOLOR PENCILS
Derwent Inktense unless otherwise noted:

Blue Grey. Burnt Sienna, Burnt Umber, Burnt Yellow Ochre, Chinese White, Cobalt Blue, Deep Vermilion, Indigo, Ivory Black, Juniper Green, Olive Green, Oriental Blue, Pale Vermilion, Prussian Blue, Sage [Derwent Graphitint], Ultramarine, Venetian Red

BRUSHES
½-inch (13mm), ¾-inch (19mm)1-inch (25mm), 2-inch (51mm) flats
nos. 3, 5, 6, 7, 8, 10 rounds
12mm flat Niji waterbrush
9mm, 12mm, 15mm round Niji waterbrushes
aquarelle brush
barbered fan brush
bristle brush
small inexpensive brush for masking fluid
stencil brush

OTHER SUPPLIES
black colored pencil, brush-tipped pens in shades of gray, craft knife, fine-point pen, fine-tipped marker, gouache paint, graphite pencil, HB pencil, India rubber, indigo colored pencil, liquid mask, Lyra Aquacolor watercolor crayons, masking fluid, mechanical pencil, natural sponge, old bamboo pen, pale colored pencil, palette knife, paper towels, pencil, sharp knife, sharpened stick, sunset-colored watercolor pencil, tissues, Tuscan Red colored pencil

MATERIALS AND SUPPLIES

What to buy, what to try: The supplies you end up using depend a lot on whether you want to work *en plein air* or in the comfort of your studio. We'll touch on both options. It also depends on how much you want to spend, and whether you like to work as simply as possible or have all the bells and whistles at your disposal. I tend toward the simpler model these days, but I have indeed tried out many other options on my way, so we'll discuss the possibilities there, too.

Just remember—there's no "right" way. What is important is finding the tools that allow you to work the way you want to and capture what you want! That means that some exploration is in order.

BASIC WATERCOLOR SUPPLIES

We'll start with traditional watercolor supplies and then move on to watercolor pencils and the things you may want for working outdoors. All you need to get started is paint, brushes, paper and a palette. What you choose to use beyond these basics is up to you!

Pencils

Most of us like to sketch at least a bit before jumping right in with watercolor. Sketching feels familiar and comfortable and gives us a little guideline. A good old no. 2 pencil will be fine for this purpose, or an HB drawing pencil (there are harder and softer pencils if you prefer, but HB is very versatile). Consider a mechanical pencil, especially for field work, since it doesn't require a sharpener. If you like, try a black or dark gray colored pencil as an alternate drawing tool. They're not as erasable as graphite, of course, but they do make a bold line that won't lift or smear if you paint over it.

You can use a regular pencil sharpener, either manual or electric. Or, try sharpening your pencil with a knife blade to achieve a more versatile and often stronger point (see yellow pencil).

Brushes

Your basic brushes should include a round and a flat, as shown, though you will probably prefer a wider range of sizes. For me, basics include nos. 3, 5 and 8 or 10 rounds as well as ½-inch (13mm), ¾-inch (19mm), 1-inch (25mm) and sometimes even 1½-inch (38mm) flat.

In addition to these basics, I often use a barbered fan brush, a stencil brush for spattering and a few small bristle brushes, sometimes with the ends broken off and sharpened.

Many flat brushes come with what is called an "aquarelle" tip, like the green one. This gives you an additional painting tool—you can incise dark lines into your washes or push damp paint out of the way for lighter lines.

Watercolors—Tube or Cake?

There are many choices for watercolorists. The products you choose will depend on your own comfort level and convenience. Artist-quality paints are nearly always a better choice than student-grade. They mix better and are more concentrated and pigment-dense. In the long run, good paints are economical: They'll go much farther because you can use less pigment. Colors are more intense and the texture is smoother. They also tend to be more lightfast, though the better grades also offer specific pigments that are not. Most of the pigments that I mention in this book are from Winsor & Newton, though I also experiment with some of the Daniel Smith and M. Graham & Co. colors. Try a variety of brands.

If you buy a set, you may get tube or moist pan colors—the latter will still re-wet well. The only drawback to buying a set is that they often come with tiny halfpans, which are more useful for sketching than painting anything larger than 7" × 10" (18cm × 25cm). Also, be aware that someone else has decided what colors you will want, and they're not always right. You can buy open-stock replacement pans in colors that you like in most brands, or you can get empty full or half pans and fill them yourself with tube pigments.

Palette-able Advice

Another option is to get an empty palette and fill it with tube paints yourself. There are many styles, sizes and types of palettes. Allow the pigments to dry at least 24 to 48 hours before taking the palette into the field, or you'll wind up with an oozy mess! You can buy a small, versatile, folding palette like the one in the illustration (great for field work!), or a full-size one for studio or serious plein air painting—I've used the same old John Pike palette for thirty years, and it's still going strong.

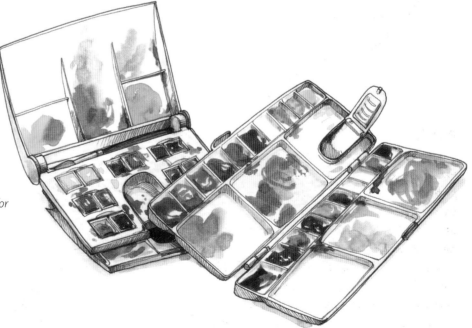

Receive free downloadable bonus materials at www.artistsnetwork.com/Newsletter_Thanks.

7

Choosing the Right Watercolor Pencils

CHOOSE THE RIGHT BRAND

Color varies from brand to brand. The name may be the same, but the hue may be quite different. Opacity varies by brand, too. Faber-Castell Albrecht Dürer Aquarelle tools seem to be the most opaque (useful when you want to cover an area); Bruynzeel Design Aquarelle and Lyra Rembrandt Aquarell are both considerably more transparent.

Derwent Watercolour pencils are versatile and consistent. The larger set has two trays of a rainbow array of pencils so you can remove the top one to see all the colors at once. You can buy as few as twelve in a set or even one at a time from open stock if you like.

Caran d'Ache Neocolor II pencils have good lightfastness, are pigment dense and come in sets ranging from ten to eighty-four pencils.

Lyra Rembrandt Aquarell pencils dissolve exceptionally well in water and are highly pigmented. You can buy sets of twelve, twenty-four or thirty-six. Lyra water-soluble wax crayons are very smooth and creamy and dissolve well in water. They are pigment dense, brilliant, and lightfast and come in sets of twelve, twenty-four and forty-eight.

Albrecht Dürer Aquarelle Sticks from Faber-Castell are said to combine the best qualities of watercolors, colored pencils and oil pastels. Although they liquefy easily on paper, they also can adhere to glass, metal or plastic, making them an extremely versatile choice. They are rich, buttery, intense, subtle, pigment-dense and a bit more expensive than some of the other brands. They are available in twelve-pencil arrays of colors just for landscapes or portraits in addition to the all-purpose regular sets.

Aqua Monolith Aquarelle pencils are brilliantly colored woodless pencils that offer up to eight times as much lead as a wood-encased pencil. At only twice the price of the more conventional pencils, they are a good choice if you work with broad areas of color, as you can use the whole side of the pencil tip.

You may wish to mix colors by overlapping, cross-hatching or mixing on your paper or palette. Or you may prefer to choose primary, secondary or tertiary colors directly from the pencils provided. Not all sets have pigments that exactly mirror the color wheels in this book, of course. In making this book, I found myself using some of the larger sets of pencils for the versatility and variety the colors offer; you'll choose your favorite tools for your own reasons—pigment density, transparency, softness or hardness of the pencil lead—whatever. Just find the tools that work best for you.

Be aware that many brands are sold according to numbers rather than familiar watercolor pigment names. Don't let that throw you; just purchase pencils close in appearance to the pigments you're used to.

Watercolor Pencils

Although the basic technology has been around for decades, watercolor pencils have emerged only fairly recently as a viable option for serious artwork. Today, you can buy artist-quality, permanent pigments in buttery textures and intense shades. You can even get "woodless" pencils that are all water-soluble pigment except for their enameled casing. Basically, they are all watercolor pigment in dry form.

Consider trying these out with one or two open-stock pencils, or invest in a set of twelve, twenty-four or more. Choose artist-quality grade items. The old discount store pencils are weak, scratchy and dry. Try Faber-Castell's Albrecht Dürer Watercolor Pencils, Derwent's in either the regular watercolor pencils or their exciting new Graphitints or Inktense Pencils or Caran d'Ache's Neocolor II Artists' Crayons.

NOTE
You do need good paper with a tough, hard surface for use with watercolor pencils, or you'll find these pencils frustrating.

Visit artistsnetwork.com/Painting-Nature-Cathy-Johnson for a FREE bonus portrait demonstration.

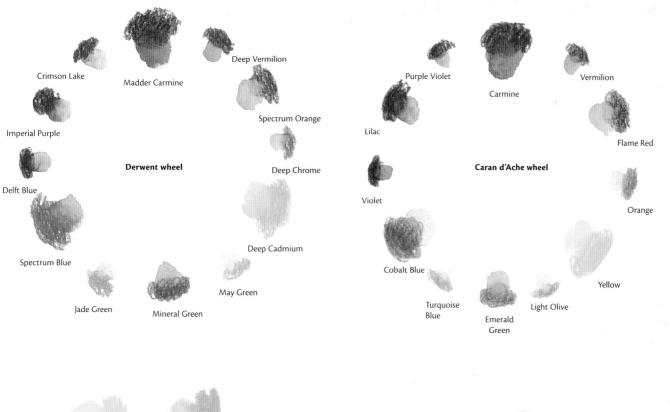

Derwent wheel

Crimson Lake
Madder Carmine
Deep Vermilion
Spectrum Orange
Imperial Purple
Deep Chrome
Delft Blue
Spectrum Blue
Deep Cadmium
Jade Green
Mineral Green
May Green

Caran d'Ache wheel

Purple Violet
Carmine
Vermilion
Lilac
Flame Red
Violet
Orange
Cobalt Blue
Yellow
Turquoise Blue
Emerald Green
Light Olive

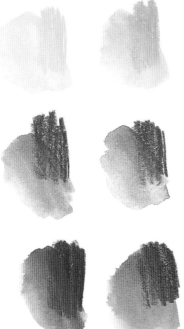

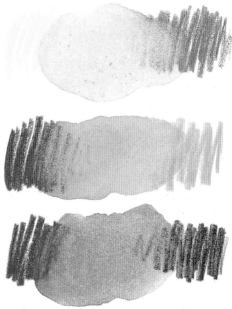

Warm and Cool Colors

If you just want to get your feet wet, buy a few individual pencils. I suggest a warm and cool of each primary color and a small handful of earth colors.

Mixing Primaries to Make Secondaries

Even if your pencil selection is small, you still can get great variety, as shown with this blending of Derwent Watercolour pencils. Here, Lemon Cadmium and Spectrum Blue make a lovely, clear, light green. Deep Vermilion and Naples Yellow combine for a fresh orange. Ultramarine and Madder Carmine make a beautiful violet.

Learning How Your Watercolor Pencils Behave

Watercolor pencils are pure, water-soluble pigment. They go on dry and behave differently from watercolor paints. Pencils are both more controllable than watercolor—in their dry form, at any rate—and a bit more unexpected, and learning to use them can be a challenge.

To help you become familiar with your pencils and their individual pigments, make samples of each of your colors. If you use different brands of pencils, make a separate chart for each brand, as they all go on differently and react differently to the application of water. Experiment with the small sets from the different brands to see which one best suits your needs. Make your sample sheets small enough to carry with you outdoors until you're completely familiar with their qualities.

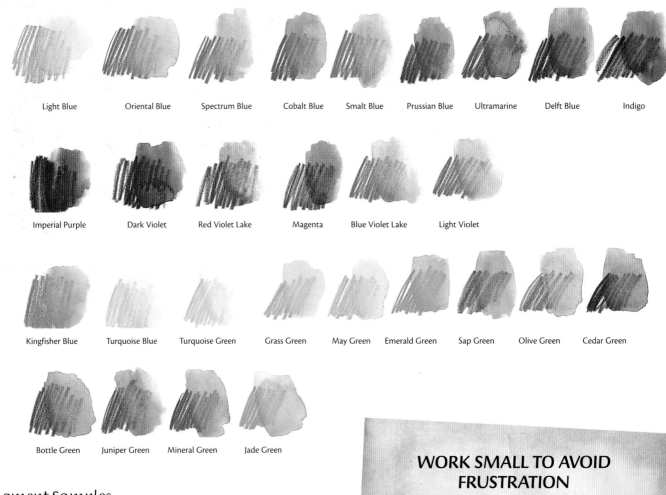

Light Blue · Oriental Blue · Spectrum Blue · Cobalt Blue · Smalt Blue · Prussian Blue · Ultramarine · Delft Blue · Indigo

Imperial Purple · Dark Violet · Red Violet Lake · Magenta · Blue Violet Lake · Light Violet

Kingfisher Blue · Turquoise Blue · Turquoise Green · Grass Green · May Green · Emerald Green · Sap Green · Olive Green · Cedar Green

Bottle Green · Juniper Green · Mineral Green · Jade Green

Pigment Samples

Here are the blues, purples and greens I use most often. Notice how much Imperial Purple changes when I add water. That change can be a bit of a surprise when you are looking for a specific value or intensity, but knowing that it will happen can help you choose the right pencil.

WORK SMALL TO AVOID FRUSTRATION

Because it can be frustrating trying to cover large areas with watercolor pencils, I usually work a good deal smaller than the half sheet (15" × 22" [38cm × 56cm]) or quarter sheet (11" × 15" [28cm × 38cm]) I usually use for painting, and I use woodless pencils, crayons or sticks where I want quicker, more dense coverage.

Visit artistsnetwork.com/Painting-Nature-Cathy-Johnson for a FREE bonus portrait demonstration.

Blending Wax-Based Pencils With Watercolor Pencils

You may choose to use wax-based colored pencils and watercolor pencils together. Although the wax-based pencil can smear if you are not careful when working over it with your subsequent layer, it won't lift or change once you add water. You can achieve bold, dramatic effects, a moody aura or interesting textures by using these two mediums together.

Archer's Hope Creek
Non-soluble wax-based pencil and watercolor pencil on
Strathmore rough watercolor paper
4¾" × 7¾" (12cm × 20cm)

Choosing the Right Brushes for Watercolor Pencil

You will need a selection of brushes to moisten the pencil lines and blend the pigment. The kind of brush you choose, its size and shape and how you use it make all the difference. A small sable brush with a good point that holds only a little water will afford great control, unlike a big, wet brush, which will allow you to blend broad areas with fresh effects.

When starting out, purchase some 1-inch (25mm), 2-inch (51mm) or larger flats and an array of rounds. Though sable brushes are a joy to use, synthetic-hair brushes will work just fine and are less expensive. They have good resiliency and a good point—I do 90 percent of my painting with them.

Bristle brushes can lift just about all of the pigment from the paper's grain, forcing it to flow across the surface like a wash. If you don't like the effect, you can quickly lift the pigment away with a tissue before it settles. Rough handling with a bristle brush can even raise the grain of the paper, making the pigment settle more darkly in those areas—a technique that can be used to your advantage if you approach it intentionally.

Working With Soft Brushes

A soft brush used with a light, quick touch and fresh, clean water will leave more pigment unmoved on your paper; in most cases, the pencil mark will still be at least somewhat visible. I like this technique—a nice vibration between painting and drawing. You still can see the backbone of your work, as in this quick sketch of my gray and white cat, Fuzz.

Removing Pigment With Bristle Brush

To lift pigment away from the paper's grain, use a bristle brush. Take a look at these three examples to see how different brands respond to lifting. On the left is Lyra Aquacolor; in the center is Cretacolor Aqua Monolith (a woodless pencil); at right is a Derwent Watercolour Pencil.

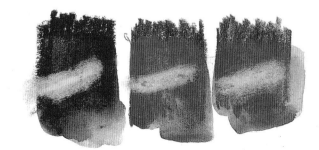

Visit artistsnetwork.com/Painting-Nature-Cathy-Johnson for a FREE bonus portrait demonstration.

Choosing the Right Paper

You will need a painting surface that matches your needs. If you are planning a fairly wet application, buy watercolor paper of at least 140-lb. (300gsm) weight, as lighter papers will buckle. If you do use a light-weight paper, either mount it or use a dry-brush technique. Consider the surface of your paper as well. Is it tough and durable or soft and delicate? You will not be happy using one of the more delicate papers.

Another paper option is a good quality sketchbook. I often use a Strathmore bristol drawing pad with a regular surface. Its two-ply paper will withstand wetness without too much buckling. A pad of regular drawing paper will work, too, as will a block of watercolor paper—just don't get one with a really rough, mechanical surface because it will be hard to draw on.

Surfaces

For working at home, you may want to buy full sheets of watercolor paper (usually 22" × 30" [56cm × 76cm]) and cut them to the size you want. If you get 300-lb. (640gsm) paper, it won't need to be stretched or taped to a support, but 140-lb. (300gsm) paper is sufficient for most needs. Tape it to a support with masking or drafting tape and you won't have much buckling. Any small hills and valleys that form will generally flatten back out as the paper dries.

You can also buy pads or watercolor blocks. The latter are comprised of multiple sheets, glued together on all four sides, with a small opening to allow you to insert a blunt blade to free a dry, finished painting. If the paper is 140-lb. (300gsm) or better, there is virtually no buckling with blocks, no matter how wet you paint. Watercolor blocks are great for travel or field work.

There are three common surface textures in watercolor paper: rough, hot press and cold press. Cold press may be the most versatile, but many watercolorists like rough paper for a variety of textural effects. It is more difficult to control your washes on hot-pressed paper, but it can be very exciting, splashy and puddly. Try them all to see which you prefer.

As always, buy a good brand—I like Fabriano, Arches or Strathmore. Inexpensive papers may have a nasty mechanical texture or refuse to take washes well. Some are too absorbent or buckle excessively when wet. Nothing is as discouraging as trying to paint on inferior or student-grade stuff.

NOTE

For use with watercolor pencils or watercolor techniques involving lifting or scraping, you will be happiest with a tough, hard-surfaced paper. Softer, more delicate papers are best reserved for traditional painting techniques.

Smooth vs. Rough Paper

A pencil will make a smooth, unbroken line on smooth paper (as shown with the green pencil strokes), while on rougher paper the pencil skips and skitters, making a broken line rather like a linear dry-brush technique (as shown with the violet pencil strokes). If you wet it quickly and lightly, the pencil stroke will retain some of the textured effect.

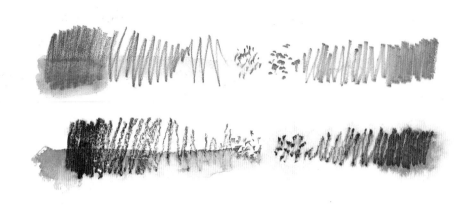

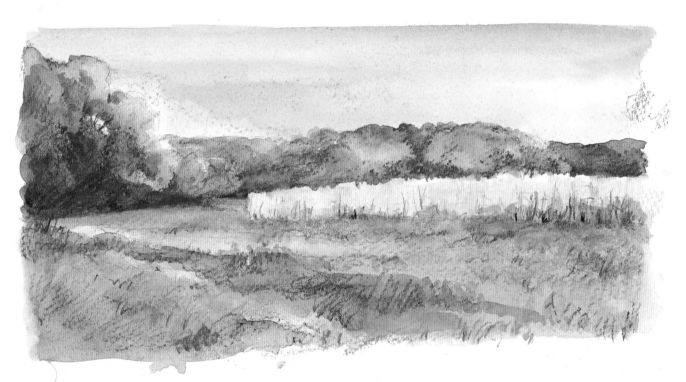

Blending on Rough Paper

Here, there are dots and dashes of texture in the shadows on the lower left. They are left over from the original pencil tone. I used a light touch to blend that area. When adding water to the sky, I wanted to achieve a smoother effect so I blended more aggressively with my brush. Of course, non-soluble pencils keep their texture regardless of the amount of water applied.

Field Piece
Graphite and watercolor pencil on Strathmore rough
watercolor paper
5" × 9½" (13cm × 24cm)

Pick Right Paper for Medium

I had planned this piece as an example of saturated color and just used the top sheet in a Strathmore paper sampler. It turned out to be a very soft-surfaced paper, fine for traditional watercolor but not at all suited for pencil work. In order to get a good strong shade the first try, you would normally apply your watercolor pencil heavily, with a great deal of vigor. But because of the fragility of the paper, I was forced to apply the color in four or five layers in order to get the intensity I was after.

Nevada Runoff
Watercolor pencil on Strathmore Imperial
cold-press watercolor paper
7¾" × 5½" (20cm × 14cm)

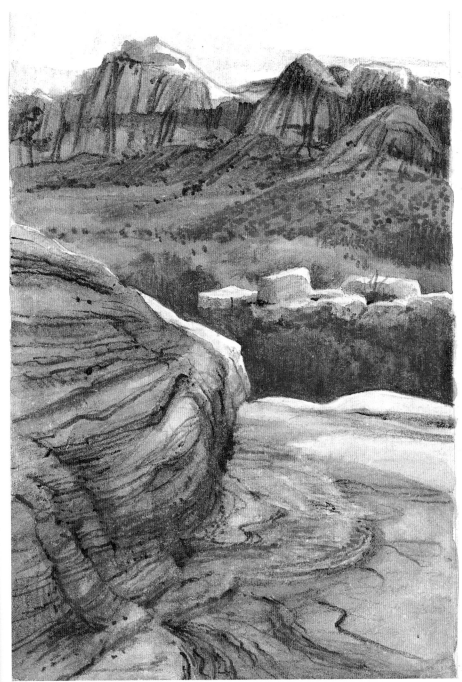

STICK TO STRONG PAPERS

Here are two squiggles of color to demonstrate the differences in paper. The one on the left is on a softer surface, while the one on the right is on a paper with a lot of sizing, so it will take rough handling. The more delicate paper would be perfectly acceptable with traditional watercolor, but it would not be the proper choice for bold pencil work.

Working With Colored Papers

Colored papers work well with opaque watercolor pencils and paints. Because the pigment is transparent in many pencils and paints, the color of the paper shows through, suggesting mood or unifying your composition. There are several brands of watercolor paper with pale, soft color, both warm and cool. You also can work on the more vibrant, textured papers intended for pastels or printing.

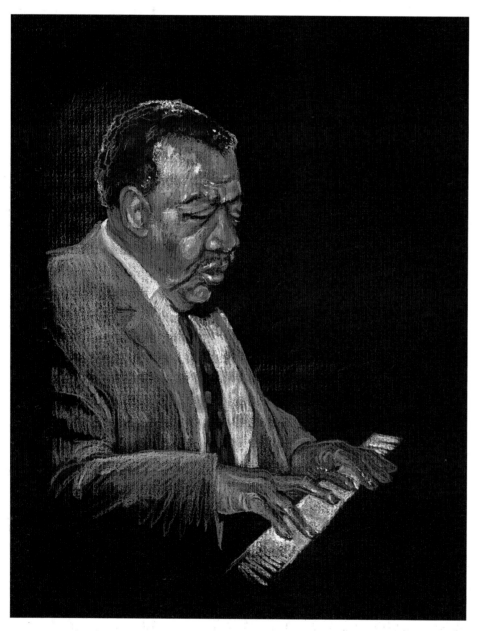

Jazzman McShann
Watercolor pencil on black Canson pastel paper
10" × 7" (25cm × 18cm)

Use Black Paper for Moody, Dramatic Effect

In this painting of Kansas City jazz great Jay McShann, I used black, grainy, textured paper to capture the moody drama of the smoky clubs where he often played. I laid in the first layers of color pretty emphatically, pressing down fairly hard, and then wet them to blend. I used a pale vermilion, pink and a light blue in the shadow areas on his suit, white with pale blue shadows for his shirt and shades of burnt sienna, burnt ochre, brown ochre and white in the face. I let the black of the paper stand in for his hair, with just a bit of definition with dancing strokes of a very sharp white pencil. When those colors were dry, I went back in and restated with both wet and dry pencils—the dampened pencil points leave bold marks, as in the highlights on his hair, forehead and mouth, as well as the designs in his tie. A bit of white pencil, lightly applied and left dry just behind his head gives a bit of dimension to the background.

Visit artistsnetwork.com/Painting-Nature-Cathy-Johnson for a FREE bonus portrait demonstration.

January 1
Ink, colored pencil and gouache on toned paper
9" × 12" (23cm × 30cm)

Using Toned Paper

Working on toned paper lets you experiment with an almost three-dimensional effect. You can achieve this effect by laying in the darks with watercolor and adding lights with colored pencil, gouache (opaque watercolor) or white ink. Buy toned paper from your art supply store or tone your own. Either way, the effects are wonderful with watercolor.

Use whatever combination of mediums you need to get the effect you're after—there's no need to stay strictly with watercolor. Here, I chose a tan paper with a medium value. I did the initial drawing in my car with a technical pen. Later, at home, I added colored pencil and watercolor washes to capture the image in my mind.

Saving Time With Toned Paper

Using toned paper can also save you time when working under adverse conditions or when you want to create a mood quickly. Here, the winter sunset was fleeting and it was cold on the porch. I grabbed the pink-toned paper to give an undertone of sunset, then laid in quick wet-into-wet washes as the darkness gathered.

Sunset
Watercolor on Strathmore
cold-pressed watercolor
paper
5" × 7" (13cm × 18cm)

Prepping for Mixed Media

It's not necessary to limit yourself to watercolor alone, of course. Mixed media can be very satisfying, and watercolor combines well with graphite, colored pencil and pen and ink. Some of these are time-honored techniques going back hundreds of years. Why not put them to work in your own paintings and sketches?

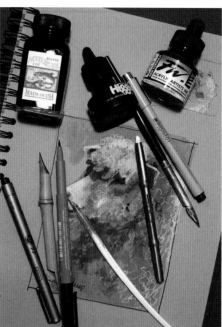

Combining Techniques

I toned the background with a loose wash of Ultramarine Blue and Burnt Sienna and allowed it to dry thoroughly, then I used black ink and white colored pencil to add the forms of the goat and the suggestion of dry grasses.

Resting
Watercolor, ink and colored pencil on Strathmore cold-pressed watercolor paper
5" × 7" (13cm × 18cm)

Adding Ink

Dip pens allow a wonderful variety of lines (you'll need liquid ink, of course). Technical pens make crisp, uniform lines and brush pens can approximate watercolor (I find black or brown most satisfying for combining with washes).

Inks (both in bottles and pens) can be waterproof or water-soluble. Both have their place and offer a range of techniques. Colored pencils combine well with watercolor, too. You can be conservative and stick with black, gray and sepia ink, or you may branch out and use a rich indigo or burnt umber.

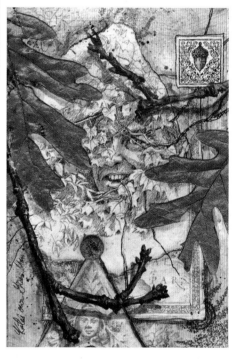

Combining Colored Pencil With Watercolor Washes

One of my favorite techniques for sketching and painting nature is combining wax-based colored pencils with watercolor washes. I might add the watercolor on the spot or add it later, back at camp (or home). Waiting helps me train my color memory. Many of us love drawing as well as painting, and this technique lets us combine drawing and painting in strong, graphic ways. The washes can be very quick and splashy, and the final result is very pleasing.

Rhythm of the Trees
Watercolor and colored pencil on Strathmore cold-pressed watercolor paper
5" × 7" (13cm × 18cm)

Combining Collage With Watercolor

You can even combine collage techniques with watercolor if you like. Underpaint the collaged elements, or paint right over them. It gives another dimension and new texture. (A bit of acrylic medium works well for attaching collage elements.)

Kate's Own Greenman
Watercolor, acrylic, ink, leaves and acorn cap on mat board
7" × 5" (18cm × 13cm)

Working on the Spot—Tools for Travel

If you plan to spend much time working on the spot, you'll need a few special tools. The specific tools, again, depend on you. And, in this context, "travel" can mean to the other side of the globe or to the park down the street. Your supplies are basically the same, unless you plan to stay for a long time, far from a source of art supplies.

If you plan a full-scale painting expedition, a knapsack or messenger bag will hold your supplies, including a large container of water, a generous palette and a watercolor block at least 9" × 12" (23cm × 30cm). Add lunch and a bottle of drinking water or a thermos of coffee, and you're set!

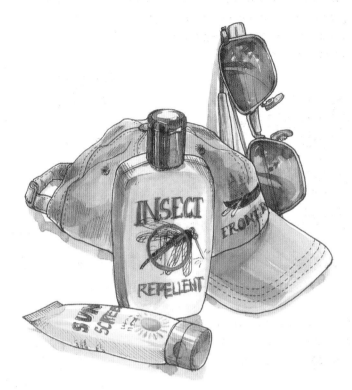

Essentials for Sun Protection and Comfort

Take along a hat for shade—just for your eyes, like a ball cap or a big straw hat that will also block the glare from your paper. Sunglasses are not just good for your eyes; they also help simplify values, especially if they are polarized. Add insect repellent and sunscreen, and you're ready for the most demanding outdoor painting trip. (Though sometimes an umbrella, an extra sweater and a rain slicker come in handy.)

Knapsacks and Chairs

Mini-messenger bags are great for sketching trips. This little brown bag goes everywhere with me, from the classroom to country roads to crowded, noisy saloons; and it contains everything I need: a Winsor & Newton Artist's Watercolor Travel Set; a folding palette with larger pigment wells; a small water container; and a tin of brushes, pencils, ink pens and a set of watercolor pencils. Throw in a few dollars, my driver's license and a credit card, and I have everything I need in one bag.

If you need a bit more comfort, and sitting on the ground isn't as much fun as it once was, consider a folding stool with a generous pocket for art supplies and so forth. Some of these stools even have backs. This one has seen a fair amount of country! You can also buy a gardening cushion or cut a rectangle from a foam camping mattress to sit on. These will keep you dry and comfortable.

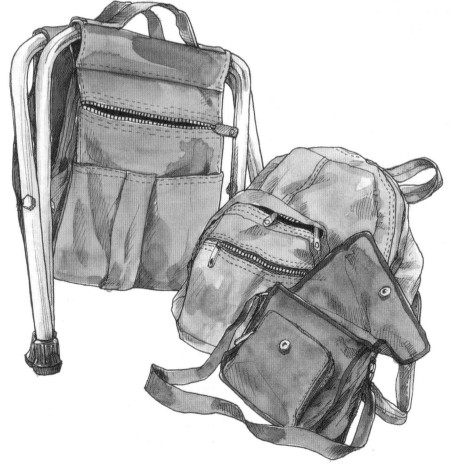

Cameras

Your camera can be anything from a small, disposable 35mm to a modern digital—whatever you're comfortable with. I prefer one with a macro capability so I can zero in on details like flowers, lichen or small insects.

You can also capture fleeting moments such as rapid changes of natural light or a scene from your car window as you streak by (only if you're not driving, of course!). Sometimes, a camera is a help if your subject doesn't have the time or patience to wait while you sit and paint. As long as we don't get caught up in trying to slavishly copy what the camera shows us, photos can be very helpful.

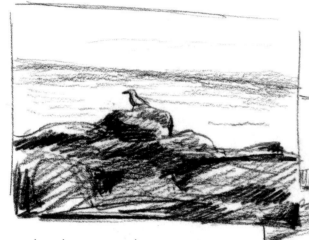

Sketch Now, Paint Later

You may not have time to do a complete painting on the spot, or you may prefer doing finished paintings back in your studio or at home, where you have controlled lighting, a comfortable chair and no bugs! In that case, you may want to make quick sketches on the spot, or even shoot photos to supplement your sketches and your original impressions.

We'll cover much more on composition, value, format and thumbnail sketches in chapter two. For now, just consider the ways you can capture your impressions with sketches or your camera.

NOTE

You may wish to invest in a small hardcover journal or sketchbook to keep everything in one place. Mine, influenced by Hannah Hinchman's wonderful **A Life in Hand: Creating the Illuminated Journal**, contains everything from sketches to finished drawings, from to-do lists to grocery lists. Keep everything in it! This not only makes things easier to find later; it also helps me feel less scattered.

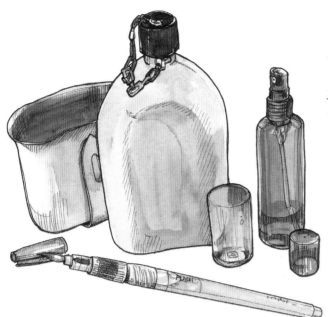

Water Containers

At home or in the studio you can use anything from a canning jar to a container made especially for watercolorists, like the double-brush tub (one side for clean water, one for sullied). Some containers include a brush-cleaning area and lid (the better to keep cat hairs out of your paint water, my dear!). You can even get a collapsible water bucket, nice for field work. Many artists go low-tech and make their own double-brush tub with a jar in a margarine tub (both filled with water).

In the field, a canteen and cup work well and are almost indestructible. For a small field sketching kit, I use a little spray bottle, plus a "cup" cut from another bottle. You can fill the cup from the bottle, then use the spray option to moisten your pan colors or paper before painting. Lately, I've been trying out Niji waterbrushes. They hold only enough water for sketching, but they work well, and there's no need to carry a separate container for water.

Other Materials and Equipment

The other items that you need depend largely on you. Here are the tools I often use—we'll see them at work later in the book.

- Roll of paper towels for cleaning my palette, lifting washes and blotting excess water from my brush.
- Clean cotton rags are stronger than paper towels for lifting, and not as likely to leave bits of lint.
- A natural sponge for blotting, lifting and painting. (They make great organic textures!)
- A man-made sponge, also for blotting, lifting and painting. These make a more even, mechanical texture.
- A bamboo pen for creating a variety of linear effects and for precise scraping or incising.
- A sharpened stick (or the sharpened end of a brush) for creating more organic linear effects, scraping and incising.
- A cut-up, expired credit card for scraping back washes (make a variety of sizes and shapes).
- A stencil brush for spattering.
- Masking fluid for protecting white paper.

GETTING STARTED: BASIC TECHNIQUES

For those who are longtime watercolorists, this chapter can act as a review, a warm-up. For those newer to the medium—or to making art at all—here are some of the basic techniques you'll want to know before starting an actual painting.

Once you know the basics, you'll be able to do anything—with practice. Some artists do have a natural aptitude, of course, but we all need to hone our skills. Besides, learning new techniques and tricks is great fun—almost like magic. So, whether you're an old hand or brand new to the medium, try these concepts on for size.

COLOR CHOICES

Color is a key to success. Think about it—we respond to some paintings instantaneously on a purely emotional level. Subject matter aside, most likely it's color that elicits that response. At a recent show I judged, one painting just made me stop and catch my breath. When I analyzed my reaction, I realized it was the artist's masterful use of color that stopped me in my tracks.

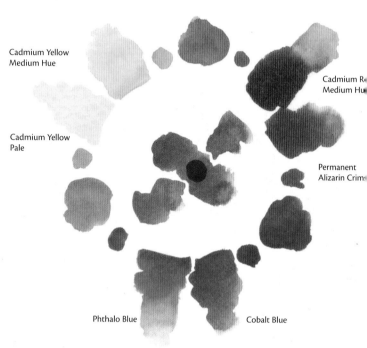

Cadmium Yellow Medium Hue

Cadmium Yellow Pale

Cadmium Red Medium Hue

Permanent Alizarin Crimson

Phthalo Blue

Cobalt Blue

TIP

To make mixing clean, fresh secondary colors easier, you may want a warm and a cool of each primary—for example:

- Lemon Yellow or Hansa Yellow Light (cool)
- Cadmium Yellow Medium Hue or Transparent Yellow (warm)
- Permanent Alizarin Crimson or Quinacridone Red (cool)
- Cadmium Red Medium Hue or Pyrrol Scarlet (warm)
- Phthalo Blue (cool)
- Ultramarine Blue (warm)

Warm and Cool Color Wheel

To start out, try choosing one or two of each primary color in tube form. These can be squeezed out onto your palette, allowed to dry for portability then rehydrated when you're ready to paint, at home or in the field.

Using a warm and a cool of each primary color will allow you to mix clean purples, hot oranges and spring-like greens, or you will be able to choose a more subtle mixture, if you like. Mixing opposites on the color wheel (complements) will give you a range of warm and cool neutrals, depending on how you balance your mixture. Mixing all your colors produces a near-black. It's very versatile!

Keep It Simple

A simpler color wheel can use very pure primary colors, like Ultramarine Blue, Azo Yellow and Naphthol Red. These three colors alone will produce a wide range of colors. It's a wonderful discipline to start out like this instead of investing in a full array of pigments.

The three spots of color between adjoining primaries are varied mixtures of those primaries. The arrows connect complements (yellow and purple, orange and blue, green and red). Mixing all three primaries—or mixing the complements, which is really the same thing—produces neutrals. The six outer colors are mixtures of the three primaries, in a variety of strengths.

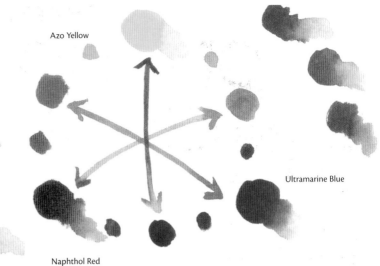

Azo Yellow

Ultramarine Blue

Naphthol Red

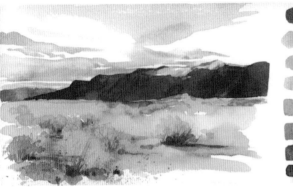

The Limited Palette in Action

It's good exercise to try a limited palette painting, that is, choosing only one to three colors for your painting. This little sketch of the Nevada desert was done on Cartiere Magnani's 4½" × 9" (11cm × 23cm) cold-pressed watercolor pad, using only Azo Yellow, Naphthol Red and Ultramarine Blue. I painted swatches of the various mixtures I used.

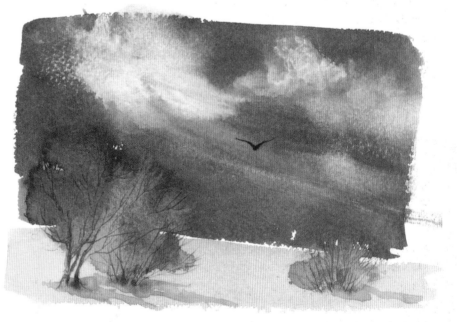

Velázquez Palette

The early Velázquez palette (named for the Spanish artist who used it so frequently) let Burnt Umber act as the red, Yellow Ochre as the yellow and black as the blue in this low-key color wheel. You may want to try the more bluish Payne's Gray as your blue.

Winter Landscape
Watercolor on Strathmore
cold-pressed watercolor paper
5" × 7" (13cm × 18cm)

Variation of the Velázquez Palette

Here I used a variation of the Velázquez palette: Payne's Gray, Burnt Sienna and Yellow Ochre. I let backruns suggest the trees and scratched the limbs into the damp wash. I lifted the clouds with a paper towel while the sky was still wet.

Getting Familiar With Opacity

There may be times when you want to work on dark paper for dramatic effect. At other times, you may simply want to lighten an area that's gotten too dark, add a bit of fresh color to a muddy spot in a painting or add a wet sparkle to an animal's eye. The more opaque watercolor pencils will allow you to do all of that, just as though they were gouache. It only takes a bit of experimentation to see what will work for you.

The surface you choose to work on affects the final outcome. A very textured paper will tend to have its texture accentuated by a strong application of the more opaque watercolor pencils (you can use that to your advantage to suggest the sparkle of light on water or to give a smoky texture to your work). A smoother paper may be difficult to get good coverage on because too much of the pigment will lift. In any case, you can reapply after the first wash is thoroughly dry.

Prussian Blue
Ultramarine
Light Blue
Sky Blue
Sap Green
Bottle Green
Water Green
Scarlet Lake
Madder Carmine
Deep Vermilion
Pale Vermilion
Rose Pink
Deep Cadmium
Zinc Yellow
Primrose Yellow
Burnt Umber
Burnt Sienna
Venitian Red
Terracotta
Brown Ochre

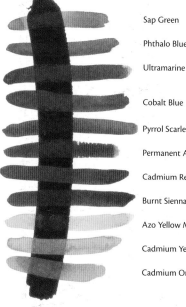

Sap Green
Phthalo Blue
Ultramarine Blue
Cobalt Blue
Pyrrol Scarlet
Permanent Alizarin Crimson
Cadmium Red Medium Hue
Burnt Sienna
Azo Yellow Medium
Cadmium Yellow Medium
Cadmium Orange

Transparent vs. Opaque Watercolor Paints

Some paints are opaque and some are transparent. You can use these qualities to achieve different effects. (To properly use these qualities, of course, you have to know which paint does which!) Paint a bar of India ink and allow it to dry thoroughly. Then mix a strong wash of each of your pigments and paint a horizontal bar right over the ink line. Let it dry and label your colored bars so you don't forget what you used. You'll be amazed at what you learn about the opacity and transparency of your paints. There's much more to choosing the right pigment than color.

Transparent vs. Opaque Watercolor Pencils

Like when you use regular watercolor, there are times when you will want to know which of your watercolor pencil colors are the more opaque and which more transparent. Make a bar of waterproof black ink (this is India) and allow it to dry thoroughly. Then make a bold squiggle of each of your most frequently used colors over it. Blend half of each with clear water, washing your brush between colors as I did here. Label these colors and keep the results with you as you work until you are familiar enough with them to know what each color will do when used light over dark.

Using Saturated Colors

To achieve the most saturated colors, lay down strong, heavy tones. To get the best results, you may wish to use watercolor crayons or woodless pencils. A liberal application of water and a vigorous touch with the brush will lift a good deal of this pigment; a drybrush technique simply will blend. Either way, it's nice. And again, be sure you have chosen the colored pencil you want from the beginning. Once you've gone to the trouble of laying in a strong area, you don't want to find you hate the moistened version of the color.

When going for strong color, choose the paper carefully. If you use a paper with a soft surface, it will be difficult to get sufficient coverage and you'll have to lay on pigment more than once as the color dries. For *Gwyllyd* I used a good hard-surfaced watercolor paper from Strathmore and was very satisfied with the effect.

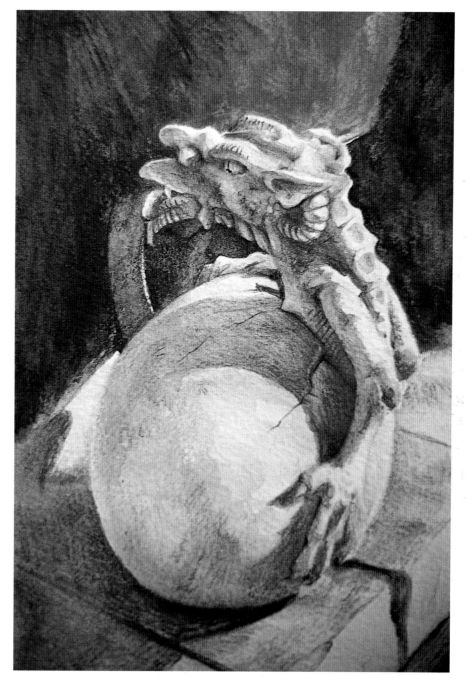

Use Saturated Colors for Bold Effects

On this painting of a sculpture of a young dragon hatchling, I used bold areas of color applied heavily in the background and shadow areas. I wanted him to pop out of the picture plane in a lively manner, so I utilized a lot of contrast. I pushed the color in the creature himself—he is a verdigris color with an underlayer of a rusty tone. I enjoyed finding ways to incorporate more color by seeing the cools and warms in the shadows and allowing the sunlit areas to remain lighter than the little figure really is.

Gwyllyd
Watercolor pencil on
Strathmore rough water-
color paper
10" × 7" (25cm × 18cm)

Values

Master watercolorist Charles Reid said, "Color gets all the credit, but values do all the work." If you have the values (the range of lights and darks) right, the colors you use don't matter all that much.

Whether you choose a high-key palette or a dark and moody one, you'll find that values give you a solid foundation to build on, and they'll get the idea across in the strongest possible way.

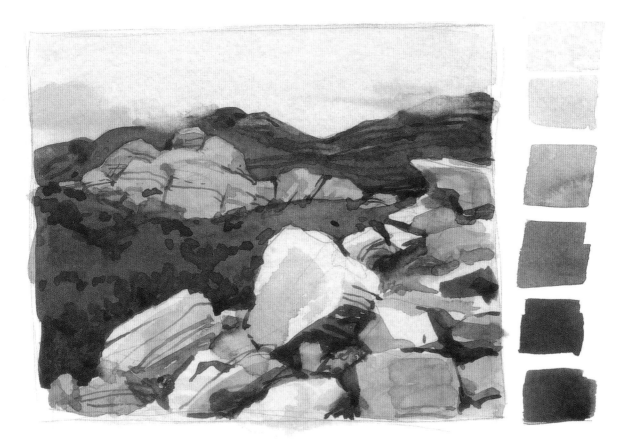

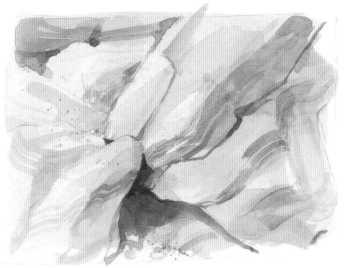

Values Experiment

Try making strokes or blobs of values from your darkest dark to lightest light (use a neutral or a color). Then see how these can give your artwork depth and interest.

High Key

This little sketch is high key, using predominately light values. It captures the sunny effect of Nevada's desert in a way that would be difficult with darker, heavier colors.

Visit artistsnetwork.com/Painting-Nature-Cathy-Johnson for a FREE bonus portrait demonstration.

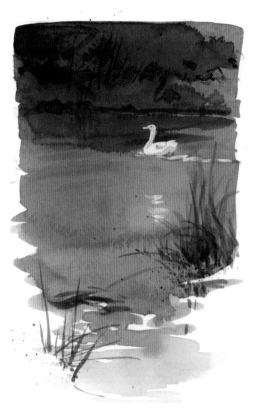

Low Key

This low-key scheme, using the darker value range, lets you know it's late in the evening, when objects become flatter and less distinct. The white goose really stands out against the deep shadows of the far bank. This image has a serene feeling that would not have come across if I'd chosen a high-key palette.

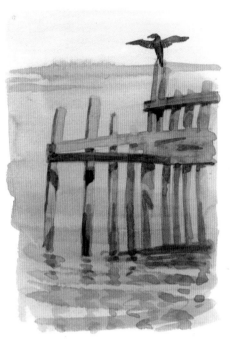

Medium Key

Using colors that are medium in key and close in value produces a foggy look that suits subjects such as this old wooden pier in Maine.

Moody Colors

Choose your colors to create a mood—cool blues feel like winter; yellows, oranges and reds feel hot and subdued; blues and greens suggest a cool, overcast day. Your colors can suggest serenity, energy, passion or peace. Think about the effect you want before choosing your palette.

Emphasize what you see before you, or create a whole new color scheme to fit the mood you want. No one says you have to paint exactly what you see.

This plein air painting was done on a cloudy day in spring, with blue, hazy skies and cool, green fields.

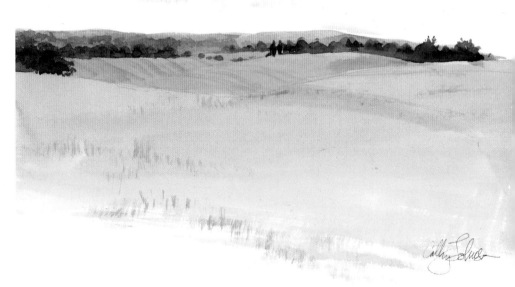

Across the Road
Watercolor on Strathmore cold-pressed watercolor paper
9" × 12" (23cm × 30cm)

Working Light Over Dark in Watercolor Pencil

This technique is a bit tricky, but it is possible to make light areas within a darker one with an opaque white pencil or crayon or one of the more opaque pastels. Choose your tools carefully, and test them before touching them to your painting, as some tools are more heavily pigmented than others. Make sure your painting is thoroughly dry before adding these lights, and then blend carefully.

If you just need to recapture a highlight in a dark area, you may do so by moistening a light-colored opaque pencil (e.g., white, straw) and touching it to the paper. For a more controlled highlight, touch a wet brush to the tip of the pencil and paint with it as you would with regular watercolor.

Creating Light Areas on Dark

It is possible to create light areas on dark. In these examples, I made three areas of deep color (a gray-blue, a blue and a black—all on handmade cold-pressed watercolor paper), wet each one and allowed them to dry. Once that was done, I applied some white pencil with bold strokes, then quickly wet it to blend.

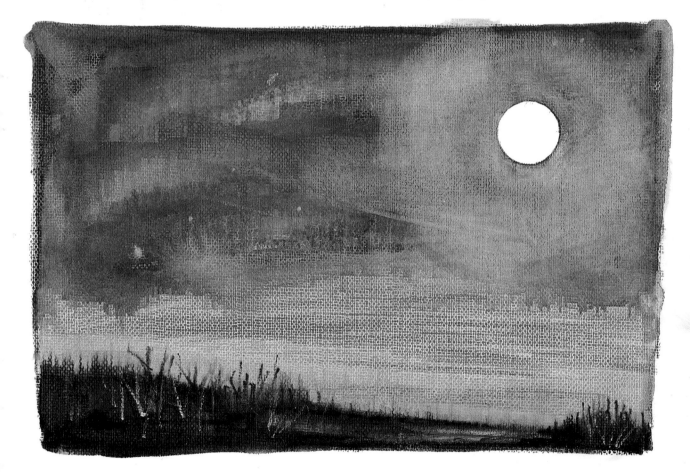

Creating a Night Scene

This technique of applying light over dark can work well to capture clouds in a night sky or other meteorological phenomena. This small night scene was done in this manner on a canvas-textured paper originally meant for acrylic paints. I enjoy the unusual texture and the sealed painting surface that makes the color float on top rather than sink in.

Visit artistsnetwork.com/Painting-Nature-Cathy-Johnson for a FREE bonus portrait demonstration.

Varying Watercolor Pencil Application

Watercolor pencils can be tricky. If you expect the dry color to be the same intensity once it's wet, you may be in for a surprise.

Depending on how much water you apply and how it is used, it can dilute the original pigment, free it from the static state and allow the white of the paper to shine through, often in very exciting ways. If you apply the pencil heavily, adding water actually seems to make it less diluted and stronger because it fills in the tiny white speckles you get from pure pigment on dry paper. Test an unfamiliar color—wet and dry—on a piece of scrap paper to make sure that what you've chosen is what you really want.

It's not necessary to stick with the narrow wood-clad pencils. If you're after a broader result or quicker application, try Lyra Aquacolor sticks, Caran d'Ache Neocolor II or Bruynzeel or Cretacolor Aqua Monolith all-pigment pencils.

If you're after a monochromatic silver-gray drawing, try the new water-soluble graphite pencils from Derwent. They come in three grades (hardnesses). Sometimes I find it necessary to restate lines once the artwork dries because it can appear too washed out. But then, I'm the bold type—you may prefer this subtlety.

Heavy and Light Applications

Here I've applied Derwent Madder Carmine and a cool, intense blue Lyra Aquacolor stick both heavily and lightly. Notice the difference as a drop of water is pulled through the pigment.

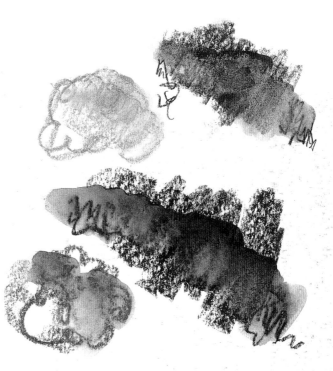

Sticks and Woodless Pencils

Here I've created broad effects with larger sticks and woodless pencils, such as Lyra Aquacolor or Cretacolor Aqua Monolith.

WORK LIGHT IN THE FIELD

Since watercolor pencils are so light, I often take nothing else with me into the field—no need to tote along heavy containers of water. After all, I can wet the whole drawing (or just selected areas) when it's convenient, be it minutes later at the campsite or years later in my studio—provided I remember that the drawing was done with water-soluble pencils to begin with!

Applying Basic Pencil Techniques With Water

The effects you achieve depend not only on how you apply the pigments, but also on how you add water. I usually scribble tone in with an energetic zigzag effect. Then I wet with broad areas of water applied with a soft brush, yielding a blended wash with a bit of a linear pattern remaining. You may prefer a more controlled cross-hatching to achieve this broken tone—try it. Use a single color or as many as you like, either simultaneously or one at a time, washing with water and allowing it to dry before adding another.

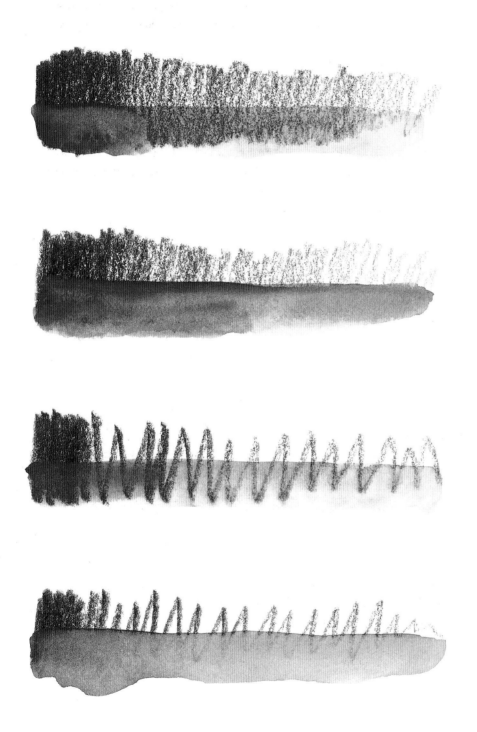

Smooth Pencil, Water Added Lightly

I applied this dark violet with a fairly even application of pigment—nearly flat on the left of the color bar, fading to a relatively smooth but light application to the right. Then I quickly and lightly added water. It still lifted the pigment to a considerable degree, but you can see the pencil marks under it.

Smooth Pencil, Water Scrubbed Aggressively

Here, the effect is even more noticeable because the pigment was scrubbed somewhat aggressively with a brush and clear water to lift and blend it, losing the effect of the pencil underneath. Personally, I like the additional texture and interest the pencil gives in most cases, so I normally would use a lighter touch with my brush.

Loose Pencil, Water Applied Lightly

In this sample, I applied the violet pencil in a much looser fashion, fading off to obvious zigzags that still show under the lightly applied water. Note that the clear liquid still picks up a lot of the pigment.

Loose Pencil, Water Scrubbed Aggressively

In this last sample, I again lifted and blended the color aggressively. You can see that even with the obvious zigzagging of the pencil, you can achieve fairly smooth results.

Visit artistsnetwork.com/Painting-Nature-Cathy-Johnson for a FREE bonus portrait demonstration.

Playing With Pencil Pigment

There is no need to be chained to straight blending of color when you add water. After all, this *is* watercolor pigment. You can lift it and paint with it just as you would a cake of pigment or a dab of tube paint. You can even touch your wet brush to the pencil's lead (or to the side of a watercolor stick) just as you would to a cake of color in your watercolor box. I find this technique especially useful for small details, such as those on flowers and portraits.

MIXING COLORS

You don't need to be limited to the colors that come with your set of pencils. If you bought one of the large sets, you'll have a wide range of versatility and subtlety. But if you've opted for a smaller set of pencils, you can mix directly on your paper, either before wetting or after. Mix and match. You don't have to own one of every color available to express a landscape, still life or portrait. Like watercolor, this is a mixable medium. To achieve a new hue, lay down two or more colors and then blend together. Crosshatch these tones, lay the strokes in side by side or layer as smoothly as possible. The residual pencil marks that remain on your paper will make a lovely vibration with the new tone. With this technique you can achieve great subtlety and create colors richer than you could ever purchase, especially since colors retain just a glimpse of their individualities on the paper.

DEALING WITH THE UNEXPECTED

There's no need to stop working if what you've produced doesn't meet your expectations. If the colors are too weak, too strong or not what you'd planned, simply add more pigment or more water. You'll find you are less likely to end up with a dull, overworked, muddy piece with this medium than with some others because each pencil is pure pigment. You mix directly on the paper much more often than on the palette.

Wetting Pencil Lead

You can put color down dry, wet it and then pull it out into dots and squiggles reminiscent of foliage. Depending on the color you've chosen and the type of pencil marks you make, you also can suggest tiny wildflowers, mosses or blades of grass.

Mixing Different Pencils

In this sample, I've made green by overlapping lines of yellow and blue and then mixing with clear water directly on the paper surface. On the sample at the right, the lines are spaced farther apart. On the left, the same two colors are applied much more heavily for richer effects.

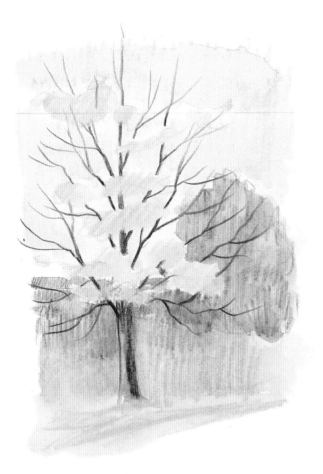

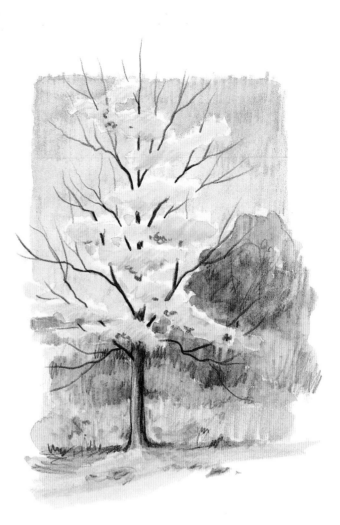

Pigment Applied Too Weakly

Don't be shy in applying your pigments—you may need to break loose a bit to achieve the values (and the emotional punch!) that you want. Don't rely on pigment names, logic or even local color. Take a look at this quick sketch I did in the field. Because the sky was blue, I used sky blue (which was much too pale and watery). As the leaves of the oak in the background were a tannish brown, that's what I chose. The distant hills were a darker blue than the sky, but because the sky was pale, so were they! And finally I chose a sepia pencil for the tree trunk and branches because I'm used to sepia being my darkest dark. I relied on familiar names rather than on the pencil colors themselves, and all in all the contrast between sky and leaves and branches turned out much weaker than I wanted. In fact, the whole piece was a bit wan.

Pigment Applied Vibrantly

Here is a much more successful sketch. I used a darker blue for the sky and added more strong blue pigment to the shaded areas of the background and more brights and stronger values in the weeds behind the trees and in the foliage itself. I was much happier with the result because it captured the spirit of a beautiful autumn day. Once the painting was dry, I went back in and added some sharp details.

Visit artistsnetwork.com/Painting-Nature-Cathy-Johnson for a FREE bonus portrait demonstration.

Working Dry-Into-Wet in Watercolor Pencil

No one says you have to sketch with dry pencils on dry paper and then wet your drawing. Wet your paper first if you like (soak it in a tub to really saturate it), then draw on it for a soft, lively, unpredictable line. Be careful not to tear the paper as you draw; it's more delicate when it's wet.

Another way to work dry-into-wet is to make dots with the pencil's tip for a pointillist effect.

Drawing Onto Wet Paper

These color samples show three different pencil brands drawn into an area of wet paper. I first mopped the paper down with clean water and then drew from left to right, directly into the wet spot. Note how the lines soften and change in color due to the wet paper.

Pointillist Effects on Wet Paper

Another way to work dry-into-wet is with dots from the pencil's tip for a pointillist effect. In this example, at left I first wet the paper with clear water and then made repeated small marks with a variety of pencils and crayons. The small grouping on the right was done in reverse, by first making the dots and then wetting the paper. Notice how the dots are less emphatic, paler, more blended and not really as interesting.

Dealing With Shadows

Shadows are interesting in and of themselves. The whimsical and unexpected shapes of shadows are wonderful subjects for the artist—both cast shadows and shadows on objects that give them dimension and shape. Depending on the direction of the light source and the shape that light falls upon, the shadows may be calligraphic and angular—El Greco shapes that echo their objects in delightfully unexpected ways. Reflected lights that bounce fresh color back into shadow areas make your paintings sing with color and life.

MATERIALS

SURFACE
Arches hot-pressed watercolor paper

WATERCOLOR PENCILS
blue and orange hues of your choice

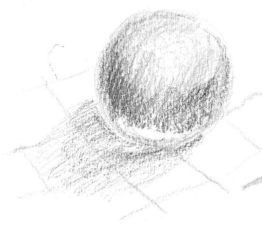

1 Lay In Basic Shape
To create the shadows for th[e] orange, first choose your colors carefully and lay in the basic shape[s] paying attention to reflected light the shadows and on the orange it[self] Notice the reflected orange color the shadow closest to the fruit.

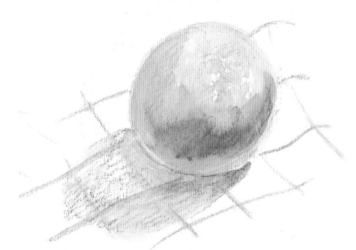

2 Wet Shapes
Next wet the shapes you created in step 1 and allow everything to dry thoroughly.

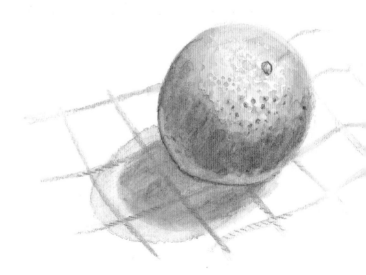

3 Add Final Color and Details
Model the shape of the orange with richer hues. Mimic the texture of an orange with a dancing touch with the tip of your brush. Go back in to restate the blue crossbars in the fabric once you've blended the shadow of the orange well.

Keeping It Clean

Out of long habit, I work with a paper towel or tissue held in my left hand—I do this even if I am working with traditional watercolors. As I move from one area to the next, I blot my brush to keep the color from picking up and sullying the new area. You also can quickly pick up excess liquid on your painting's surface or lighten an area that is darker or more intense than you intended.

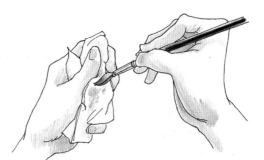

Use a Tissue to Keep Things Clean
You may find it useful to keep tissue handy for blotting your paintings or for removing excess moisture from your brush.

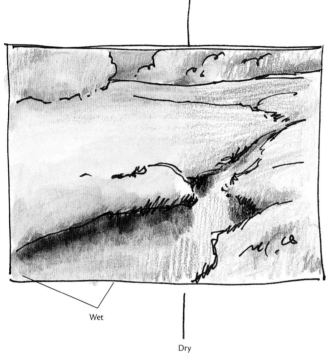

Wet

Dry

Careful, Clean Wetting
Notice in this little sketch of a meadow how I overlaid the dry pencils on top of the quick ink drawing, as shown on the right-hand side. You can see how I carefully wet the colors on the left, rinsing the brush and dabbing it on my tissue between wetting each area. I lifted and blended the colors only where I wanted to.

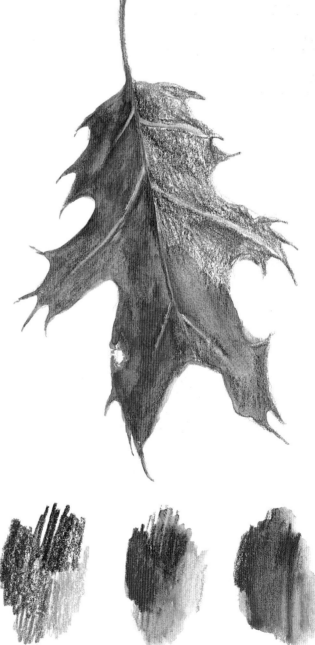

Avoiding Muddy Results
You can see the effects in a bit more refined manner in this partially finished drawing of a red oak leaf. I wanted the colors to blend but not too much, so I kept the tissue in hand and cleaned my brush whenever it looked as though the colors were getting too muddy.

Retaining Whites in Watercolor Pencil Paintings

Just as when you work with regular watercolor, you will sometimes want to retain clean, fresh lights. And just as with traditional watercolor, you can do it by painting around the areas you wish to keep clean. You may find this approach more satisfactory than trying to use a liquid mask, as applying pencil up to the edge sometimes lifts the mask before you want to.

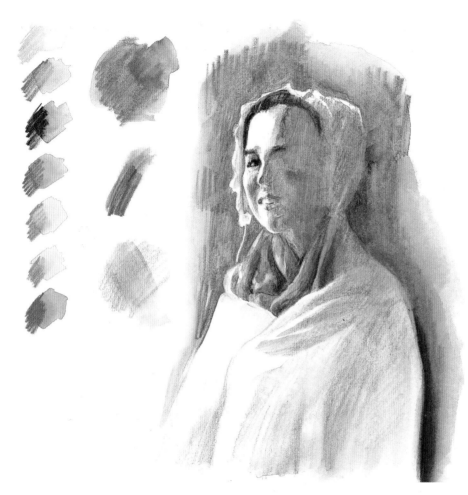

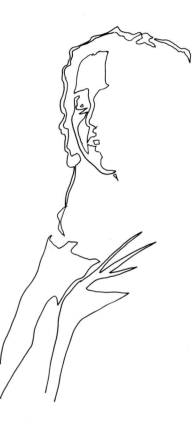

Paint Around Saved Whites

Here, my young friend Naomi was standing by a window in a very dark log cabin. I drew around the lightstruck areas very lightly with a graphite pencil, just to try to capture the likeness, then drew up to that line with my watercolor pencils. I allowed the shadow areas to remain dark and very simple—they were nearly featureless in that chiaroscuro lighting. I used a lot of lost-and-found edges for this painting. In areas where the lights meet the shadow, there is a sharp line; but where shadow meets shadow, the areas are allowed to blend.

Plan Your Saved Whites

You may want to plot out ahead of time the areas you plan to keep untouched by color, as in this black-and-white "map," which helped me see where I needed to retain the pure white paper.

Visit artistsnetwork.com/Painting-Nature-Cathy-Johnson for a FREE bonus portrait demonstration.

USING LIQUID MASK

Instead of painting around the areas you want to save as white, you can use liquid mask with your watercolor pencils. Apply it to those areas where you want to retain the white of your paper, then *carefully* work the color up to the mask before washing with water. Exercise caution when using a strong scribbly effect in conjunction with liquid mask, as the bold strokes could damage the edges of the masked areas if you bang into them, lifting or altering the shapes you've just put down.

You may prefer a more traditional approach in small areas where you've decided to use mask to protect the white. Apply the liquid latex by whatever means you prefer (my most successful method is to apply it with a bamboo pen, which is easily cleaned afterward). Allow the mask to dry thoroughly, then use your watercolor pencil or crayons as though they were cakes of dry watercolor pigment. I like to use the large Lyra crayons for this, making up a small wash with clear water rubbed over the end of the crayon, then applying the wash over the mask.

However you choose to work, wet your pencil drawing as usual, allow it to dry and remove the mask just as you would with watercolors. Voilà—clean, white paper just where you wanted it. Add more small, sharp details with your watercolor pencils and then wet them judiciously.

You also could add the mask after drawing if you wanted to retain small areas as pencil, but remove it carefully because it might pull away some of the pigment with it.

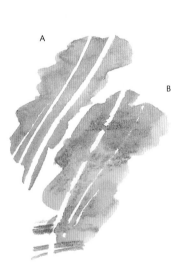

Experiment With Liquid Mask

The sample at left shows what happens when you paint over liquid mask with a brush (A) and what happens when you've scribbled carelessly over the dried mask with a pencil (B)—the white lines are broken every place the pencil tore the mask loose. For the main drawing of a cactus flower, I used liquid latex mask in a traditional way by making a pool of pigment with water and the tip of my water-soluble crayon so I could paint right over the top of the mask, allow it to dry thoroughly and then remove it.

Watercolor Washes

As you might have guessed, doing a wash doesn't refer to laundry. It is the basic act of getting paint to paper in whatever way works best for the effect you're after.

The process itself is simple: Dip your brush (either a flat or round) in clean water, rub it on your pigment, carry the brushload of liquid to the mixing area of your palette and rub it around a bit to mix well. Repeat until you have a nice-sized puddle of water and pigment. (If you want to mix colors, simply alternate between the two pigments until the color is right.)

The white surface of the palette will help you judge how strong or how bright your wash is, but the amount you mix up depends on how big an area you need to cover. A larger painting will need a larger wash. Judging that amount is mostly just practice, but it's better to mix too much than too little! You'll soon get the feel of it.

Some artists wet their paper before the initial washes for soft, misty, wet-into-wet effects. Tape your paper to a board with masking or drafting tape, then run it under a faucet or use a sprayer. Aim for uniform wetness, then lay in your color(s), allowing water and pigment to blend on the paper surface.

Once you've finished your painting, let the paper dry thoroughly before removing the tape, or it may tear into the painted area. Pull the tape away gently and firmly at a shallow angle to the paper's surface.

TIP
If you're working with moist-pan watercolor, or if the mounds of paint have dried on your palette, you may want to spray your paint with clear water to soften it and assure good, smooth mixtures.

Flat Wash

Just as the name implies, a flat wash involves putting down as flat an area of color as possible. It is most easily done on rough or cold-pressed paper (the color averages out in the little hills and valleys!).

There aren't too many times when you need a totally featureless expanse of color, but it's good to know how to make one. Make a line across the top of the area to be painted with a brushload of your color mixture. Tip your paper a bit so that a "bead" of color collects at the bottom of the stroke. Fill your brush again, touch that line just where the bead is formed and make another, slightly overlapping stroke. Pull the bead of color downward with each stroke (gravity's a big help here!) and fill the area you need with color. Pick up the last bead of liquid with a damp brush or tissue, or you'll get backruns as it dries.

Visit artistsnetwork.com/Painting-Nature-Cathy-Johnson for a FREE bonus portrait demonstration.

Graded Wash

This wash is made in the same way as the flat wash, but you progressively add more clear water rather than pigment. Pull the diluted wash down the page with each stroke, and it will get lighter and lighter. Again, pick up that last bead of water to prevent backruns. This wash is nice for skies and still water.

Variegated Wash

This wash is my favorite and, I believe, the most versatile. Here, you use two or more colors and mix them partly on the paper for a wonderful, exciting vibration or a subtle blending. Your brushstrokes can go every which way, with great abandon.

Two-Way Graded Wash

This wash is very similar to the graded wash, but you let the initial wash layer dry thoroughly first, then turn the paper upside down and do a wash in a different color in the other direction. (You can suggest a lovely sunset glow this way!)

"Flowering" Paint

This little pink blob shows how paint can run back into your wash as it dries, making a "flower" you don't want. Lift excess liquid with a brush or tissue to prevent this effect (unless you're using it intentionally, as I did in some of the illustrations for this book).

Wash Versatility

Here you can see one of the many, many ways washes can be used!

NOTE

For all but the variegated wash, some artists work back and forth across the page rather than making their strokes all in the same direction. Try it both ways!

Creating Flat Tones in Watercolor Pencil

Though not really a "wash" in the same sense as a watercolor wash, there are times when you want an effect that is similar—a relatively smooth, flat tone. With watercolor pencils, you can achieve this in several ways (though you may have better luck if you do not use hot-pressed paper). How you handle your brush can be a deciding factor in how smooth this area becomes as well; vigorous scrubbing will lift more pigment to be distributed over your paper while a lighter touch will leave a bit of texture.

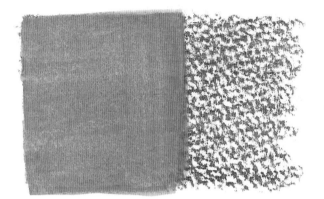

Pigment Laid on Rough Paper

First, try laying down your soluble pigment as smoothly as possible (as you can see, that step is easier on a smoother paper, as in the next example, than on rough paper, as shown here). Then wet it carefully. Here, I used a brush that was only just damp and went over the area several times to lift the color as smoothly as I could.

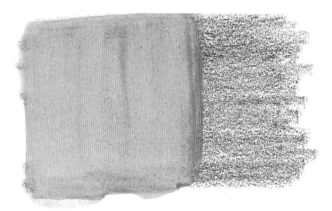

Pigment Laid on Smooth Paper

Here, I went for the same effect but on smooth paper.

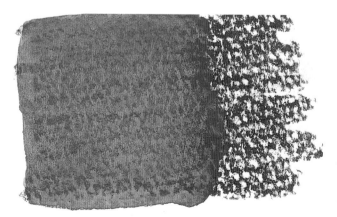

Picking Up Pigment Energetically

As an alternate approach, use your brush a bit more energetically and pick the pigment right up off the paper, redistributing it smoothly and allowing it to dry. Pick up any pools or puddles with the tip of a wrung-out brush or a tissue, or the pigment will spread back into the area you want to keep smooth. Because this is a rather rough paper, you still can see a bit of the pigment where it wanted to stick to the peaks of the paper's texture.

Visit artistsnetwork.com/Painting-Nature-Cathy-Johnson for a FREE bonus portrait demonstration.

Creating a Graded Wash in Watercolor Pencil

Possibly one of the most useful effects in painting situations is a graded wash. You can work from a saturated color to its paler shade, or you can grade one color into another either in a single step or in two steps, allowing each layer to dry in between. You'll notice that the effect is generally not as smooth with watercolor pencils as with watercolor. If you really need that kind of smooth transition, use larger watercolor crayons just as though they were big cakes of watercolor pigment. Simply make a pool of color, touching the end of your crayon repeatedly with water until you have a large enough puddle on your palette for the area you wish to cover, then apply it as you would a watercolor wash. You can mix more than one color here, of course, just as with watercolors.

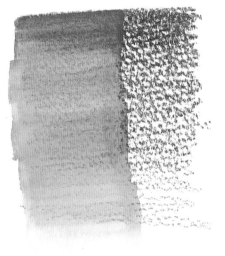

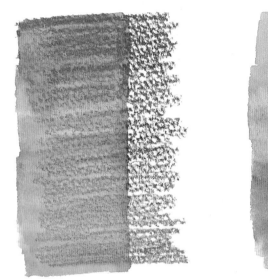

Creating Single-Color Graded Wash

Begin with a smooth, rich application of pigment applied with a firm touch. Then apply less and less texture until your wash area is covered. Wet with your brush and clear water, rinse your brush frequently and lift any too-wet areas often as you work down the page.

Grading One Color Into Another

If you want one color to grade into another, simply put down the first color and then layer over it with the second. You can wet it all at once, as shown at left, or you can wet the first color, let it dry thoroughly and then add the second color, as shown at right.

Layering in Watercolor Pencil

You can layer as many colors as you like to get the effect you're after. If you mix too many, however, you run the risk of creating mud. Often it's better to put down one or two colors, let them dry, add another color layer or two, then wet them and dry again, and so on until you achieve the depth or subtlety you want.

DRY-INTO-WET, WET-INTO-WET

For a different, spontaneous and somewhat less predictable approach, try wetting the paper before applying your color, either dry-into-wet or wet-into-wet. Don't be afraid to be a bit out of control. In watercolor we refer to things like this as "happy accidents." If the effect startles you a bit, put it aside for a while and come back—you may find you really like what you see, or perhaps you then can find a way to incorporate what you thought was a mistake into a fresh, exciting effect.

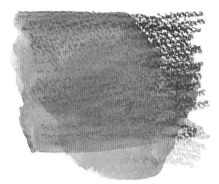

Layer Colors to Make Glazes

In this example, blue, green and yellow worked well to make subtle variations of greens and blue-greens. Layering after your preliminary layers have dried allows maximum control and works well with a more formal application.

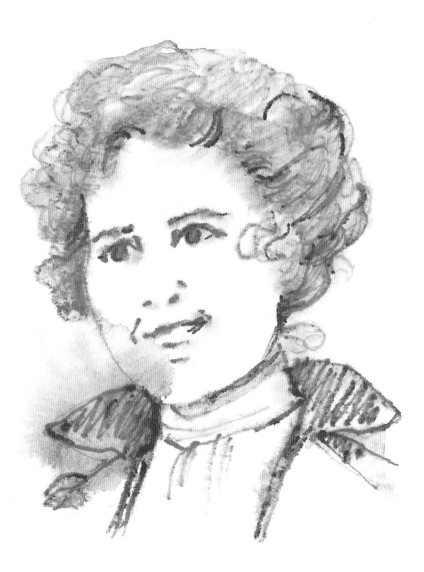

Dry-Into-Wet and Wet-Into-Wet

In this sketch, I soaked the paper thoroughly so it would stay good and damp through my drawing. I drew the warm sienna colors with a dry pencil point into the wet area of my paper. For the darker browns, I wet the pencil point first before touching it to the paper for stronger, more emphatic lines in this drawing of my grandmother Annie Kelley.

WET-ON-DRY

Wetting art after you put it down on paper creates a completely different effect, more controlled but somewhat less exciting.

DRY-ON-DRY

You can, of course, use watercolor pencils just like ordinary colored pencils, that is, on dry paper and without blending them with water at all. They are not quite as intense as wax-based colored pencils and are a bit more delicate, but the effect can be very satisfying. Try this approach if drawing is your first love.

Wet-on-Dry

I tried Annie again (with somewhat less success at a likeness), going for the mood of a delicate old sepia photograph. I used a smooth Arches hot-pressed watercolor paper for greater control over details as I drew, then wet each area separately and carefully, lifting and blending as I went. I left a bit on the right side of the head untouched to show the extent of coverage needed to achieve that effect.

Dry-on-Dry

When you work dry-on-dry, you'll need to protect the surface because, unlike a wax-based colored pencil drawing, an inadvertent spill on a watercolor pencil painting will cause the paint to run. I deliberately spilled a bit on this example to demonstrate.

Painting With Color Lifted From Your Watercolor Pencil

For maximum smoothness and control, paint with color lifted directly from your watercolor pencil point (or from a water-soluble crayon). This technique works best for fairly small, tight pictures unless you are working with larger crayons.

When working this way, I often hold the colors I plan to use in my left hand—they become a kind of mini palette. For the painting on this page, I made squiggles of pigment on the edge of my paper and lifted color from there with a wet brush. You just as easily could use the points of the pencils as if they were small cakes of watercolor.

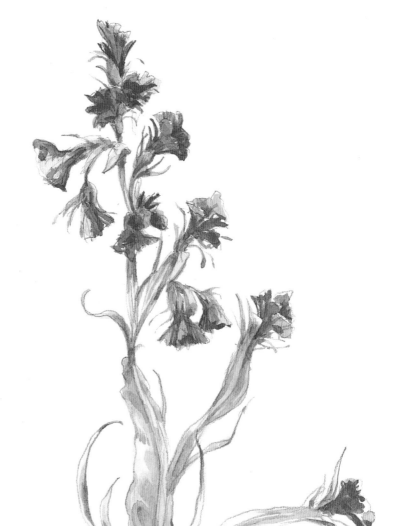

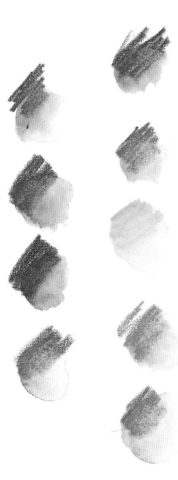

Lifting Color From Your Pencils
To create this sketch of statice flowers, I first did a careful graphite pencil rendering, then added color a little at a time. I modeled the green stems and leaves first, allowing some colors to blend wet-into-wet and others to dry thoroughly before I added a second and third layer. Then I did the same thing with the purples and lavenders of the flowers themselves and was pretty happy with the results.

Visit artistsnetwork.com/Painting-Nature-Cathy-Johnson for a FREE bonus portrait demonstration.

Using Linear Effects in Watercolor Pencil

Lines can express everything from value to form to shape, especially when you judiciously wet your paper. When you add in the water, touch it only here and there—just where you want to suggest shadow or volume.

You also can use a combination of techniques for variety. Mix narrow lines with broad, washy areas. Add repeated cross-hatched lines into the shadows if you like. If you've lost too much definition once the water has dried, go back and restate where you need a bolder line. Or you can add the restatement while the paper is still damp to give you a very intense effect. Be advised though—if you go back in while the paper is still wet, you'll have a harder time later altering that look if you're not happy with the result.

Use Linear Effect for Expression
Rather than filling spaces with solid tones, draw lines with your watercolor pencils as you would with pen and ink.

Incorporating Elements of Design

In art, choosing a composition means deciding how to place things within the picture plane. There are some very simple, classic rules you can rely on, or you can break free and make new rules of your own!

The basic elements of design hold true for all mediums. The elements may be new to you, or if you're a longtime painter, you're probably familiar with them. But even after many years as a professional artist, it's good for me to review them from time to time.

VALUE

Familiarize yourself with values—the extremes of light to dark and all of the shades in between. See what your tools are capable of and how you can use them to create the various values. Keep the range of values relatively simple—a scale of no more than six values ranging from lightest light (the white of your paper) to the darkest dark your pencil can produce.

DOMINANCE

Normally, you want to let one value or range of values dominate. If you use too many values in your painting and space them too evenly, it will look like a camouflage jacket—an easy mistake to make and a difficult one to rectify. Preplanning can help avoid that mistake.

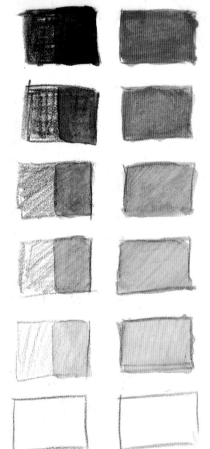

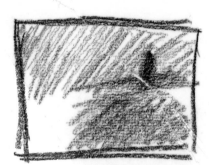 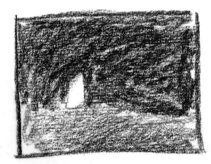

Variations in Dominance

Though extremely simplified, these two images show how the concept of balance might work in a composition. At left, large areas are mostly light in value and the darkest dark is a small, sharp accent. At right, darks dominate and the white paper is the accent.

Make a Value Scale

Black is the simplest way to illustrate value, as shown at left. I left half of each value square untouched by water to show the difference—the swatches become much darker when wet. The swatches at right illustrate the same principle, except this time I've used a range of color values instead of black.

Visit artistsnetwork.com/Painting-Nature-Cathy-Johnson for a FREE bonus portrait demonstration.

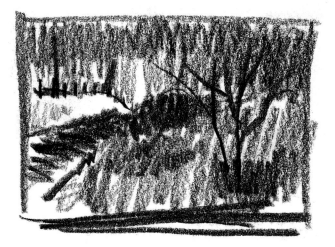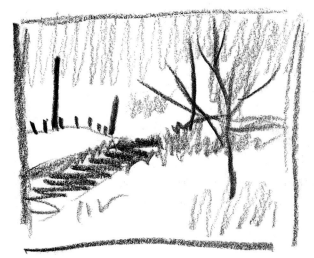

Create Value Thumbnail Sketches

Consider how you want your composition to look, and think about such things as what kind of lighting and mood you want to establish. Value can help you accomplish these goals. Try several possible effects for each composition with small thumbnail value sketches, as shown in these two examples of the same rural scene.

Thumbnails: Blueprints for Success

These tiny sketches are a big time-saver, and they'll save you paper and supplies. Take a few moments to plan out what you'd like to do and how best to handle the sometimes confusing scene before you. It isn't as overwhelming if you break it down into little "bite-sized" pieces.

You can plan format, values, composition, focus and many other elements in just a few moments with a page full of little thumbnail sketches. These can range from 1" × 3" (3cm × 8cm) to perhaps as large as 5" (13cm).

Zero in on a single subject and explore a variety of possibilities, or do half a dozen sketches in and around your locale. You may decide to focus on one aspect of the scene, or you may decide that you want a broader view, with more going on.

You can make your thumbnails in black and white (or another dark color, as I did, for more interest) or in full color. Use thumbnails to decide on a color scheme, too.

THE RULE OF THIRDS

For centuries, artists have relied on the rule of thirds or the Golden Mean when planning a composition. That is, when the picture plane is divided into thirds vertically and horizontally, it is classically considered most pleasing to have your center of interest—the most riveting thing in your painting or the area of the most contrast—at or near one of those intersection points.

The rule of thirds is only a guideline. If you prefer your most interesting area above or below those intersections, off to one side or even dead center, put it there! Just be sure that you maintain a balance within the larger composition so this area is neither too static and boring nor looks as though your subject will fall off the edge of the page.

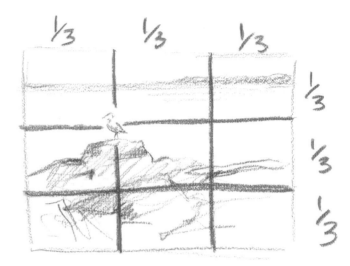

The Rule of Thirds

The most familiar compositional tool is the rule of thirds. Divide your paper into thirds, vertically and horizontally. One of the intersections will be a good place to put your center of interest, since the eye goes there more or less naturally. In this illustration, the little gull is perched at the intersection of the top and left lines.

You can use a variety of devices to lead the eye to that spot: curving lines, S-shaped lines, values, color. Use whatever works for you.

 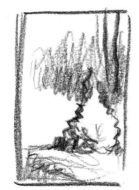

Variations in Composition

Rules were made to be broken! On the right is the more conventional composition, with the small evergreen tree and its strong contrasts off to the side a bit. In the sketch at left I chose to put the tree front and center for a bit of variation.

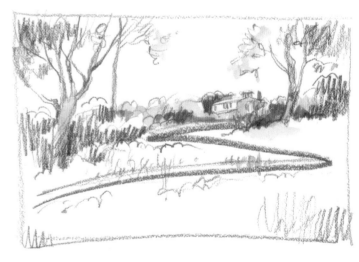

Create Curves

Look for curves that occur naturally in the outdoors, or rearrange your scene to suggest such a curve. You can use objects like the trees in this little sketch to redirect the eye back into the picture plane.

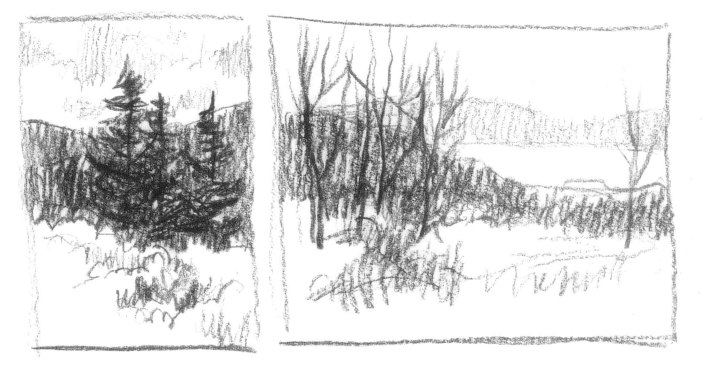

Format: Vertical or Horizontal?

Deciding on a format means determining whether your picture would work best vertically or horizontally. Try looking at the scene through a viewfinder or a little frame (an empty slide sleeve, one of the commercial viewfinders just for artists or one you've cut yourself), and see which format creates the most interesting and pleasing picture. Some formats will seem almost inevitable, but consider breaking out and doing something that focuses in a new way.

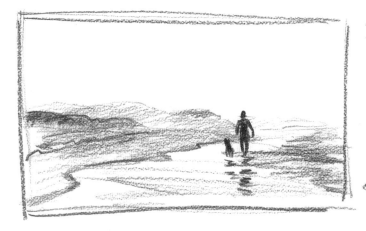

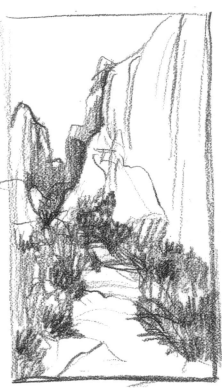

Going to Extremes

There are some exciting new sketchbooks and watercolor pads that offer an extreme format—a long, thin vertical or a broad, shallow horizontal—depending on the direction in which you choose to work. Try using one of these elongated formats to capture a mood or an aspect of your subject.

A prairie or seascape might lend itself to the wide-open horizontal, while a tall tree, mountain or even a heron might cry out for the skinny vertical format. Let your choice of format supplement the mood you're trying to create or the statement you want to make.

KEEPING AN ARTIST'S SKETCH JOURNAL

Journaling is a subject close to my heart; I've kept journals of various types literally for decades. I keep my sketches, thumbnails, studies and other plans for future paintings here. I also make gesture sketches, contour drawings, even stick figures. I test new materials or plan out different color possibilities for paintings. I draw my friends and neighbors, my cat and dog friends, and I entertain myself when I have to wait by filling up the pages of my sketchbook. I even sketch when I'm nervous. It helps me focus on something outside of myself.

When I record artifacts in museums, I use my journals to study natural history and human history. I keep a visual record of a special trip to a beautiful place, whether it be San Francisco's Ocean Beach or a quiet lake in the Adirondacks. Travel journals allow us to revisit these places every time we open the pages of a book, reminding us not only of what we saw but of the sounds and smells and even our own thoughts and emotions.

I also keep my grocery lists, to-do lists, telephone numbers and notes of meetings in the same journal. It has become an integral part of my life.

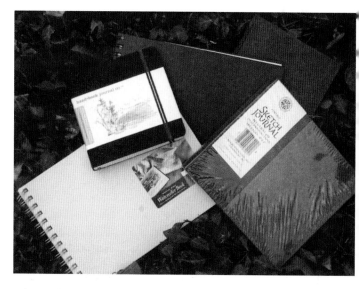

Choosing Your Journal

I recommend a hardcover journal rather than a regular sketchbook. You're going to be giving it hard use, and it needs to stand up to travel and weather!

There are any number of journals to choose from, in a variety of sizes and shapes—from handmade journals (I like making my own, so I have the exact paper I prefer to work on) to commercially available products. Try to find one with paper heavy enough to withstand at least light watercolor washes—you'll likely want to add some color. (Watercolor pencils work well and are less likely to buckle the paper since they take less water.)

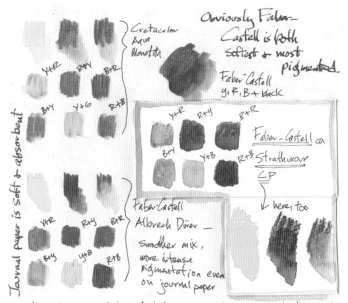

Record Experiments

Your sketch journal is a great place for trying out new materials so that you have a permanent record in a place you can find easily. Here, I compared watercolor pencil brands on various papers, then glued them into my journal for easy, permanent access. In the lower right is the page number—it's even indexed to make it easy to find!

Visit artistsnetwork.com/Painting-Nature-Cathy-Johnson for a FREE bonus portrait demonstration.

How to Get Started

First, decide what kind of journal and format you want—a traditional rectangular landscape or portrait format, a square or an elongated rectangle for wide vistas. (I find the latter slightly harder to work on—the extra length seems to get in my way.) Choose the kind of paper you want for drawing in graphite, ink, colored pencil or painting. Strathmore's spiral-bound watercolor journal offers a choice—their excellent watercolor paper is interspersed with lightweight drawing paper, which lets you sketch, paint and take notes, all in one place.

Canson and American Journey also offer nice, hardcover watercolor journals, as do several other companies. Look around, experiment and find the perfect choice for you. And, of course, you can always make your own. Bind them with the aid of a good instructional book like Dover's *Hand Bookbinding: A Manual of Instruction* by Aldren A. Watson. That way, you'll have the paper you prefer working on in the size you want.

If that seems too time consuming, consider cutting your favorite paper (I prefer Fabriano Artistico, myself) to size, and take the stack to a copy shop. They'll spiral bind it with a sturdy cover quickly and at a reasonable cost, and you can even alternate watercolor paper, drawing paper and toned paper, if you like.

You'll also want a good watercolor field kit. A lightweight container for water or a selection of watercolor brushes; a mechanical pencil; a gray, black or indigo wax-based colored pencil and a set of watercolor pencils should be sufficient for keeping an artist's journal.

What you start with depends on how wide a focus you plan for your journal. Will it encompass your whole life? Will it be a "themed" journal, with a monthly or yearly theme? Will it be a nature journal or a travel journal? I prefer mine to contain everything under one cover—whatever's going on in my life. However, I began first with a sketchbook dedicated just to art, and then moved to a nature journal. Another pad held notes and lists. Now all this is under one cover, and life is much more integrated!

A compact bag to carry all this in can go with you everywhere. Mine started out life simply as a dedicated field kit—I'd carry it in addition to my purse and whatever else I needed, whenever I went out of the house. I finally simplified things considerably and just put a credit card, driver's license and checkbook into my field kit. Now it *is* my purse. You'll find more detailed information on all of these important considerations in the materials section of chapter one.

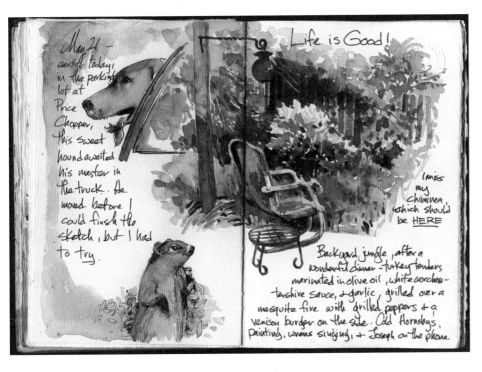

Capture Your Day

Work across a two-page spread if you like, and create a montage of a single day. Just keep adding till you run out of room. Design the page, use a grid with small, quick sketches or allow your design to evolve naturally to fill as much space as it seems to need.

Here, the morning's grocery shopping included a sketch of a sweet hound waiting for his master, an ink sketch of the woodchuck that frequents a den under my deck and a watercolor of my backyard jungle completed later in the day. I added color to the dog and woodchuck later.

This is in my hand-bound journal with hot-pressed watercolor paper.

Creating a Field Journal

If you want to keep a naturalist's field journal, consider the things that will clarify and help you identify what you see later. In addition to my normal art supplies, I might take a 6-inch (15cm) ruler and a magnifying glass. I even have a hand microscope that goes with me on occasion.

A journal can be a true "tool for learning," as artist and naturalist Clare Walker Leslie calls it. As you draw and paint in nature, you will take time to get to know an area as you seldom would when just passing through. You respond, you question, you record the things you see and . . . you slow down. It's as much your own experience, your own life you're recording, as the life around you.

WHAT TO INCLUDE IN FIELD JOURNAL NOTES

On the art itself, you'll want to include field notes and other observations. Include the date, the time, the weather and the type of habitat in which you find your subject—prairie, forest, wetlands or backyard.

If your subject is animate, write down what it's doing—feeding, nesting, claiming territory? If it's feeding, on what? (That may help you identify the bird you're looking at later, if you don't recognize it—some prefer thistle seeds, some worms or bugs.)

Draw or paint your main subject, but also as many details as you have time for. If it's a flower, for instance, zero in on the leaf, stem, bud or seed—whatever you can find. Add color, if you can, either in reality or as written notes. All of these will help you to identify it later.

Write down what other plants grow nearby, or what mammals, reptiles, insects or birds you can see. Include a small habitat sketch in one corner, if you like.

You can even note the sounds you hear. Birdsong, insects in the grass, human voices—all those notes will help bring back the moment clearly to you later.

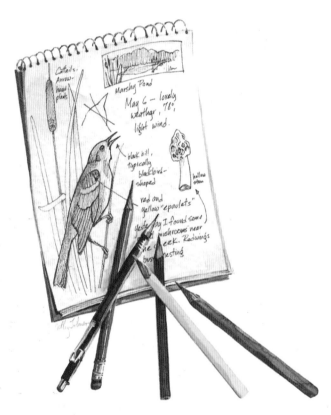

Sample Field Sketchbook Page

This detail of a larger illustration was done for Country Living *magazine when I was their staff naturalist. It shows a field sketchbook page with many of the things I like to include.*

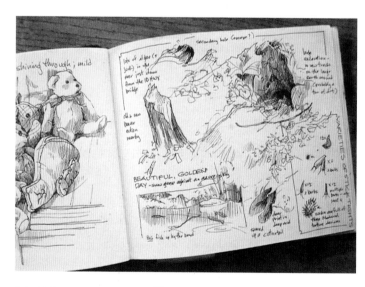

Nothing Is Too Small

Typical of my field journal entries, this page includes enough notes and sketches to allow me to remember even the most minute details. Nothing's too small to notice, even the variety of seeds you pull out of your socks! As you can see from the stuffed animals on the facing page, my journal really does include all aspects of my life.

Visit artistsnetwork.com/Painting-Nature-Cathy-Johnson for a FREE bonus portrait demonstration.

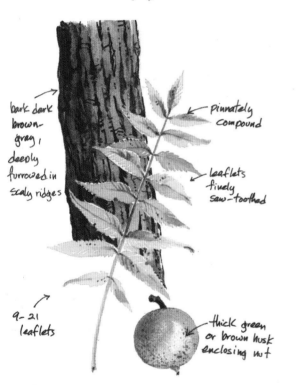

Big Picture and the Details

It can also be useful to include the growing habit of a flower, bush or tree, then include a close-up detail sketch as well, as I did with this ornamental crab apple tree.

bark dark brown-gray, deeply furrowed in scaly ridges

pinnately compound

leaflets finely saw-toothed

9–21 leaflets

thick green or brown husk enclosing nut

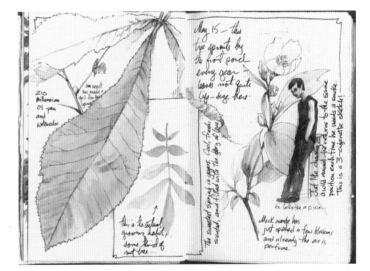

A Specific Moment

Include everything you find at a specific moment in time—here, a close-up of a leaf by my porch, a silhouette of its growth pattern, an insect gall on its stem, a flower from the mock orange that grows nearby and my neighbor, out for a smoke on his front porch. I even noted the art supplies I was using. I loved the feel of the pen and wanted to remember which one it was.

Include Color

Watercolor is terrific for this kind of nature study, letting you capture color as well as shape and growing habit. Here, the green husk of the walnut contrasts with the golden leaves of autumn. The detailed study of the bark would allow me to identify this tree later if I didn't already know what it was.

Learning From Your Own Art

There are times when you see things in your rambles that make you stop and ask, "What on earth is that about?!" If you take the time to sketch or paint what you see, sometimes you can find an answer to that question. Once, out by my creek, I discovered a woodchuck up a tree and quickly sketched him. No one would believe what I had seen until I showed them my sketch. Eventually, I asked the right person with the Missouri Department of Conservation, who told me that climbing woodchucks are not all that uncommon!

Similar Mammals

Sketching similar mammals will help you understand the differences among them. Muskrats are similar in size and shape to woodchucks, but not in habitat. Beavers share a habitat with muskrats, but their size and their tails are quite different.

Woodchuck in the Grass

These woodchuck sketches are far more conventionally posed than the character up the tree, but they are still fun to draw (as quickly as possible!).

Climbing High

Here, you can see my climbing friend. I wondered if he had been chased up the tree by a predator, or maybe he was looking for food.

Asking the Right Questions

Write down as much as you can observe about what you see, even if it appears to make no sense to you. Sketch as many details as you can, and note your questions: what puzzles you, what don't you understand, what's new to you, what seems out of place or different? With any luck, you can find the answers in a field guide or by asking an expert in the field.

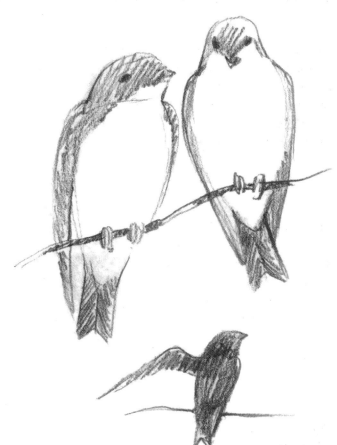

Bank Swallows

Years ago, I saw a pair of very active little birds up the creek near my home. I watched them for a long time, delighting in their swooping flight and their balancing act. I wasn't sure what these fast, stubby little birds were. I drew them as they sat and preened, and later identified them as bank swallows from my rough sketches and from my memory of their actions.

Fascinating Finds

It was fascinating to find these "nested" leaf cases tucked into a hollow branch. Most likely, a wasp had parasitized the eggs of an ant.

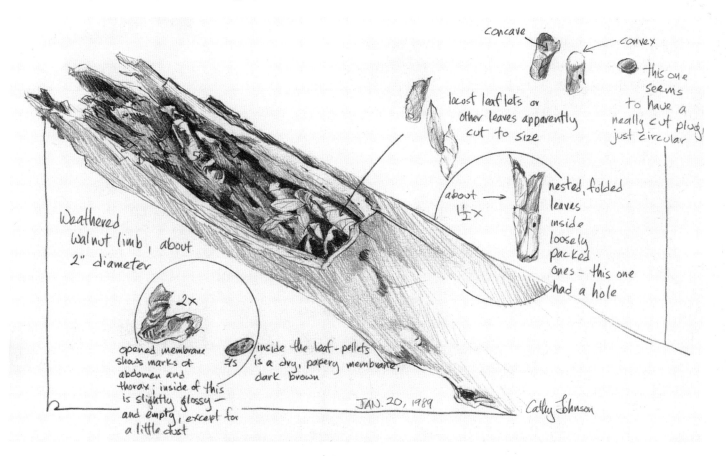

concave

convex

this one seems to have a really cut plug, just circular

locust leaflets or other leaves apparently cut to size

about 1½x

nested, folded leaves inside loosely packed ones – this one had a hole

Weathered walnut limb, about 2" diameter

2x

opened membrane shows marks of abdomen and thorax; inside of this is slightly glossy – and empty, except for a little dust

⁴⁄₅ inside the leaf-pellets is a dry, papery membrane, dark brown

JAN. 20, 1989

Cathy Johnson

Bird Watching With Journal in Hand

Many people keep a "life list" of birds, but your journal is a perfect place to record sightings, oddities, questions and more. Get the feel for a specific location through the birds that nest there (or pass through on their migration paths).

Quick gesture sketches or longer studies, incidental sketches or drawings that take the whole page (even supplemented with photos or field guides if necessary) can make your journal an invaluable birding resource.

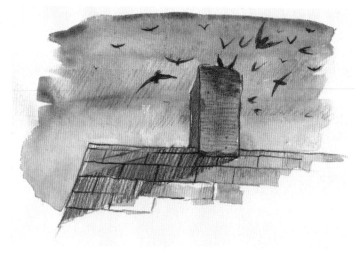

Bird Behavior

You can record bird behavior in your journal, too. Take time to watch behavior, even if you have to do it several days in a row. I watched the chimney swifts' nightly ritual over a period of three evenings until I really got a feel for their routine. They'd dive toward their chosen roost in my neighbor's chimney, then drop down into it, one at a time, in a great black funnel of birds.

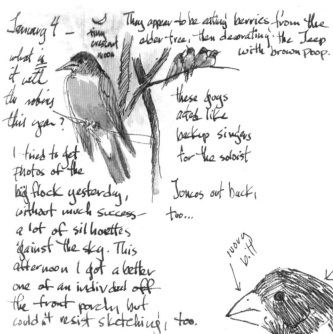

Winter Robins

Use your journal to record unusual happenings. Although we always have a few robins winter here in the Midwest, especially out in the woods, one year they stayed in record numbers, even in town. I tried photographing the flocks that frequented my backyard, wondering what they found to eat. (Robins are not seed eaters, so putting out feeders isn't helpful.) My photos were too distant and fuzzy, but my quick sketches really caught something of the phenomenon.

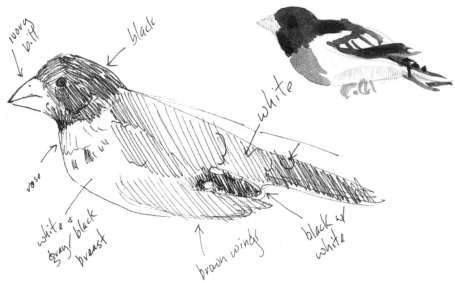

Memory Sketches

When doing bird studies in your journal, memory sketches are a big help. Often, a bird stays no longer than a minute in a single place, but, if you've practiced sketching from memory, you'll be surprised at how much you can recall. The annotated ink sketch of the rose-breasted grosbeak in my journal wasn't that far off from the markings I added later, in watercolor.

Visit artistsnetwork.com/Painting-Nature-Cathy-Johnson for a FREE bonus portrait demonstration.

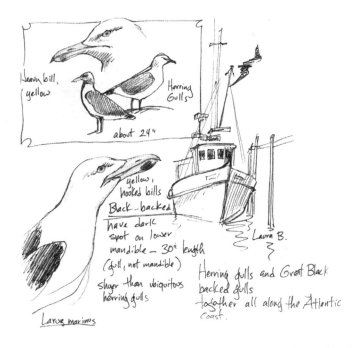

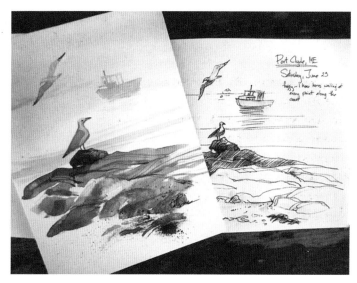

Reference Notes

If you're as specific and complete as you can be with your notes, you can use your annotated field sketches for reference. Here, I sketched great black-backed and herring gulls at the wharf in Port Clyde, Maine, in 1991. I was able to get close enough to observe and note details, then fleshed them out from a field guide back at the hotel. I also added the color later.

Sketch and Study

Even years later, you can combine information from your sketches in satisfying ways. The original composition in water-soluble ink touched with water for halftones came from another journal entry a few pages before the gull sketches. I was able to use information from the close-up sketches to make the whole more believable.

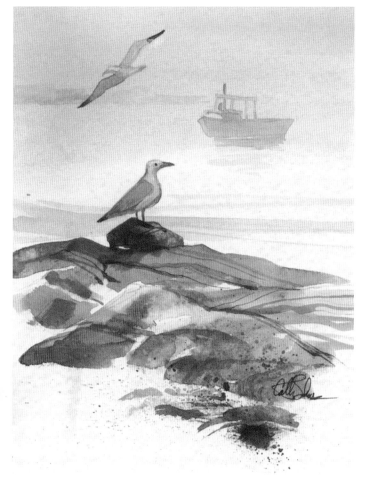

Original Sketch

This is a close-up of the original sketch done in 1991.

Final Study

This little watercolor study was done fifteen years after the original sketch!

Morning Gulls
Watercolor on Stonehenge
cold-pressed watercolor paper
7" × 5" (18cm × 13cm)

Travel Journal

One of my favorite uses for my hardcover journal is keeping a record of my travels. I nearly filled a journal the year I went to Maine, and I have worked from my sketches many times since. Let yourself go—paste in bits of memorabilia if you like, along with your sketches. Ticket stubs, boarding passes, business cards, a menu—all these can add special flavor to a travel journal.

Maine Landscape

This watercolor pencil painting was done from an ink sketch I made on a trip to Maine to teach a workshop. I'd get up every morning before the sun and walk for miles, delighting in the landscape and sketching what I found on my rambles.

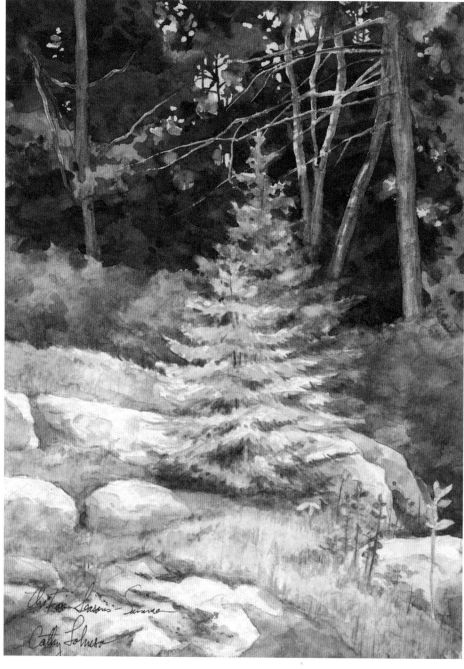

Someone to Watch Over Me
Watercolor pencil on Strathmore
cold-pressed watercolor paper
10" × 7" (25cm × 18cm)

Finished Painting With Original Sketch
Here's the same painting with the original travel journal sketch.

Visit artistsnetwork.com/Painting-Nature-Cathy-Johnson for a FREE bonus portrait demonstration.

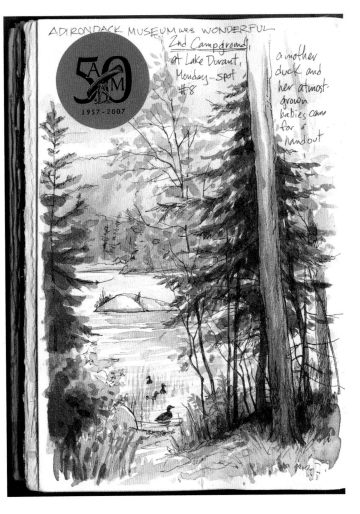

Wildflowers

I was delighted to find a variety of wildflowers near our camp on Lake Durant. I had intended to paint them all, but we ended up exploring the area, and then a rainstorm blew up, so this was all that got finished on the spread.

There are two different colors of background because I used both Fabriano hot-pressed and Aquarius paper in my hand-bound journal. They don't look very different until you scan them.

Hawkweed
(though the locals call it
Indian Paintbrush)
18" tall - yellow flowers
(others are orange)
very hairy stems
and leaves.
Flowers look like
dandelions-on-a-stick

Port Clyde, Maine

Lake Durant, New York

This was our second camping trip in the Adirondacks, all by ourselves. It was lovely, except for the black flies! The ducks would come up to the camp, expecting a handout, with their ducklings in their wake. We had visited the Adirondacks Museum, and I didn't want to lose the sticker, so I just put it right on the page with my drawing of the view over the lake from our camp.

Quick Ink Sketch

When we travel, we often have deadlines, schedules or other people pulling us this way and that. If you don't have much time, just do a quick ink sketch with color notes. You can always add the color later, as I did here.

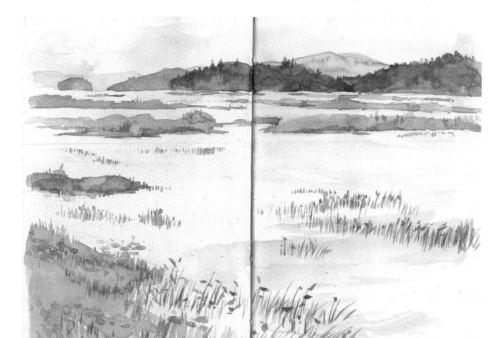

Go Wider

Again, don't feel constrained by a single-page format. If you want a larger space, work across the page. Some earlier traveling artists actually pasted in yet another sheet when they wanted a broad landscape, so they had three page widths.

This watercolor done at New York's Tupper and Raquette lakes needed space, so I used two pages. Again, two different types of paper in my hand-bound journal made the difference in scanned colors.

. . . Or Work Longer

Sometimes we have only a short while, and other times we can work for a much longer period. Construction workers were working on the road in Nevada's Valley of Fire, and we had to wait for a pilot car to lead us through the construction zone. I didn't realize when I began that I'd have time to do a pretty complete landscape sketch.

Study Details

If you've got a longer period of time, make a study of some of the details you find in your travels. These studies are a variety of desert plants outside Henderson, Nevada, in watercolor.

dead-looking and brown

tiny glass-like stickers

sharp, spiny—dead and silvery

tough gray-green bushes with tiny leaves

Visit artistsnetwork.com/Painting-Nature-Cathy-Johnson for a FREE bonus portrait demonstration.

Doing What You Have to Do

Adjust your materials and techniques to the working conditions. If it's cold out, you may not want to do a detailed watercolor in your journal. Try an ink and colored pencil sketch. The latter will work in all weather conditions, as will most modern ink pens. Keep pens in an inside pocket until you're ready to draw if it's below freezing.

Up Close

Occasionally, we may get the chance to draw mammals in the wild much closer than usual. This little opossum had found a hole in my foundation and wandered into the house. We caught him in a live trap and relocated him to the country, but not before I did some quick sketches with a warm dark gray colored pencil. The little pink nose was so striking. I added it later, along with the soft gray coloring, using watercolor washes and a touch of colored pencil.

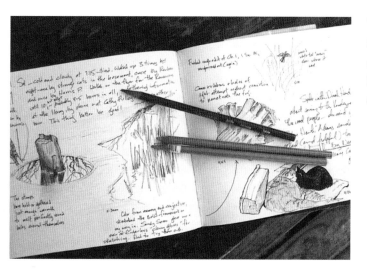

Winter Sketching

It was bitter cold when I did this sketch at my pond. The dark stump had absorbed enough of the sun's warmth to melt the ice around it, resulting in a reflective circle of water. I did the sketch on the spot with my ink pen and a very limited selection of colored pencils.

Field Journal

Your journal sketches and paintings can be as simple or as complex as you wish. If you're relaxed and comfortable with no particular place to be, you can do a complete painting or a detailed field study, even in a smaller journal. Nature studies, details, a landscape in preparation for a larger painting, travel notes or whatever, your journal is the perfect place to keep these memories in one place.

MATERIALS

SURFACE
Fabriano hot-pressed watercolor paper

WATERCOLORS
Burnt Sienna, Cobalt Blue, Permanent Alizarin Crimson, Phthalo Blue, Transparent Yellow

BRUSHES
9mm, 12mm and 15mm round and 12mm flat Niji waterbrushes

OTHER MATERIALS
fine-tipped marker

Flower Detail
Catalpa trees make fascinating, orchid-like flowers. They had fallen from the tree and decorated the grass all around me, so I took a photo for later reference and made a detailed study of them on the spot.

Choose a Location
I found a comfortable place to paint in the shade of a catalpa tree. I loved the sunny landscape across the park.

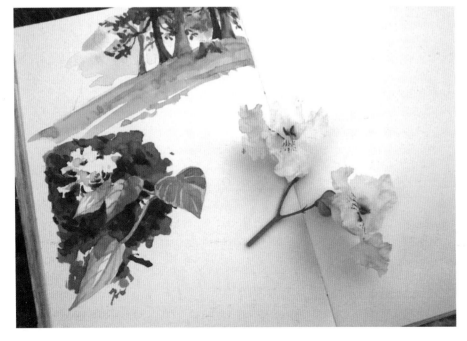

1 Sketch the Flowers
I did a simple landscape at the top of my page, then sketched in the flowers as they looked at a bit of a distance, at middle left. I was interested in their growing habit on the stem and the shape of the leaves. I began painting them as carefully as I could, using my Niji waterbrushes.

Visit artistsnetwork.com/Painting-Nature-Cathy-Johnson for a FREE bonus portrait demonstration.

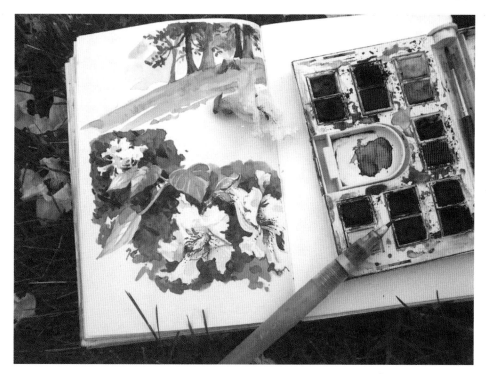

2 Add the Details

Next, I added the close-ups of the flowers, working as accurately as I could from the real thing. When painting flowers on the spot, pay attention to details. Are the petals separate or are they attached like ruffles at the edge of a cone, as they are here? How many are there and how are they arranged?

Here I used Phthalo Blue and a pale wash of Cobalt Blue to model the flowers and added Transparent Yellow and a mix of Burnt Sienna and Permanent Alizarin Crimson for the details.

3 Make Notes

Finally, I added the unifying Phthalo Blue background wash and allowed the watercolors to dry. Then I added the notes in ink, using a fine-tipped marker. I wrote down the date, the sounds I heard, birds I saw nearby and other pertinent information, including my need for coffee! Every time I look at that page in my hand-bound journal, it really brings back that lovely May morning.

Catalpa Tree
Watercolor on Fabriano
hot-pressed watercolor paper
7" × 5" (18cm × 13cm)

CHAPTER FOUR
WOODS AND FORESTS

No matter where you go—unless you're above the tree line, in the tundra or in the driest of deserts—you're going to find trees of one sort or another. In winter, they are bare ink-line limbs against the sky, or they huddle in their evergreen coats. In spring, they burst out with pale green buds and some with flowers. Heavy with leaf, nut and fruit in summer, or flaming as though lit from within in autumn, trees are our largest plants, and they're always a challenge and a joy to paint and draw.

Find the Right Medium

Try out different mediums to see which works best with your subject, mood or situation. Here, from left, the palm tree is done with Derwent's new Inktense watercolor pencils, the cedar is Derwent's Graphitint watercolor pencils, the elm is watercolor and the oak is colored pencil. Use your drawing or painting tools to suggest the type of foliage—linear marks for the palm fronds, tight scribbles on the cedar, etc.

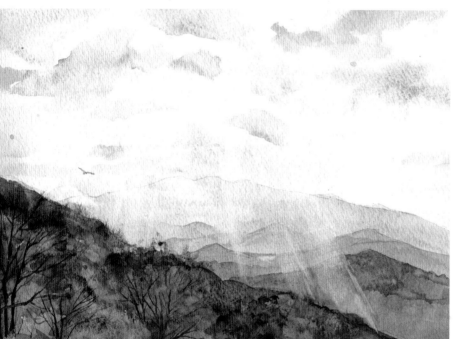

Variations Make a Difference

Even when you paint massed trees in the distance, as I did here, you'll need some variation in shape and color to get the idea across. Suggest the shadows between the trees, the varied shapes of their crowns or different colors.

Shenandoah
Watercolor on Strathmore cold-pressed watercolor paper
9" × 12" (23cm × 30cm)

Shape Up

Even trees you think might have a common shape, don't necessarily. Consider evergreens. They're not all conical. Here, you see silhouettes of (1) a towering, narrow Eastern white pine, (2) a dense balsam fir, (3) a conical Norway spruce, (4) a very open Douglas fir and (5) an oval shortleaf pine.

Visit artistsnetwork.com/Painting-Nature-Cathy-Johnson for a FREE bonus portrait demonstration.

Tracking the Seasons

If you live in an area where trees lose their leaves in winter or turn bright oranges, reds, golds and russets in the fall, you've got a lot of material to work with. Try out different ways to capture these changes, or choose a single tree and paint it, season after season, to understand its life cycle.

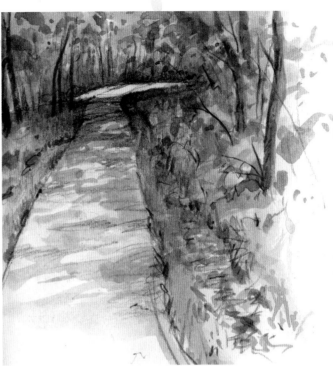

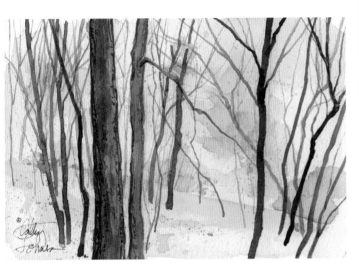

Fall Glory

One year, in the new Missouri Department of Conservation holdings at Cooley Lake, everything turned gold. There were a few spots of red here and there, but it was like being in a space made of tangible sunshine. Glorious! My quick sketch captures some of that glory.

A varied underglaze can set the mood for your painting. In this case, I quickly covered almost the whole surface of my small watercolor block with a glaze made from Cadmium Yellow Medium Hue and Transparent Yellow, with just a bit of Phthalo Blue and Cadmium Red Medium Hue to provide a hint of autumnal variation. Then, I added tree shapes and other details.

Gold Forest
Watercolor on Strathmore cold-pressed watercolor paper
5" × 7" (13cm × 18cm)

Spring Growth

Take the opportunity to track spring as well. A simple pencil sketch of a tree bud will capture the burgeoning rebirth of the year's cycle.

Capturing Summer Greens

Sometimes it seems as if summer is just one unbroken shade of green, but, if you pay attention and look carefully, you'll see a wide range from light yellow-greens where the sun shines through the leaves to deep, shadowy blue-greens. Layering can help you capture the stained-glass effect of a deep summer forest.

Watkins Path
Graphite and watercolor on Pentalic journal paper
6" × 6" (15cm × 15cm)

Revealing Winter

Winter gives us a chance to really see the bones of a tree: how it's constructed, how the trunk narrows to branches and then to limbs and twigs. Make some limbs appear to come toward you with foreshortening and push others back with overlapping shadow or less detail to give a sense of overall volume.

Receive free downloadable bonus materials at www.artistsnetwork.com/Newsletter_Thanks.

65

Leaves and Tree Bark

If a tree is the main subject of your painting, the leaves and bark will be an important part of your work. These elements are as varied as the species of tree.

LEAF VARIETIES

There are many different kinds, shapes and configurations of leaves, from the simple canoe shape of the elm's leaves to the mulberry's mitten-shaped leaves to the fern-like leaves of walnuts and ash.

Bark Patterns

Take a look at how different these bark patterns are.

If you wanted to draw a specific tree with its growing pattern and shape, it would be best to at least suggest something of its bark. Above, you can see how different a box elder is (left) from a silver maple (right).

The bark of younger trees is generally smoother than that of older trees. That's because part of what makes the distinctive ridges and plates is the growth of the tree itself.

Know Your Bark

Some trees have deep, rugged grooves in their bark. Some trees have long, relatively thin peeling bark (that's why they call it "shagbark" hickory). Some have shiny bark that looks as though it were stretched over the tree. Some trees have bark that is dark and gray. Others, like sycamore and paper birch, are almost pure white in places. Because these trees grow in different habitats, painting them correctly will give your work a real sense of place. Here you can see the bark and leaves of the walnut (far left) and wild cherry (left).

Easy as 1-2-3

You can simplify painting tree bark to an easy three-step progression. First, lay down a variegated wash, keeping it cooler on the shadowed side. Let that dry, and then add sharp details of shadows and crevices. Allow that to dry, and add warm and cool shadows (these will help integrate the crisp lines you've laid down in step 2). This illustration is of the peeling bark of the maple tree in my backyard.

Visit artistsnetwork.com/Painting-Nature-Cathy-Johnson for a FREE bonus portrait demonstration.

BARK VARIETIES

Unless you are painting a landscape on a grand scale, you will want to be aware of the differences in tree bark. They're not all chocolate brown and they certainly are not all the same texture. Even trees in the middle distance will show some variation in color or texture, but if you are doing a close-up, depicting the type of bark takes on almost as much importance as catching a likeness in a portrait. After all, if you painted a sycamore tree (which should be a pale greenish white on the upper branches) in the manner of an oak (with deeply ridged gray bark), the sycamore would never look believable. In a landscape, the variation in hue and texture can give your painting both depth and a sense of reality. After all, isn't that what landscapes are all about?

Bark is one means for identifying trees in the forest. There are tree identification guides that allow you to tell what tree you are looking at, even in winter, by just such details as bark. Though most types of bark aren't as different as the ones I've illustrated here, you can at least learn to tell which family the tree is in—if not the exact species—through studying the bark. By learning the different types, you can give your landscapes a sense of place and reality.

Cherry Trees

Wild cherry bark is not always this colorful, but there are varieties that certainly come close. The reddish areas are smooth and glossy, and the rougher bits that girdle the tree are whitish tan or light gray. Imagine how such warmly colored bark would attract attention in a landscape. Use it judiciously, and let it be the center of interest.

Sycamore Trees

Sycamores shed their thin, cardboardlike bark on their upper limbs and trunks, but the lower parts are still clothed in warm brown. To achieve this look, I used a light cool blue and a warm brown ochre to lay in the subtly varied bark on the upper part of the trunk.

Hickory Trees

Hickory bark pulls loose in interesting ways. One variety is actually called shagbark hickory. I think you can see why.

Walnut Trees

Walnut trees have deeply grooved bark that tends to form diamond shapes as the tree matures. Walnut trees have a somewhat warmer colored bark than many other varieties of trees do.

Painting Tree Bark

This rather generic bark is more of a demonstration of how water-color pencils can work to paint this subject than it is a portrait of a particular type of tree bark.

MATERIALS

SURFACE
Arches hot-pressed watercolor paper

WATERCOLOR PENCILS
Ivory Black, Burnt Umber, French Grey, Gunmetal

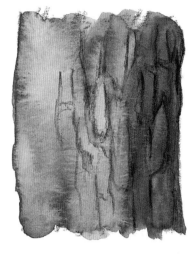

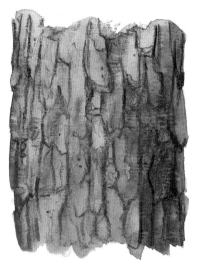

1 Lay Down Basic Colors
Begin by laying down a varied block of color, warm on one side and cooler and darker on the other. I used warm browns and cool blues here.

2 Blend Colors and Begin to Add Details
Blend the first layer with clear water, then begin drawing in dark lines (use black, dark gray and burnt umber) to form the rough, blocky bark. On the left, I've begun to blend the colors with water, just touching the lines themselves, not the background, with a small round brush.

3 Add More Details
Continue developing the bark lines, small shadows, dots and dashes that suggest the rough texture of the tree. You can add a little detail or a lot (actually I would have been perfectly satisfied to stop where I was on step 2).

Foliage Colors and Shapes

What colors you use to paint foliage depend on the effect you want, the season, the type of tree, the time of day and a dozen other considerations. One of the simplest and liveliest approaches is to combine the complementary colors of yellow and blue to make a variety of greens. Or you can choose a variety of green pencils.

There are as many types of foliage as there are types of trees. Some trees have large, simple, boat-shaped leaves; others have lacy, fernlike leaves; and still others, such as the aspen or eucalyptus, have rounded ones. Study these simplified approaches, and adapt them to the type of tree you want to paint.

Different Shapes of Foliage

Foliage comes in all shapes and sizes. Here are two examples of trees you may run into and want to depict. At left is a leaf from an aspen tree with a small leaf grouping shown immediately above it. At right are the leaves of a willow. Notice how they turn and spiral.

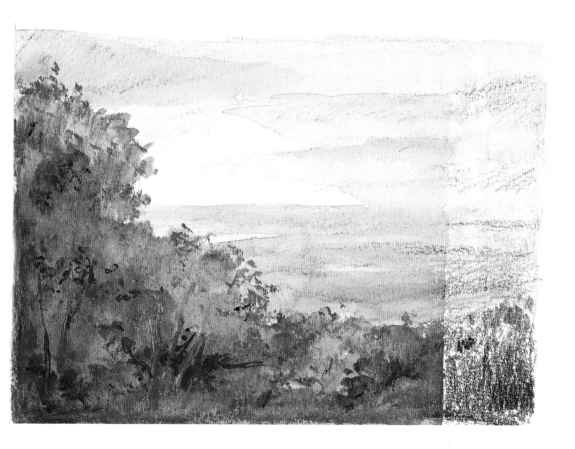

Virginia Landscape

In this small landscape sketch, I used a variety of green pencils rather than combinations of yellow and blue. To suggest individual leaves on the edges of the leaf mass, I wet my pencil point and touched it to the paper, each dot representing a leaf. You can see on the right, where I left my drawing untouched by water, that the process is quite simple.

Painting Foliage

MATERIALS

SURFACE
Arches hot-pressed watercolor paper

WATERCOLOR PENCILS
blue and yellow hues of your choice

BRUSHES
small round

1 Lay Down Basic Colors
Lay down a strong area of color where you want your foliage to be. Use a strong medium yellow and a cool, intense blue. Use the yellow (or a much lighter green) where you want to suggest sunstruck foliage, keeping these areas relatively warm.

2 Blend Colors
Wet the area of your tree's canopy, blending just enough to get a good varied green rather than two separate hues of yellow and blue. Use a few lacy brushmarks around the edge to suggest leaves.

3 Add Details
When the first wash is thoroughly dry, go back in and add however much detail you wish. Use more cool blue to define shadows and suggest some leaf masses within the overall tree.

Painting Tree Shapes

Trees are essential to many landscapes—only deserts and open prairies are likely to be empty of these largest forms of plant life. Endlessly varying and challenging to paint, trees are a wonderful place to practice your powers of observation as well as try out your watercolor pencils.

When we are children, we learn to draw trees as simple, somewhat rounded shapes with a brown stick for a trunk and foliage shaped like the top end of a lollipop. But in fact trees are far more interesting and challenging than that. Think of the possibilities: gnarled and weathered or arched and graceful limbs; the marvelous, changing colors in autumn; the variety of foliage, from the huge leaves of a cottonwood to the delicate fronds of a locust tree; the overall shapes that vary from conical to oval and everything in between. I have explored only a few here. Of course you'd never use this many tree types in a single painting unless you were painting in an arboretum!

Maple Trees

Both the rainbow of colors and the ovoid shape of the foliage identify this tree as a maple in fall. I applied the pencil in a simple zigzag stroke in large areas and in a dancing, squiggly stroke at the edges where I wanted to suggest individual leaves. When wet, the colors blended just enough to make them believable.

Palm Trees

This palm tree, more common in tropical and desert environments, has a very different shape. Sharp, single strokes of my pencil worked well to capture the linear forms of the fronds. I wet these gently and carefully so they wouldn't lose their individuality.

Spruce Trees

This is only one type of spruce of course, but this shape is common to western forests. T trunk rises far in the air, and the crown is open and lacy. I used a sharply pointed pencil suggest the bare limbs and th wet only some of them. I used gray-green pencil for most of t crown.

Oak Trees

Oak trees may have a great deal of variety within the species. For example, the pin oak is much more regular and almost triangular in overall shape, while this gnarled shape is characteristic of white or red oaks. Note that I depicted the foliage in clumps, the open space between them showing the strong, twisted limbs. I chose to use the russet and red-brown hues of an oak tree in fall and winter; in sheltered areas, these trees can cling to their leaves almost until spring.

Blue Spruce Trees

This blue spruce is very different in shape from the spruce above. It is more triangular, with graceful, sweeping branches. I emphasized the blue color when drawing the foliage, using short zigzag strokes that I blended very lightly in select spots.

Visit artistsnetwork.com/Painting-Nature-Cathy-Johnson for a FREE bonus portrait demonstration.

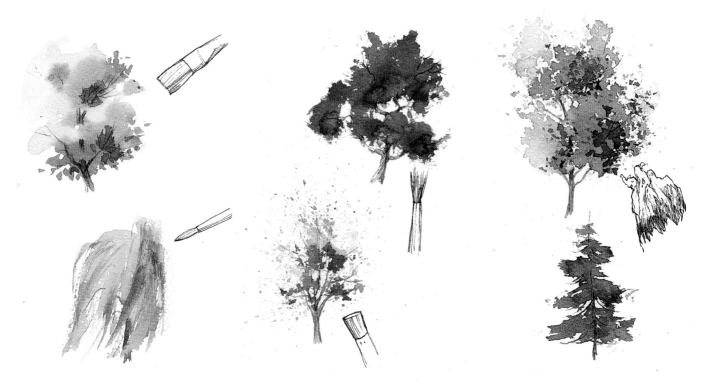

Variegated Washes

A flat brush is very handy for laying in large, variegated washes. Make multiple dots and dashes with one corner of the brush to suggest the smaller clumps of leaves at the edges, as shown.

Drybrushing with a round brush creates a linear effect that says "weeping willow."

Loose, Open Foliage

A ratty old oil brush is great for loose, open foliage. Use a pouncing stroke with just the tip, and be sure to suggest lights and shadows.

You can spatter on an open effect with an old stencil brush. You may want to cut or tear a mask out of paper to spatter through so you don't get droplets all over your painting. Blot here and there with a clean tissue for variation, then add limbs.

Sponge

A natural sponge can be a wonderful painting tool. I tore a small piece from a particularly raggedy sponge and used it to paint both of these small trees. For the top one, I used a pouncing motion, dabbing repeatedly into a puddle of paint and then onto my watercolor paper.

In the lower example, I used quick, sweeping motions, following the shape of the evergreen tree. I then made the connecting branches by dragging the wet paint out with a pointed stick.

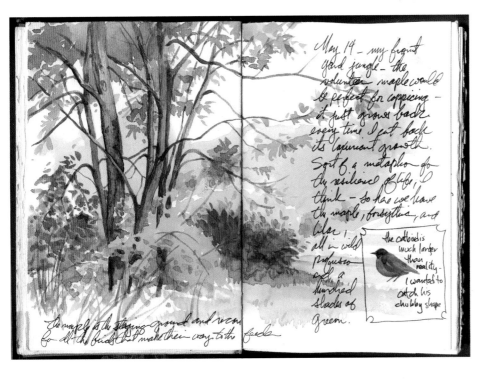

Experiment

Use your journal to try out various ways of painting foliage. Try quick, dancing strokes, massed shapes, variegated washes and single strokes to suggest leaves at the edges. Be sure to notice the variation in color.

Weston Bend

It's interesting to approach a familiar subject from a different vantage point. Here, we're looking through the dark foreground trees, with all their sharp detail, to the soft, sunlit Missouri River valley far below. It was a trick suggesting that sense of distance.

MATERIALS

SURFACE
Strathmore cold-pressed watercolor block

WATERCOLORS
Burnt Sienna, Cobalt Blue, Manganese Blue Hue, Phthalo Blue, Transparent Yellow, Ultramarine Blue, Yellow Ochre

BRUSHES
¾-inch (19mm) flat
no. 5 round with sharpened end

Partner Up

It's fun to go plein air *painting with a partner. Here's Joseph Ruckman (my partner in every way!), at Weston Bend State Park in northwest Missouri.*

1 Start With Tree Shapes

The tree shapes and the spaces between them are important so sketch them in first, then lay in the sky and far hills using Manganese Blue Hue and some Cobalt Blue. Allow the deeper blue of the hills to bleed up into the sky so there will be no sharp demarcation—it helps push them into the distance. When that's dry, add the wooded valley, mixing your greens with Phthalo Blue and Transparent Yellow. Next, for the river, use a stronger mixture using Manganese Blue Hue, Transparent Yellow and a bit of Yellow Ochre. I love the way the settling colors suggest a muddy old river. Finally, add the suggestion of shadows and tree crowns using a richer mix of Phthalo Blue and Transparent Yellow with a bit of Burnt Sienna.

2 Define Trunks and Leaves

Paint the trunks with a no. 5 round and a strong mixture of Burnt Sienna and Ultramarine Blue to make a lovely deep gray. Scratch the suggestion of bark into the trunks, using the sharpened end of a brush. Use the same sharpened brush to dip into a puddle of paint to delineate the small limbs and twigs. Begin to add the leaves using a small brush and a strong mixture of Phthalo Blue and Transparent Yellow, with a bit of Burnt Sienna added to make a really deep green.

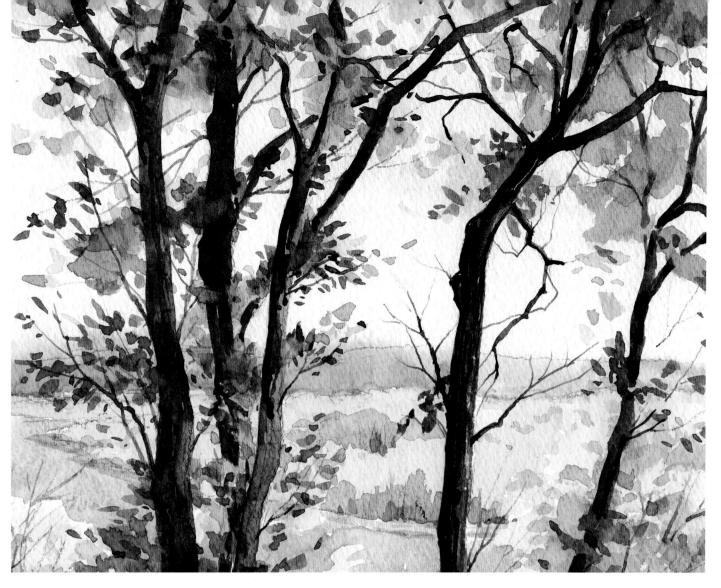

3 Add Twigs and Details

Sometimes I think it's a good thing we get tired working outdoors on the spot. It's easy to get lost in all the detail and overwork our painting. I hope I stopped in time with this one. The limbs and twigs were so intriguing. I used one of my favorite tools to make the small twigs—the end of a wooden-handled brush that I had sharpened with a pencil sharpener. Dip in a strong wash of Ultramarine Blue and Burnt Sienna, and then drawn onto the paper. The sharp point makes delicate, believable twigs. Quick, small dabs suggest lacy leaves.

View From Weston Bend's Overlook
Watercolor on Strathmore
cold-pressed watercolor paper
9" × 12" (23cm × 30cm)

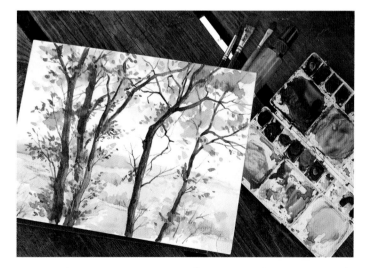

4 Take a Step Back

Here you can see the finished painting with some of my gear on the shady bench. Stepping back from your work lets you get a bit of perspective and evaluate where you need to go next—if anywhere! I liked how the twigs and leaves looked and decided this was finished.

Using Trees in Your Landscapes

When I stayed with my friend Sue in Concord, Massachusetts, one April, I was quite taken by the view from her back window. I loved the way the four stately lichen and moss covered trees in her yard seemed to lean into each other, conversing amiably. I liked, too, the lights and shadows on their greenish gray trunks, contrasting with the willows and osiers in the swamp just beyond. In the early spring when the sap rises in the understory trees, they seem to glow with a lighter, more subtle version of the colors they will wear in fall—in this case, the willow twigs are greenish yellow and the osiers are warm reddish tones. Contrasting those colors with the cool, shadowed trunks of Sue's trees was an exercise in observation, and what I observed was that they were too interesting not to try to paint.

Even if the trees you choose to paint are of the same species and close in age and size, remember that they are not simply lollipop shapes on a stick. Pay attention to their innate rhythms and their grace.

MATERIALS

SURFACE
Arches hot-pressed watercolor paper

WATERCOLOR PENCILS
hues of your choice

OTHER SUPPLIES
masking fluid

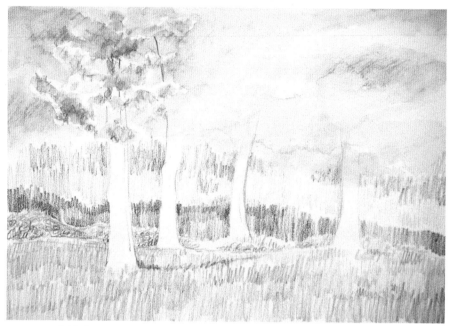

1 Establish Basics

Sketch in the basic shapes of the trunks, keeping the trees' rhythms in mind, and lay in the first color strokes in the background, avoiding the trunks. Use Burnt Sienna for the leaves that cling to one oak tree and a variety of warm and cool colors for the swamp beyond the yard. Yellowish greens seem to work best for that tender spring grass. Use zigzag strokes here.

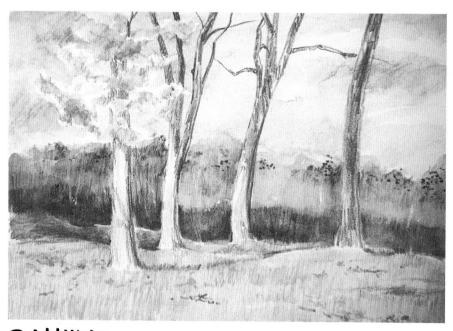

2 Add Water

Wet the first applications of color carefully with clear water, trying not to let the colors run into each other too much, and begin to model the trunks of the trees. Use just a bit of liquid mask on the narcissus flowers at the base of the tree on the right.

Visit artistsnetwork.com/Painting-Nature-Cathy-Johnson for a FREE bonus portrait demonstration.

3 Add Background Trees

Now begin to draw in the small bare trees in the background. Watercolor pencils are great for areas like this where you want some control. Then you can wet the twigs with clear water and an arcing stroke to suggest the hazy look of branches too small to see clearly at this distance, as you can see at center and right just beyond the four main oak trees.

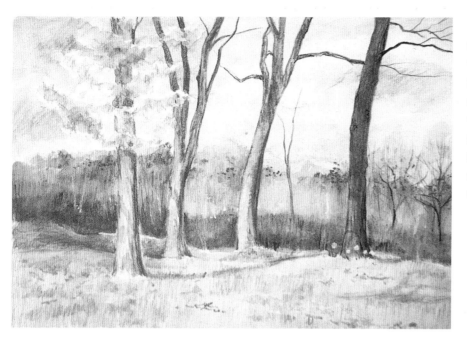

4 Add Finishing Touches

At this stage, work back and forth over the whole painting to make sure it is balanced and expresses what excites you about the subject. Wet the pencil point and touch it to the paper to suggest the reddish buds on the understory trees, and use much the same effect to suggest the dead leaves in the foreground. Use a dancing stroke to suggest the leaves still clinging to the oak at left. Add the rest of the small, delicate branches, wet them carefully and call it finished.

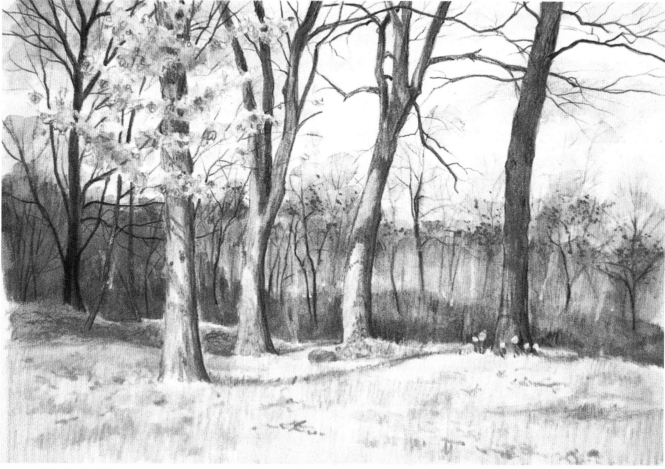

Battle Road
Watercolor pencil on Arches hot-press watercolor paper
7" × 10" (18cm × 25cm)

Trees From a Distance

You won't see individual trees from root to crown when they are massed in a distant landscape, but you may still need to suggest that this *is* a forest made up of many different trees, not a single organism. There are almost as many ways of doing this as there are artists, but here's one that works quite simply.

MATERIALS

SURFACE
Fabriano hot-pressed watercolor paper

WATERCOLORS
Burnt Sienna, Cadmium Yellow Medium Hue, Cobalt Blue, Phthalo Blue, Yellow Ochre

BRUSHES
½-inch (13mm) flat
nos. 3 and 7 rounds

OTHER SUPPLIES
mechanical pencil

1 Lay In the Basic Shapes

Begin by laying in the basic shape of the forest's foliage mass, allowing for some variation in edge, color and shape to suggest different individual trees. (If you want to suggest some lighter trunks or branches, you can mask them out before painting or lift them with a damp brush and clean water.) Let your brush dance along the edges to give a lacy, foliage-like effect.

Drop in color at this point to make wet-into-wet areas of shadow or varying color. Let this dry thoroughly. I used a mixture of Cadmium Yellow Medium Hue and Phthalo Blue, mixing in a heavier amount of yellow for the right side. I used Yellow Ochre for the right bank.

2 Build Volume

Suggest some shadow shapes to give the trees in your forest volume. Use a darker shade of the color you've mixed from Phthalo Blue and Cadmium Yellow Medium Hue or a wash of cool Phthalo Blue. The shadow shapes can have lacy brush marks at their edges, too.

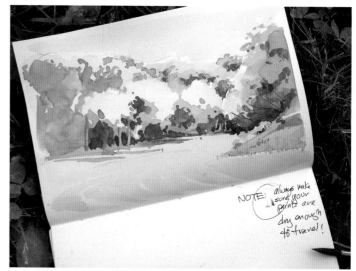

NOTE: always make sure your paints are dry enough to travel!

3 Paint the Limbs and Trunks

Let the shadows dry. Paint a few limbs or trunks within these dark shapes using Burnt Sienna and Cobalt Blue, and add little bare twigs at the edges. You can suggest a bit of detail by drawing back into a damp wash with the tip of a sharp mechanical pencil. It will bruise the fiber of the paper, making it take the pigment more deeply. You're not so much drawing graphite lines as making the paper respond differently when it's wet.

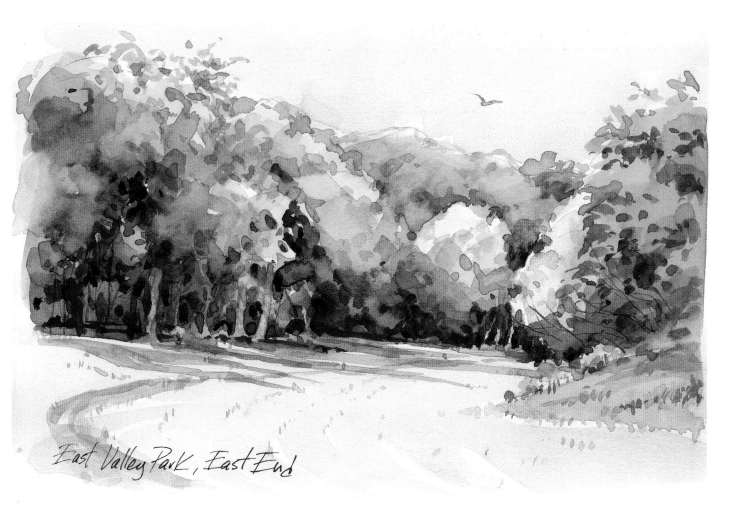

East Valley Park, East End

East Valley Park, East End
Watercolor on Fabriano hot-pressed watercolor paper
5" × 7" (13cm × 18cm)

4 Refine the Shadows

After I got home, I refined the shadows a bit and added more suggestions of lacy foliage. I watched for the negative shapes and added deeper glazes of color to suggest these shadowy areas. Phthalo Blue and Burnt Sienna make a wonderful deep green. Small squiggles and dots suggest foliage.

Another Option: Add Complexity

If you want more complexity, first use masking liquid to preserve some light-struck, lacy leaves and lighter branches, as I did here. Then proceed more or less as before. Allow everything to dry, and remove the mask.

You'll have hard edges where the mask was, so you'll want to soften them with a brush dampened in clear water. Scrub here and there and lift the loosened pigment with a tissue. Then, using a small brush, add color and any details you wish.

Hill Castle
Watercolor on Strathmore
cold-pressed watercolor paper
9" × 12" (23cm × 30cm)

Painting Morning Light

When the sun is rising over a misty forest clearing, it is a luminous, lovely time of day that is irresistible to paint. The far trees are abstract and almost flattened in their simplicity and the colors are simplified, too. Details are visible only in the foreground, and the contrast between warm and cool colors is subtle and dreamlike, as though the viewer is not quite fully awake so early in the morning.

One early June morning in Maine, I came across just such a scene and it has haunted my imagination ever since. I couldn't resist trying to capture that almost abstract luminescence with watercolor pencils. I chose just a few pure, clean colors to keep the scene as fresh and simple as it was that morning.

MATERIALS

SURFACE
Strathmore rough watercolor paper

WATERCOLOR PENCILS
hues of your choice

WATERCOLOR CRAYONS
hues of your choice

1 Create Thumbnail
I tried a couple different formats for this painting—vertical and horizontal—and did a couple small thumbnail sketches. Here's the one I settled on.

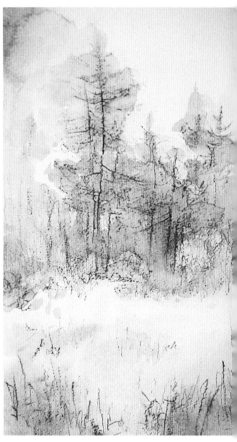

2 Apply First Colors
Use a rough paper with a strong texture that can handle the very wet washes without buckling for this painting.

To suggest the luminous effects of early morning light, keep your colors almost pastel in the first application, using mostly a cool yellow and a small amount of warm, light blue and blending to make a soft, tender green. Wet your painting and blend very smoothly in the grass area.

3 Add Textures
You may be excited by the interesting textures in the simple tree shapes in the background (the result of the waxy pigment from the watercolor crayons deposited on the peaks of the rough watercolor paper), but resist the urge to blend too much. Use cool, transparent blues there to maintain a sense of distance.

Visit artistsnetwork.com/Painting-Nature-Cathy-Johnson for a FREE bonus portrait demonstration.

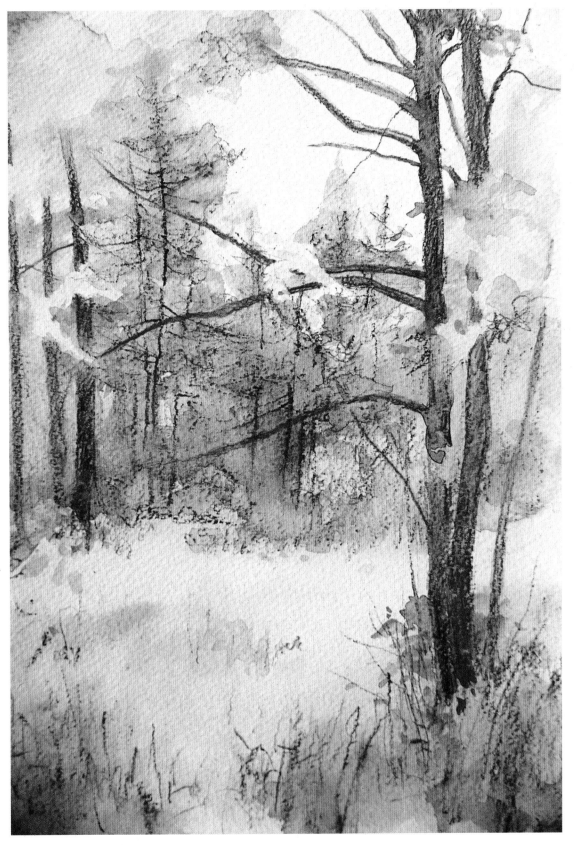

Morning Light, Maine
Watercolor pencil and watercolor crayon on Strathmore rough watercolor paper
12" × 9" (30cm × 23cm)

4 Add Final Details

To maintain a strong, textured effect in the middle ground, draw some of the tree trunks and branches directly into a damp wash with the tip of your watercolor pencil. The rough paper works well to capture that effect. In order to retain the misty, dreamlike effect of a morning in Maine, resist the urge to add too much foreground detail.

Denizens of the Forest—Plants and Creatures

One of the lovely things about spending time in the woods is that you can look around and see things you might not notice otherwise. Small wildflowers at your feet bring your attention to a patch of unexpected color, a complex and ornate flower in early spring or the rough-and-tumble of late summer's tall golden flowers. They're all worth sketching and painting.

If you're quiet when you go into the woods, you're liable to see wildlife as well as flora and fauna. Be still and quiet, and they'll accept you—albeit warily—and go back to their normal life. Squirrels may scold from behind a branch. Birds resume their song, feeding and mating and nesting all around you. Butterflies and moths flit by, without a care. Watch for graceful lunas and the amazing camouflage io moths, who flash large "eyes" at would-be predators.

Nature's Beauty

Different flowers bloom in different areas, of course, depending on your latitude and longitude, weather, soil type and elevation. The beautiful, modest coral-colored columbine in my woods is nothing like the huge sky-blue versions in the evergreen forests of Colorado's Rocky Mountains.

The light was fading and I was hanging onto the side of a steep bluff as I tried to capture this pretty bellwort, but I painted as much as I could.

golden-brown "fur"

tightly-furled frond called a fiddlehead

leathery fronds

spent frond

Woodfern

fruitdots on backs of fronds

Add Detail Later

I added some detail and tightened up the sketch a bit after I got back home.

Fern Fun

Ferns and mushrooms are fun to paint and draw. Look around as you hike or ramble, or just sit for a while and let the forest show itself to you. You may see something you'd normally overlook.

Here's a quick technique for sketching in nature: Do the basic drawing with a wax-based colored pencil (I used black here). Then use watercolor pencils or watercolor washes to splash in some color.

Visit artistsnetwork.com/Painting-Nature-Cathy-Johnson for a FREE bonus portrait demonstration.

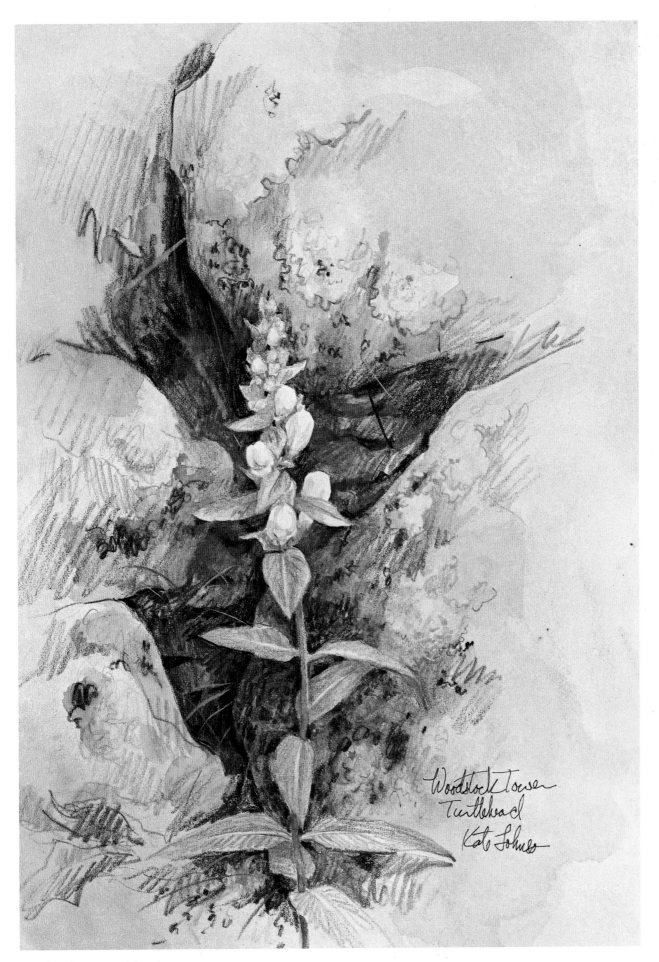

Woodstock Tower Turtlehead
Watercolor pencil and watercolor crayon on Arches hot-pressed watercolor paper
12" × 9" (30cm × 23cm)

Now You See Them

The larger mammals like deer are a bit shyer, but you may still see them, especially in parks where they are protected by law. They seem to know they're safe.

Butterfly and Moth Proportions

A quick sketch will help you get proportions right. If you need to, you can draw one side of the butterfly or moth, then lay a piece of tracing paper over that half, trace it and flip the tracing over to make sure the other side is symmetrical.

Big Eyes

The io moth comes in several shades. Some have very dark upper wings, and some are bright golden yellow, but the underwings are always a surprise when they "open" those eyes at you.

Binoculars Are Best

In your wanderings, you might even see a bear (they're becoming more common in many states). In that case, though, I don't suggest a close-up study. Binoculars are good when the animal is a large predator. A quick sketch to finish at home may be your best bet. You can always work from your drawing or just splash on a quick watercolor wash.

Visit artistsnetwork.com/Painting-Nature-Cathy-Johnson for a FREE bonus portrait demonstration.

Dragonfly

I rendered this little fellow with watercolor pencils, first lightly sketching in the shape with a graphite pencil that doesn't lift when wet. I left the wings on the left almost untouched to show the progression, and here you can see the very light pencil lines. I worked from light to dark, wetting and blending each layer as I went—on the left side the top wing has not been wet while the bottom one has. I continued to strengthen the values of the greens, blues and prismatic lights on the wings on the right, then added the rich blacks, blending carefully where they met the more brightly colored areas, and keeping sharp, dark edges where they needed to be defined. The green background that allows the dragonfly to shine was done with a variety of yellow, blue and dark green pencils, blended but allowed to retain some variation for more interest.

Dragonfly Prisms
Watercolor pencil and graphite on Arches cold-press watercolor paper
7" × 10" (18cm × 25cm)

Painting Plants Up Close

The texture and shape of plants provide wonderful subject matter. They needn't all be flowers. The ferns on the forest floor caught my eye one year in Maine, and I determined to see if I could capture the varied layers of their complex beauty. It was a wonderful opportunity to explore negative shapes—those woodland plants have such intricately cut foliage. It was also a challenge to see if I could avoid a boring sameness with a subject that was essentially all green. I wanted to suggest the wonderful variety of value and hue and chose to utilize the primaries in the first layer for a lively undertone.

MATERIALS

SURFACE
Arches hot-pressed watercolor paper

WATERCOLOR PENCILS
blue, green and yellow hues of your choice

WATERCOLOR CRAYONS
blue, red and yellow hues of your choice

BRUSHES
large flat

1 Lay Down Base Colors
This painting is a good one on which to try larger watercolor crayons. To achieve a quick, broad coverage, use a light application of warm yellow, cool blue and fairly red Lyra Aquacolor crayons, concentrating on the yellow and blue for a predominantly green wash. Then blend them well with a large flat brush and plenty of clean water. Scrub vigorously if necessary.

2 Draw In Fern Shapes
Once that layer is dry, begin to draw in the fern shapes with dry pencils, at first just as simple leaf shapes. Draw two larger, simpler fronds at lower and upper left that are essentially the color of the background wash. Add a bit of modeling along the veins and the warmer colored midrib. Then color in behind each frond to push that background away from the viewer. Wet these small, delicate areas as you go, being careful to preserve the shape of the individual frond.

3 Add More Color

For this layer, mostly use a warm, light blue-green and a light green-blue pencil, varying here and there for interest. Begin exploring the lacier frond shapes as you go, drawing into the main shape to suggest the intricately cut edges. On a few of the ferns, apply a layer of yellow-green for a variation that mirrors nature, and model here and there with a variety of pencils. Soften these layers with clear water.

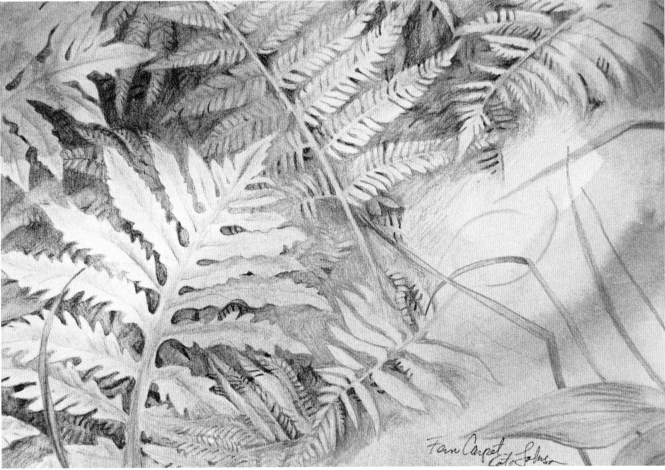

4 Add Final Details

Suggest the fronds and the shadows underneath with an application of a dark Prussian blue. Wet it carefully and pull some of the pigment over the leaf shapes to suggest shadow and to soften edges.

Fern Carpet
Watercolor pencil and watercolor crayon on Arches hot-pressed watercolor paper
7" × 10" (18cm × 25cm)

Painting Fur and Hair

There are many ways to capture the look of fur or hair with watercolor pencils. Decide whether the animal you want to depict has smooth, sleek hair, such as a deer and some domestic dogs; mottled coloration for camouflage, such as a rabbit; or thick, curly fleece, such as a sheep. The technique you choose will depend a great deal on the type of coat the animal in question has.

Your approach also depends on how far you are from your subject. Up close, you may wish to do an almost hair-by-hair approach. If your subject is in the distance, you will more than likely content yourself with its basic shape or color. Somewhere in between, you may choose a mostly simple approach with just a suggestion of the roughness of the hairs.

Be careful to give your animals lively eyes. All four of the examples to the right have very dark brown pupils with no white showing. I rendered them by first laying in a black pencil, drawing around the highlight, then wetting, blending and moving the pigment around, blotting where necessary to suggest roundness. While this area was still wet, I flooded in a bit of warm brown by touching my wet brush to the tip of a brown pencil then touching the animal's eye, still keeping the highlight of white paper.

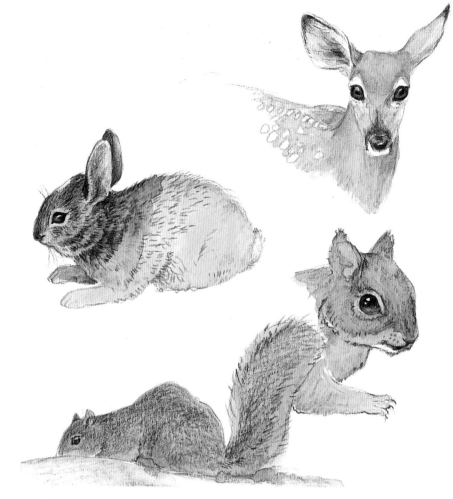

Painting Different Types of Hair

This white-tailed deer has a very smooth, glossy coat. Unless you are very close, you can't see the individual hairs or color variation except in broad terms. There's a bit more variation than normal on this little fellow because it still has the spots of a fawn. But other than the light areas around the eyes and muzzle or the dark hairs near its nose and on the tips of its ears, its coat is fairly uniform in color. For that reason, I chose to apply the pencil as smoothly as possible, blending it with clear water and paying attention to the tonal variations in these large areas only.

The young rabbit has a variegated coloration that helps it avoid detection by predators. Its fluffier coat is a light brownish tan, mottled with black hairs that are a bit more of a challenge to suggest accurately. I chose to use a smooth underlayer of warm ochre, blending with water and allowing it to dry thoroughly. Then I went back in with black and gray pencils using zigzag squiggles and quick, repetitive marks. I blended that layer only very lightly so the hairs were still suggested. Finally, I used a dry watercolor pencil on the head and ears to restate and darken some hairs and whiskers.

I used two different techniques for the squirrels. I used a warm undercolor for both squirrels, but on the head I used a combination of squiggles in a dark blue-gray and smooth areas of black to model the animal here and there. Then I wet these areas again. I used only a bare minimum of dry pencil along the edge of the jaw and on the tufts of the ears to suggest the soft fur there. For the distant squirrel, I chose to leave the black watercolor pencil untouched by water to let the texture of the paper show through, suggesting variations in fur color.

Painting an Animal's Eye

MATERIALS

SURFACE
Arches hot-pressed watercolor paper

WATERCOLOR PENCILS
Burnt Sienna, Burnt Umber, Cobalt Blue, Ivory Black

1 Draw Basic Shapes
To achieve a realistic look for this white-tailed deer's eye, first draw the basic shape and scribble in black, brown and Burnt Sienna pencils, being careful to avoid the curved highlight.

2 Add Pupil
Blend the colors you laid down in step 1. Wait till they dry, and then draw in the black pupil.

3 Add Final Details
Wet the pupil and blend a bit more. Wash in a bit more warm brown and touch the wet wash with the tip of your brown pencil to suggest the rays in the iris. Soften the highlight and add a bit of cool blue to reflect sky color. For the final touch, suggest a bit of the light ring of hairs around the eye.

Birds

One species or another, birds are everywhere. In the woods near my home in Missouri, I see robins, cardinals, jays, titmice, chickadees, wrens, goldfinches, sapsuckers, a variety of woodpeckers, owls and more. Every once in a while, I even see a hermit thrush. Unlike many mammals, birds are seen even in towns and cities. Some will come right to your feeder to model for you.

Speedy Sketching

Birds move fast, so you need to be ready. Just make a quick sketch like this to capture the basic shape. You can fill in the details later, from memory.

Journal Detective Work

Use your journal to study the wildlife around you. I did this rough sketch of a mystery bird and added written notes. Later, I was able to identify it as probably a hermit thrush, so I did a more complete illustration on the same page.

Little Brown Bird, utterly silent in the back yard

May 12

CLOSE-UP FROM MY TINY PHOTO

smaller than a robin, bigger than a wren

Brown spots on throat + upper breast

Could it really be a hermit thrush, in town?

Sneaky Studies

Owls are usually asleep in the daytime. If you come upon one just overhead, you may have a chance to sketch it with some detail. It may wake and become restive, so do as much as you can before it moves off.

If you get a chance, make the acquaintance of the local wildlife rehabilitator. That will give you lots of occasions to sketch and paint animals and birds, often at close range. This little screech owl (left) was just about ready to be released back into the wild, but I was able to study him closely and paint the subtle patterns of his feathers.

Visit artistsnetwork.com/Painting-Nature-Cathy-Johnson for a FREE bonus portrait demonstration.

Living Color Wheel

I used the bunting along with a cardinal and a goldfinch to make an avian color wheel. I especially liked the way the goldfinch turned out with his little black cap and black and white wing feathers (merely suggested here). I had done a similar color wheel for another project years ago and had always wanted to redo it more accurately. I paid careful attention to the shapes of the birds—I chose these specific species because their primary colors actually do make the secondaries when mixed. Between the birds you can see that the strong red and ultramarine blended well to make a royal purple and the smaller dots of purple-blue and a reddish purple. This same red and the goldfinch's bold yellow make a beautiful orange with lovely gradations, and the blue and yellow make a range of serviceable greens.

BY THE WATER

Water is one of the most beautiful, intriguing, challenging and magnetic of subjects for the artist. And, it's naturally suited, of course, to being rendered in watercolor. Reflective and still or moving in patterns determined by winds, rocks, elevation or the pull of the moon on tides, water calls to us to try to capture its quicksilver beauty.

Depicting water is an endless challenge given all the variables and circumstances, but it needn't be an impossible one. You can even employ a kind of shorthand to indicate water, using pure watercolor or combining it with other mediums.

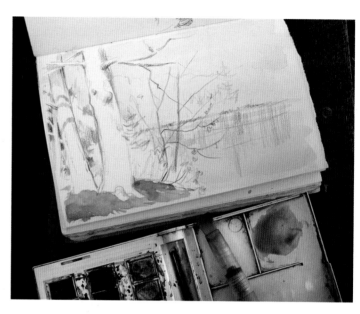

Indigo Magic

Indigo colored pencil provided the framework for this multimedia sketch. It's one of my favorite tricks for depicting water. The vertical strokes near the shore suggest reflections, and the horizontal strokes in the water make it look limpid and wet. It's magic. You can see the first washes in this on-the-spot photo as well as some of my tools.

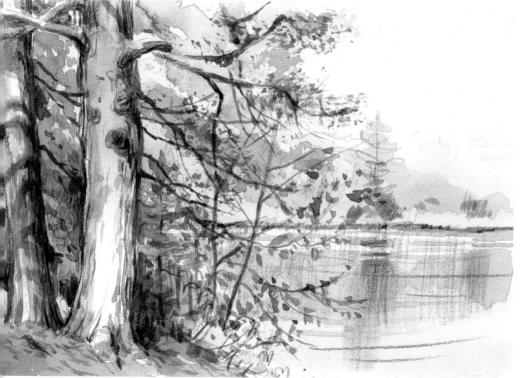

Finish With Washes

A succession of quick watercolor washes finishes the scene. I worked wet-on-dry, letting the first washes dry thoroughly before adding more. Leaving some horizontal areas of untouched white paper gives them the sparkle that reads as water, too.

Adirondack Camp
Watercolor and colored pencil on Fabriano
cold-pressed watercolor paper
5" × 7" (13cm × 18cm)

Visit artistsnetwork.com/Painting-Nature-Cathy-Johnson for a FREE bonus portrait demonstration.

Still Water—Lakes, Ponds, Coves, Marshes

It might seem that this is the easiest type of water to paint, and perhaps it is. Still, there are some tips and things to watch out for. The way your body of water looks depends on a lot of factors. How far away are you? Close up, near a shoreline, in a still cove or on a pond, you'll find reflections can play a big part in capturing the "look" of water and adding to the overall composition. At a distance, especially on a cloudy or rainy day, reflections may not be very visible if they show up at all (see image below).

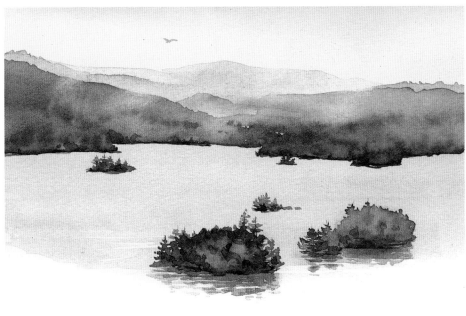

Adirondack Lake
Watercolor on Fabriano hot-pressed watercolor paper
5" × 7" (13cm × 18cm)

Rainy Reflections

This was painted from a window table in the Adirondack Museum's café on a very rainy day. You can see the reflections of the nearest islands, but, in the distance, the lake appears almost featureless. I used a smooth wash for the water and the cloudy sky, lifting here and there in the sky to suggest the low clouds. In the water, I paid close attention to the reflections of the little islands. I painted them with a small round brush, letting my brush dance along the edge nearest the viewer to give the impression of reflections broken by wave action.

The colors used for the reflections were a lighter mixture of the ones used in the islands themselves, which were mainly Phthalo Blue and Burnt Sienna.

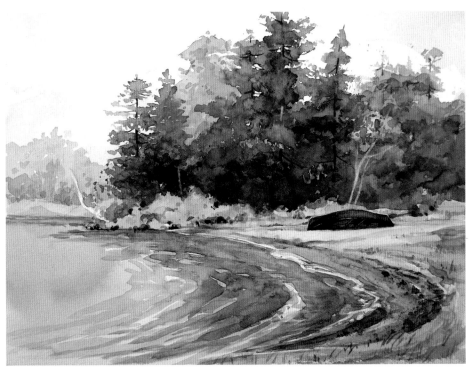

Red Canoe
Watercolor on Strathmore
cold-pressed watercolor paper
9" × 12" (23cm × 30cm)

Level Horizons

Notice, when painting a body of water like a pond, lake or even the ocean, that the distant water almost always looks flat and straight. Unless you're trying to paint a wild storm in the ocean, as Winslow Homer often did, the horizon line (or the distant shoreline) should be level.

The shore or coves closer to you may have more shape to them, as you see in this painting of a red canoe on New York's Lake Durant, but the water farthest away appears flat.

Reflections and Wave Patterns

Painting reflections can give a lot of life to your work. They really say "water!" Keep it simple or go as complex as you choose, but pay attention to the fundamentals. Generally speaking, a reflection is darker and sharper closer to its object, particularly if you are painting a close-up. A reflection gets lighter and less like what it reflects as it gets farther from the object and closer to the viewer.

Angling Reflections

Keep the angle of the reflection roughly the same as the object (remember that it will angle in the opposite direction since it is a mirror image). Try placing a mirror flat on a table, then stand a pencil up straight on top. It looks like one continuous line. Angle the pencil to the right or left and you see that its reflection leans the same way, at the same angle to the mirror's surface. Factor in the natural variations of wavelets that you usually see in water, and you're there!

Notice the angle of the reflection on the left—that's how it should be. Now look at the one on the right. You can see that something's just not quite right!

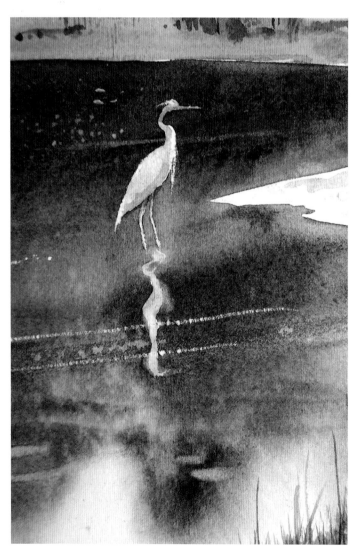

Light Reflections

Plan ahead when painting the reflection of a lighter object. Mask out the shape of the egret and its reflection with liquid mask and allow to dry thoroughly.

Paint the water with a bit of clear water spattered in to give it sparkle (the droplets push some of the pigment out of the way where they land). When that is thoroughly dry, remove the mask. Lift an edge with a bit of India rubber, and pull the rest away gently.

Paint the egret with a small, round watercolor brush and a pale wash of Cobalt Blue to suggest the shadows on this pure white bird. Add a bit of Burnt Sienna for the bill and legs. Use a sharp craft knife to scratch in the long, plume-like feathers on the big bird's head and chest.

The reflection needs to be less distinct than the bird itself. Remove the mask and soften the edges with clear water and a small, stiff brush, blotting up most of the loosened pigment. Flood in a suggestion of the same blue used for the bird, and let everything dry. Use a craft knife to scratch a couple of long, horizontal sparkles across the water and the reflection.

Mosby Lake Heron (detail)
Watercolor on Fabriano
cold-pressed watercolor paper
22" × 15" (56cm × 38cm)

Visit artistsnetwork.com/Painting-Nature-Cathy-Johnson for a FREE bonus portrait demonstration.

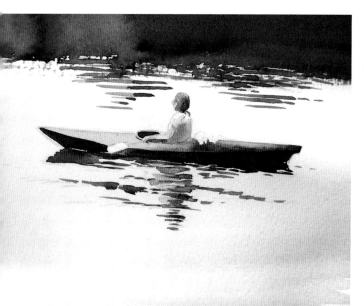

Other Reflections

In this little watercolor sketch, I first laid in a light Phthalo Blue graded wash for the water with a ¾-inch (19mm) flat. I made the wash darker in value near the bottom of the page by adding a bit more pigment to my wash as I pulled it down the page. After allowing it to dry, I added the reflection of the trees on the shore across the cove. You can't see the trees, but you know they're there from the reflection.

I used dry-brush strokes on the closer edge to suggest the sparkle of light on water and painted a few ripples using the same strong mixture of Phthalo Blue and Burnt Sienna. Then, using the wet-into-wet method, I added a lighter green made up of Phthalo Blue and Transparent Yellow and let it blend and flow to suggest trees of varying colors on the invisible bank.

Meanwhile, I laid in the first small, simple washes to begin suggesting Leslie in her bright yellow and red kayak. I laid in some of the reflections at the same time so that the colors could blend—that keeps them from looking pasted on.

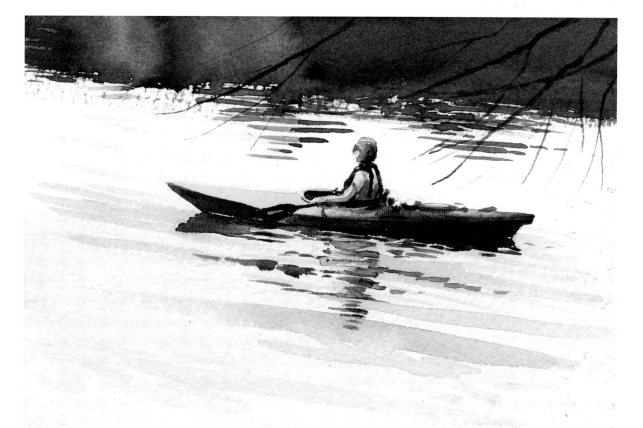

Leslie in the Afternoon
Watercolor on cold-pressed
watercolor paper
4" × 6" (10cm × 15cm)

Finishing Touches

I let those first washes dry and went back in to finish the darker shapes of shadows, paddle, life vest, sunglasses and other details, mostly using a rich mixture of Ultramarine Blue and Burnt Sienna and a small, round brush.

I added a stronger mix of the same blue I used in the water to suggest the wave patterns. Then I added a few more details in the reflection as well as the bare branches reaching into the picture from the upper right. It's a tiny painting, but it has a sense of life and motion.

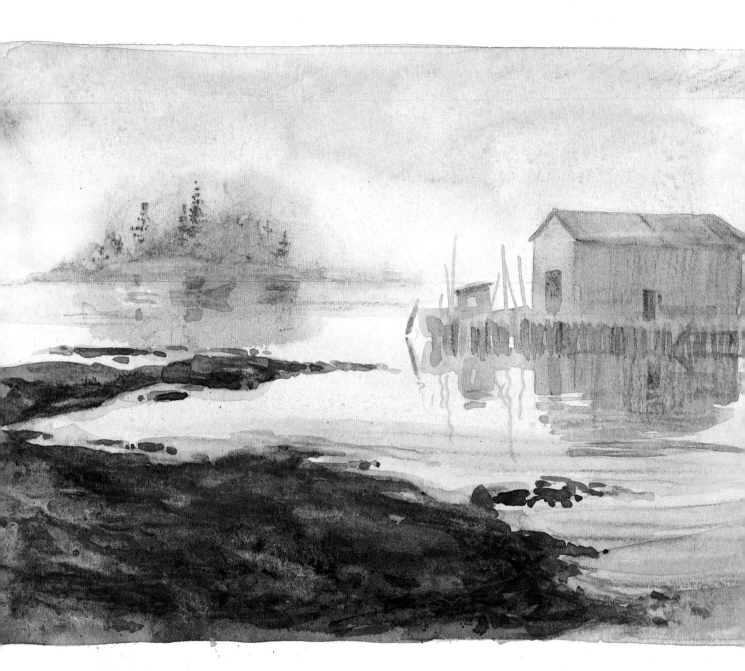

Maine Boathouse
Watercolor and watercolor pencil
on Arches hot-press watercolor paper
5" × 7" (13cm × 18cm)

Visit artistsnetwork.com/Painting-Nature-Cathy-Johnson for a FREE bonus portrait demonstration.

Painting Reflections

Among the most inviting and delightful things to paint when considering the challenge of water are reflections. These can be as simple as the reflection of a far shore in a still lake or as complex as a child's reflection in a puddle. Much depends on the surface of the water you wish to describe. A very still body of water will create a reflection almost indistinguishable from the actual object. Slightly more active water will make a wavier reflection. Water that's being constantly disturbed, such as that in a fountain, may be confusing and complex. Pull it off, though, and those reflections almost carry your painting. This demonstration shows just the water part of a reflection scene.

MATERIALS

SURFACE
Arches hot-pressed watercolor paper

WATERCOLOR PENCILS
black, blue and orange hues of your choice

BRUSHES
bristle brush

OTHER SUPPLIES
tissues

SIMPLE RULES FOR REFLECTIONS

There are some simple rules to painting reflections. The most important is that the reflection is a mirror image of its object. That is, if the object leans to the left, so does the reflection. It's not going to go stubbornly off on its own like a rebellious teenager!

Also note that reflections are usually (but not always) both simpler and darker closer to their objects. As the reflections fall away, they may begin to get rather wavy and lighter. These are not hard-and-fast rules but fairly safe generalizations.

1 Put Down Basic Lines
Make horizontal lines for the water and vertical lines for the reflection of the trees.

2 Add Color
After everything has been wet with clear water and blended nicely, introduce a bit of orange at the bottom of the reflection to suggest the sunset light caught there.

3 Strengthen Reflections
Strengthen the reflections here and there with a black pencil. When that is dry, lift light lines with clear water on a bristle brush, using horizontal strokes to suggest the limpid quality of the small lake. Lift the loosened pigment with a clean tissue and let everything dry.

Painting Reflections of a Fountain

MATERIALS

SURFACE
Arches hot-pressed watercolor paper

WATERCOLOR PENCILS
black and blue hues of your choice

1 Map Out Reflections

When painting something as complex as the reflections beneath my friend Ginger's bronze crane fountains drawn darkly on rippled water, it may be best to plan your attack first. Draw a line map of the shape and direction of the reflections of the metal cranes and the rings on the water.

2 Create Underwash

Do an underwash of the color you want the majority of your water to be. It's fine to follow with your brush the overall rings formed by the water of the fountain striking the water of the goldfish pond.

3 Add Darker Values

Once that layer is dry, sketch in the shape of the second layer of a darker value, and fill it in carefully. Wet it carefully, keeping the color fairly smooth. You still may want to follow the line of the ripples.

4 Add Final Details

Finally, come in with your darkest dark to give sparkle to the water and the kind of contrast that makes your picture look very wet. I left part of this dark area untouched by water in the foreground so you can see how it looks

Finished Details

In this more complete version of the same happy concept—cranes are considered good luck—you can see the bronze statues of the cranes themselves, the edge of the small goldfish pond and the rich green plants that surround it. The reflections follow the circles in the water disturbed by the constant droplets from this lovely naturalistic fountain, and the water looks very wet with its bold, calligraphic contrasts, like constantly shifting Celtic knots drawn on the surface of the water.

Ginger's Cranes
Watercolor pencil on Strathmore
cold-pressed watercolor paper
9½" × 6½" (24cm × 17cm)

Maine Coast Morning

This beautiful estuary near Port Clyde, Maine, is the mouth of a tidal river, where salt water mixes with fresh water with each incoming tide. The distant house and its outbuildings were so inviting in the early morning light that I had to paint the scene. The water was wonderfully still and reflective, catching and holding the sunlight and cloud shadows.

MATERIALS

SURFACE
Fabriano cold-pressed watercolor block

WATERCOLORS
Burnt Sienna, Cadmium Red Medium, Cadmium Yellow Medium, Cobalt Blue, Phthalo Blue, Ultramarine Blue

BRUSHES
1-inch (25mm) flat
nos. 3 and 10 round

OTHER MATERIALS
paper towels, pencil

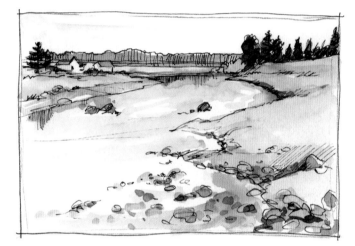

Small Reference
This tiny sketch helped me plan the painting. I was able to decide on the horizontal format as well as what I wanted to include and what I should leave out.

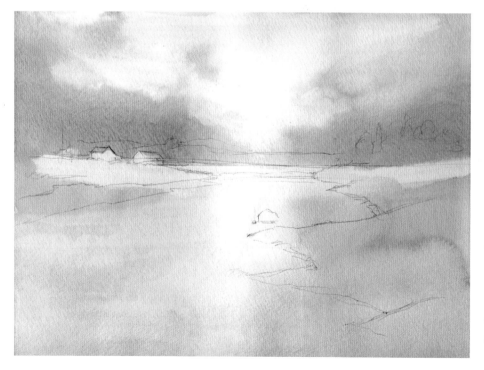

1 Lay In the First Washes

On a simple pencil sketch, lay in the first wet-into-wet washes, using a large 1-inch (25mm) flat and fresh mixtures of Cobalt Blue, Phthalo Blue and Cadmium Yellow Medium Hue. While that is still wet, lay in the clouds and fog bank with a mixture of Ultramarine Blue and Burnt Sienna, concentrating the darkest area close to the land.

Lift the areas of lightstruck clouds and water as well as the white buildings and the land the buildings are on. In my painting, I wanted a purer, cleaner, sunstruck green. Use the edge of a folded paper towel to get into the shapes of the buildings with some accuracy.

These washes should dry with a few hard edges and "flowers," but they'll be covered with subsequent washes, so don't worry about it.

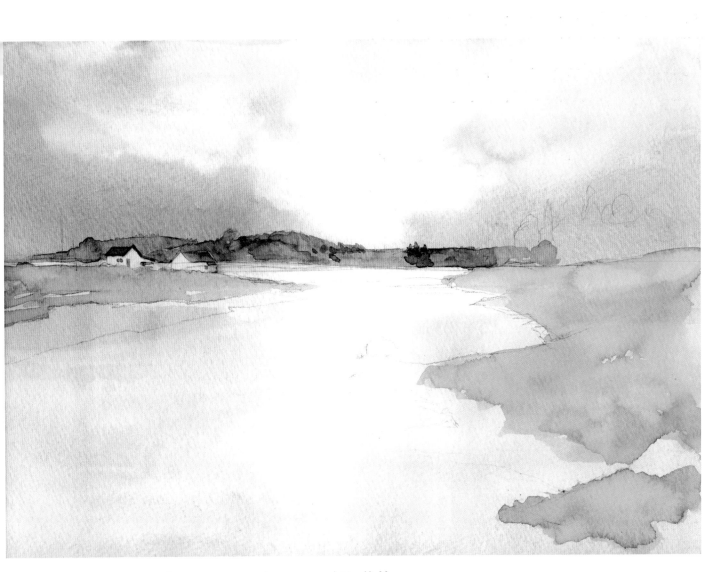

2 Enhance Trees, Grass and Buildings

Using a medium value of Phthalo Blue mixed with Burnt Sienna, suggest the trees on the far shore, with intentional "flowers" of wetter paint here and there to give the illusion of a variety of tree shapes.

Phthalo Blue and Cadmium Yellow Medium Hue make the nice rich green for the grassy shorelines. A no. 10 round works well in these areas. Encourage some variation in value as you go along.

The red roofs help to define the buildings' strong architectural shapes, even at a distance. Use a mixture of Cadmium Red Medium Hue and Burnt Sienna, applied with a no. 3 round. It's important to get shapes like this down accurately. I held my breath while I painted them!

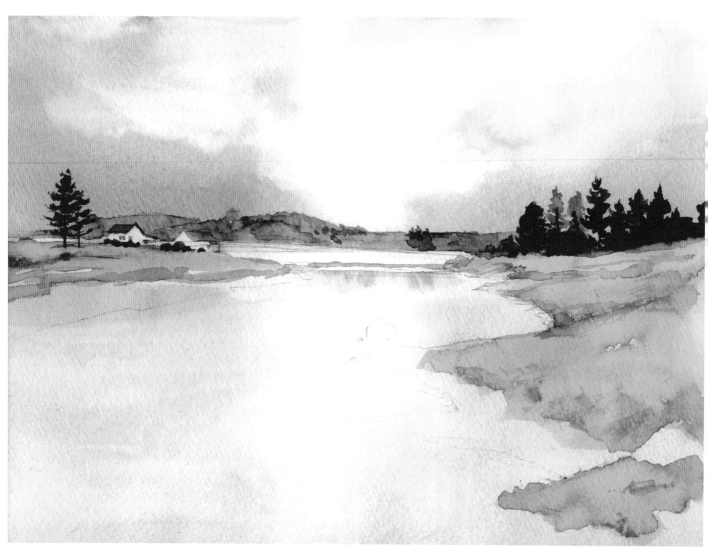

3 Paint the Distant Trees

Use a very strong, rich mixture of Phthalo Blue and Burnt Sienna for the distant evergreens. A dancing touch with the tip of a no. 3 round will capture their lacy shapes, even at a distance. Use darker mixtures of Phthalo Blue and Cadmium Yellow Medium Hue to shape the grassy areas, giving them form and roundness.

Visit artistsnetwork.com/Painting-Nature-Cathy-Johnson for a FREE bonus portrait demonstration.

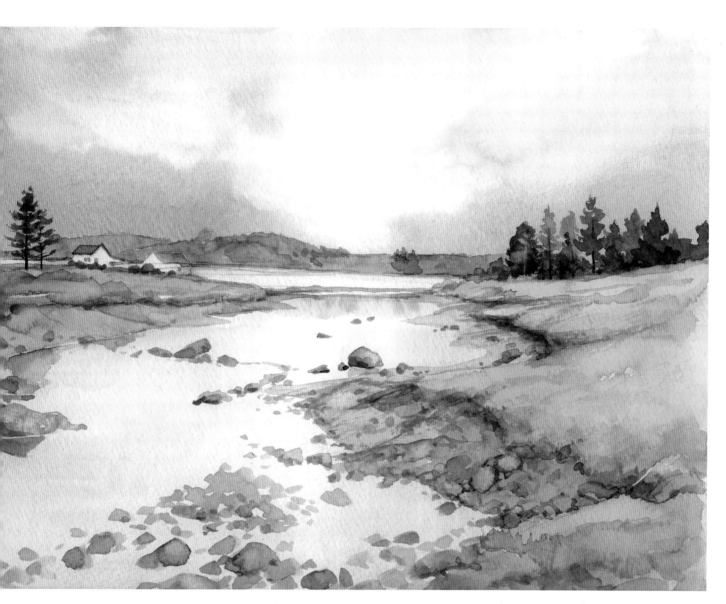

Maine Coast Morning, Early
Watercolor on Fabriano
cold-pressed watercolor paper
9" × 12" (23cm × 30cm)

4 Paint the Shoreline and Rocks

The shoreline and rocks, exposed at low tide, are a mix of Burnt Sienna and Ultramarine Blue, leaning more toward the warmer brown. Paint them wet-on-dry for maximum control, and add the reflections of the trees and rocks judiciously and simply.

Important Details

It's good to sketch some of the details you find near your primary subject, though they may never find their way into a finished work. Your understanding of the subject becomes much deeper when you pay attention to the small things that make a place unique. Exposed by the low tide near this estuary, I found a mussel shell with a live barnacle in it and couldn't resist a quick sketch.

Creating Reflections in Rivers and Streams

Still or slowly moving streams are very reflective, more so than rapidly moving water where the action of the water itself serves to break up reflections. You may find these small watercourses reflecting a dramatic sky at dusk or dawn, shining like mirrors set in the dark earth. I decided to try to capture that effect when I was struck by the beauty of this small hidden creek as I took an early morning walk near the village of Port Clyde, Maine.

MATERIALS

SURFACE
dark-toned pastel paper

WATERCOLOR PENCILS
*Blue-Grey, Chinese White, Deep Vermilion,
Ivory Black, Pale Vermilion*

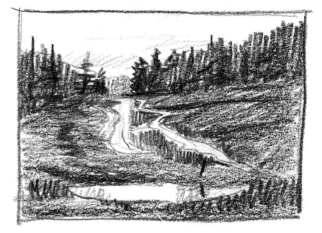

1 Draw Value Sketch
To achieve something simple and dramatic with this painting, first experiment with a quick value sketch.

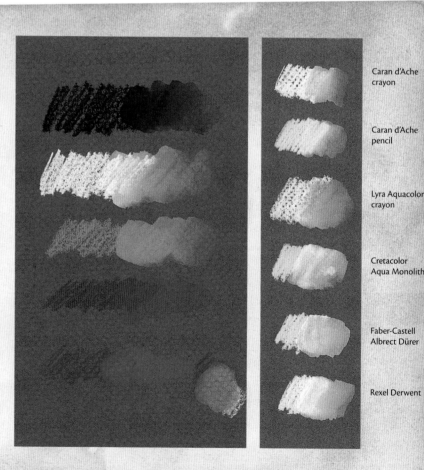

TEST YOUR COLORS

I wanted to use a dark paper, but I was not certain which one or which watercolor pencils might work best. After testing the opacity and workability of several brands, I settled on Derwent's Ivory Black, Chinese White, Pale Vermilion, Deep Vermilion and Blue Grey pencils. I was able to get a sufficient range of values to suggest the simplified light of predawn on dark paper with just these five colors, using the opaque pencils very heavily in some areas and thinned with water in others. I used the Blue Grey pencil mostly mixed with Chinese White (bottom right) to lighten it up a bit.

Note that different brands have differing degrees of pigment density, which also affects opacity. Consider the six samples of white shown right and choose the right tool for the job at hand. Of course these samples reflect only the opacity or density of a single color—the brands handle differently with other colors.

Caran d'Ache crayon

Caran d'Ache pencil

Lyra Aquacolor crayon

Cretacolor Aqua Monolith

Faber-Castell Albrect Dürer

Rexel Derwent

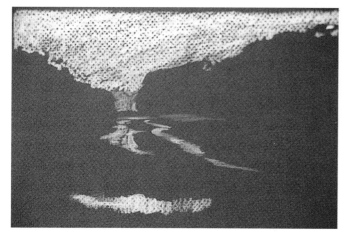

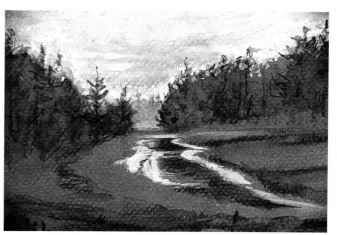

2 Add First Colors

Lightly sketch in the shape of the horizon and the little stream, then lay in your lightest lights with a very firm touch so they will be opaque enough to cover the dark paper. Then blend rather lightly to keep from disturbing too much of the opaque pigment.

3 Add More Color and Detail

When the layer from the previous step is dry, add a bit more color to increase the opacity of those lightest areas, then add a bit of reddish brown to the sky closest to the ground. Begin to strengthen the darkest areas with Ivory Black and Blue Grey. In this detail you can plainly see how simply I handled the foliage in the background and the reflections in the water.

4 Add Final Details

Because of the subdued light at this time of day, keep details to a minimum. The sharp contrasts between the lights and darks in the water are what makes it look so wet. This was a small tidal stream, so the banks were still wet with the receding tide. Use a smoother tone of Chinese White and a Pale Vermilion to suggest the damp, sandy banks. The pool of water in front was in a slightly higher place and reflected only the sky and an upright stump on the bank.

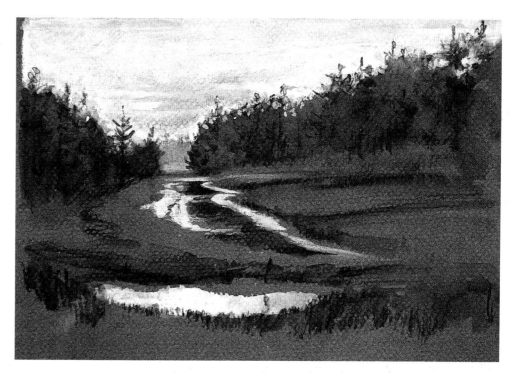

Maine Dawn
Watercolor pencil on dark toned pastel paper
6½" × 9¼" (17cm × 23cm)

Painting Lakes and Ponds

Lakes and ponds afford wonderful prospects for painting. Reflections are mirror perfect on that unruffled surface on a day with almost no wind. A breeze produces ripples and a slight distortion of reflections, while on a day of brisk wind and choppy water, you may find yourself attempting to depict a surface much like that of the sea in miniature. I've seen pretty respectable breakers on the small lake in a state park near my home when the wind howled out of the west, and I paint them just as I do the waves on the ocean.

Watercolor pencils allow you to be very flexible in your handling of lakes and ponds because they adhere well to a number of paper surfaces, and their relative transparency or opacity mimics both traditional watercolor and water-soluble gouache or opaque watercolors, depending on which pencils you choose. Remember the tips from chapter two to become familiar with your medium. You will know which colors to reach for when you want a transparent effect and which to grab when you need an opaque effect.

1 Draw Thumbnail Sketch

Draw a small thumbnail sketch to make sure you can maintain the sense of distance through the use of values, along with the very wet, reflective quality of the still water at the end of a late autumn day.

MATERIALS

SURFACE
Arches hot-pressed watercolor paper

WATERCOLOR PENCILS
Blue Gray, Burnt Sienna, Burnt Yellow Ochre, Ivory Black

WATERCOLOR CRAYONS
dark blue, orange and yellow hues of your choice

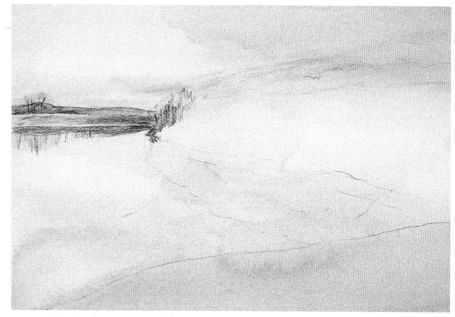

2 Add First Colors

Because everything is infused with a sunset glow, do a varied wash over the whole paper—sky, water, far shore and hill, foreground and trees—everything. To combine a soft gray sky and its reflection in the water as well as the warmth of the dying sunset, mix yellow, orange and dark blue watercolor crayon, blending them well, but vary the color from warm to cool where you need to suggest sunset light.

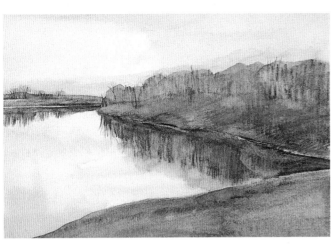

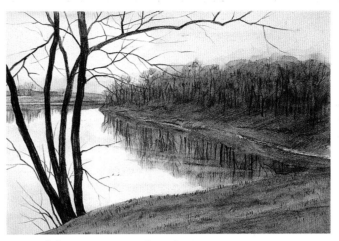

3 Add Details and More Colors

Begin to lay in the far shore and the beginnings of the hill to the right. You can see the flat line of the water against the dam. Use Blue Grey, Burnt Yellow Ochre and Burnt Sienna and keep the colors simple and the values fairly subtle, without a great deal of variation. Do the trees beyond the dam with a very finely pointed Ivory Black, lightly applied then blended carefully to look like bare twigs against the sky.

4 Add Foreground Colors

Begin adding the dark foreground and trees.

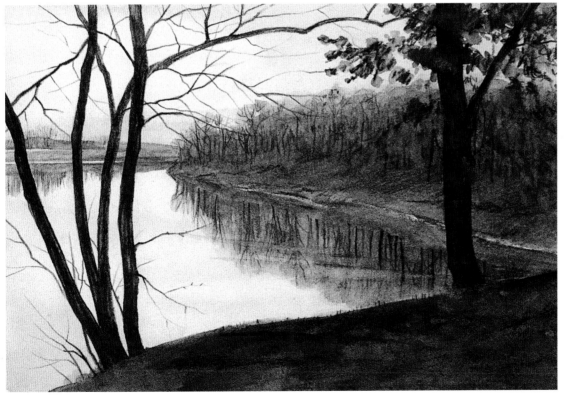

Rocky Hollow Sunset
Watercolor pencil on Arches hot-press watercolor paper
7" × 10"
(18cm × 25cm)

5 Add Final Details and Colors

Make the foreground nearly as dark as the trees, and add the second tree on the right to frame the little lake and its reflections. In reality, there was an oak tree there with its lacy leaves still clinging to it.

Fast-Moving Water—Rivers and Streams

Painting fast-moving water is a different kind of challenge, but don't let it scare you. All you need to do is sit and look long enough so you can discern the patterns. Just as rocks and tree limbs breaking the surface of the water cause disturbances, so do submerged rocks and limbs. Depending on the elevation (the steepness of the fall), you may see more or less white water. Reflections appear only in the slower moving water or still pools. Often as not, they just show as a rich glow of color, without any detail.

Water Maps

It's fairly easy to follow what's going on in a scene with moving water if you draw a simple map of what direction the water is moving and, if you can tell, why it is moving that way.

Light Difficulties

Painting this scene on the spot in the Elizabeth Furnace Recreation Area was a real challenge. The light changed almost as frequently as the shapes in the water. Eventually, I was able to discern what caused the water patterns and simplify them. Rocks just under the water's surface made subtle shapes of light and dark, while those that broke the surface made a more broken, lacy pattern.

I allowed granulating pigments and intentional hard edges within the mountain's bulk to suggest the richly forested slopes. I kept the rest of the trees simple, so most of the focus would be on that sparkling, moving water. Rapid, calligraphic brushwork with minimal detail worked well for the mountain stream.

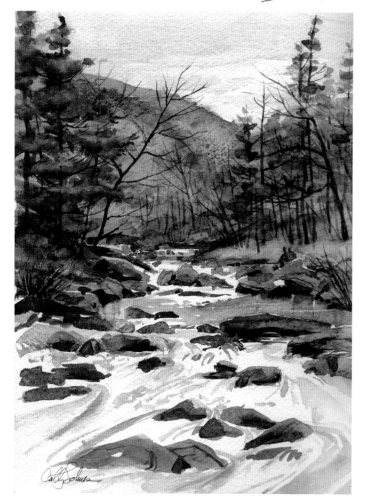

Elizabeth Furnace
Watercolor on Fabriano
cold-pressed watercolor paper
12" × 9" (30cm × 23cm)

Visit artistsnetwork.com/Painting-Nature-Cathy-Johnson for a FREE bonus portrait demonstration.

Painting Rivers and Streams in Perspective

The lovely serpentine shapes of rivers and streams attract life like a magnet, whether to feed, drink, swim, play, fish or paint! If you are a long way from the ocean, remember this is a world of many rivers. Painting opportunities are everywhere, even in our own backyards. Rivers may be as impressive as the Mississippi or the Nile or as dramatic as the Colorado or the Rhine. They even can be as small as a backyard stream. They all provide us with endless opportunities.

It may seem difficult to capture this subject effectively. Sometimes our efforts look as though the water must go spilling off the side of the page. We may have trouble seeing the perspective correctly, but rivers and streams do follow the rules of perspective. Look closely—they are generally narrower and higher in the picture plane in the distance. Often there is less detail the farther back they go. Look for ways to suggest aerial perspective and your paintings will ring true.

White River, Shepherd's Country
Watercolor pencil on Canson Montval rough watercolor paper
7" × 5" (18cm × 13cm)

Pay Attention to Negative Shapes

It may help you draw your river in the picture plane accurately if you pay attention to the negative shapes that surround it. If you wish, draw a border around your intended subject and look at the landforms between that line and the edge of the body of water. Note that the stream often seems to widen perceptibly at bends in the river; this particular spot also had a small oxbow to the left where the old river channel used to be.

Use Aerial Perspective

I was on a promontory overlooking the White River in southern Missouri and was rewarded with this aerial view to work from. The wind was blowing hard, so I just did a quick sketch but was happy with the result nonetheless. I liked the dark sky and shadowed hills in the background and the more pastel-looking landscape that waited in the sun for the storm to hit. Watercolor pencils work wonderfully for such sketchy handling. If you like to draw, you will love their versatility, allowing you to turn your drawing into a painting with a few strokes of a watercolor brush.

Painting Waterfalls

When you think of a waterfall, what immediately comes to mind? A thundering cataract like Niagara Falls that makes the very earth vibrate beneath your feet? My first thought is of the tiny "falls" in my creek; it was dry the first time I saw the land where I later built my cabin, but it whispered to me even then. I've seen it flood when it roars like a miniature Niagara, and I've seen it in spring when runoff pours merrily over its edge, chuckling loudly to itself. I've listened to the musical plink-plink-plink when it's slowed almost to nothing. I've since drawn and painted that tiny intermittent cascade many times, and it's still my favorite waterfall. You probably have your own favorite. Water in the thrall of gravity is wonderful to paint, and each waterfall has its own personality.

Waterfalls may seem dauntingly complex, but each individual waterfall has its own logic, depending on what it falls over and how much water is flowing at the time. If it flows slowly with only a small amount of water in the stream, it's likely to separate around obstructions in its path. If there is a great volume of water, it may mound over rocks and even boulders, hiding them completely, though we know they are there by the shape of the water itself. There are any number of ways to paint them, from almost photographic in detail to as simplified as possible. Look for the logic behind what you see, and it will become much easier to understand and paint.

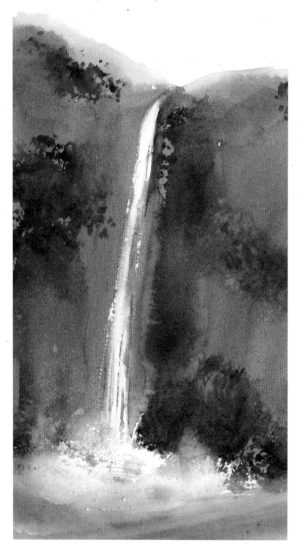

Minimal Detail

From a distance, very little detail is visible. The waterfall may look like little more than a silver ribbon against a cliff face. You can use a bit of drybrushing and scratching to good effect, but little else is needed.

Different Strokes

Try a variety of stokes to capture the effect of moving water. Here you see (from top) a flat brush used in both a dry-brush and straight manner, a rigger brush used to make linear strokes, a round brush to suggest intermittent or complex "braided" streams, a ragged old moth-eaten brush and a round brush applied lightly on the side of the brush's body to depict the frothy area at the bottom of the falls. At left, a bamboo pen was used to apply masking fluid, not all of which has been removed.

Visit artistsnetwork.com/Painting-Nature-Cathy-Johnson for a FREE bonus portrait demonstration.

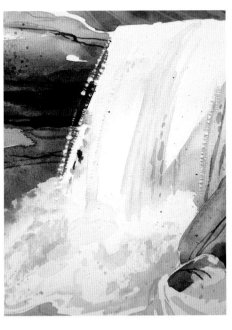

Simple Washes and Strokes

In this strongly graphic handling, the shadow shapes are only hinted at, with pale washes of blue. Washes that are darker in value give the impression of the more deeply shadowed areas, while the foam at the waterfall's base is painted with quick, loose strokes that mimic the motion of the water itself. When everything is completely dry, you can scratch through a few sparkly lines with a sharp blade.

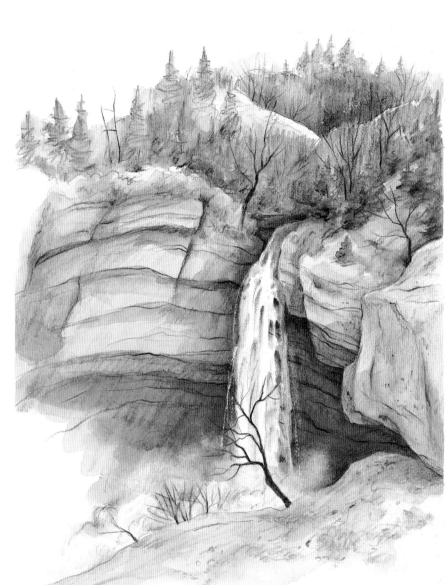

Distant Waterfall

This tall waterfall is in Arkansas. The earth is red, the rocks are warmly colored and the pale water stands out in stark contrast. Don't paint the flowing water as a solid sheet of white. Leave holes where the water separates over an obstruction.

A falls at a distance like this won't have too much detail, but you can scratch out small, shining bits with a sharp-bladed craft knife once your picture is dry. Notice that such waterfalls with a long drop often send up quite a cloud of mist at the bottom; there may be prismatic colors in the spray. Emphasize them as I did here.

Arkansas
Watercolor pencil on
Arches hot-pressed
watercolor paper
10" × 7"
(25cm × 18cm)

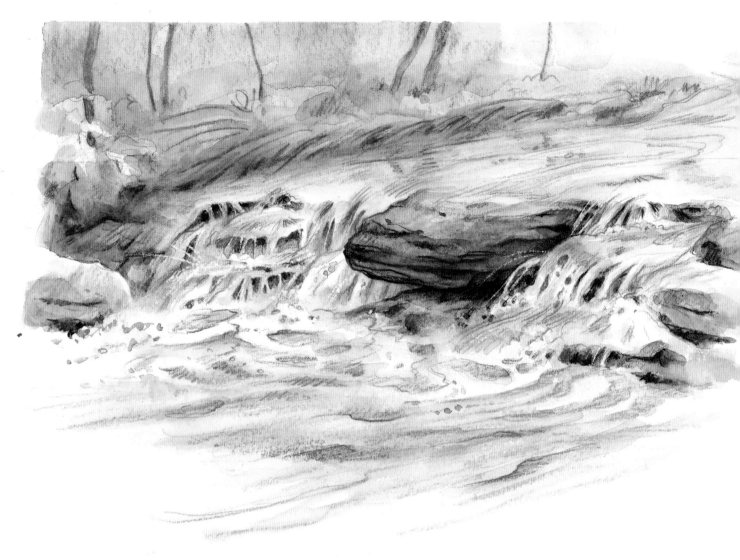

Watery Sound Effects

One of the loveliest things about painting the varieties of water on the spot is the sound effects. When I look at my painting later, I can't help but hear the crash of surf, the whisper of foam, the rushing gurgle of a small stream and the sounds of birds and wildlife that are inevitably attracted to water. The sound is compelling and deeply stirring—so peaceful I could almost sleep right there by the little brook. See if you can find ways to suggest the environment as well as the subject itself. Show a bird bathing in the small creek or water-loving birds fishing in the surf.

Shack Creek
Watercolor pencil on Strathmore cold-pressed watercolor paper
6½" × 9" (17cm × 23cm)

Visit artistsnetwork.com/Painting-Nature-Cathy-Johnson for a FREE bonus portrait demonstration.

Promised Land

When I found this beautiful little waterfall deep in the Pennsylvania Poconos, I couldn't resist painting on the spot. I had gone out expecting to paint something entirely different, but the sound of falling water downstream drew me, and I had to give it a try. Time was all too short, so first I did a thumbnail, then a larger value sketch so that I'd have a framework if I ran out of time—which I did!

MATERIALS

SURFACE
Fabriano cold-pressed watercolor block

WATERCOLORS
Burnt Sienna, Cadmium Yellow Medium Hue, Payne's Gray, Phthalo Blue, Transparent Yellow, Ultramarine Blue

BRUSHES
½-inch (13mm) and 1-inch (25mm) flats no. 6 round

OTHER MATERIALS
brush-tipped pens in shades of gray, masking fluid, natural sponge, sharpened stick

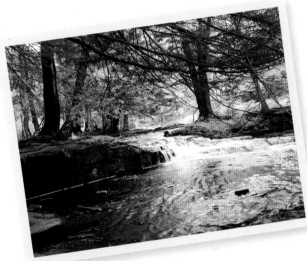

Reference Photo
The spot was idyllic and primal. The waterfall sparkled and roared, the rocks were acid-green with moss, and I felt as if I were miles and millennia away from civilization. It was the perfect place to paint!

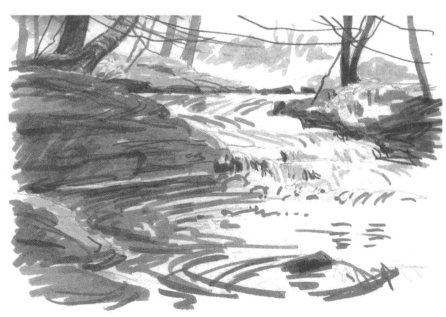

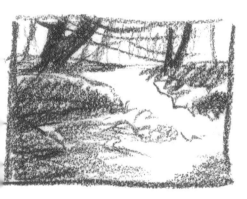

Thumbnail Sketch
When considering a complex subject like this—especially one where I know I won't have time to finish—I find preplanning sketches like this thumbnail are a big help.

Value Sketch
A quick pencil sketch let me get the bones of the scene down on paper. Then I added a range of values using brush-tipped pens in shades of gray.

1 Lay In Washes

Working as quickly as I could, I transferred my sketch to my Fabriano watercolor block by eye and laid in the first washes, keeping values light in the background and painting around white areas. I used a 1-inch (25mm) flat for these largest areas.

I mostly used Transparent Yellow, Phthalo Blue and Burnt Sienna. You can mix a wonderful range of greens with just these three colors (substitute Cadmium Yellow Medium Hue if you prefer).

The waterfall itself was a riot of color. The pure white of the falling water, shaded areas that varied from pale to a medium gray-blue, earth tones where the color of the rock showed through and wonderful reflections from the sky and trees. I pushed the color, emphasizing these differences, because I wanted this area to really sparkle. At that point I ran out of time and had to settle for taking an array of resource photos. The reference photo in this demonstration is the closest to what originally inspired me, though it was taken from a slightly different angle.

2 Add Midtones

Later, back at home when I could get my photos developed, I continued painting. Here, I've added the midtones in the greens and more distant trees, just suggesting the shapes of trunks and branches in the shadow areas of the background. I used a ½-inch (13mm) flat for the broader areas and a no. 6 round for the trees and branches.

You need to use a stronger value and more detail on the trees on the left to give them their proper importance. I paid more attention to the bark patterns on the big leaning birch, letting my brush follow the rounded shape, and included more details.

The rocks are mostly Burnt Sienna and Phthalo Blue, with a little stronger mix of Transparent Yellow to suggest the moss that grew abundantly in this moist environment.

3 Highlight and Accent

After masking some of the highlights in the water with masking fluid, I laid in stronger washes below the falls and in the shadowed areas where the water was less active. This is basically a mix of the same pigments, leaning more toward the Phthalo Blue. When those first layers were dry, I carefully removed the mask and softened some of the edges with clear water.

I've begun to add small, dark accents in the rocks and some of the branches, using a small round brush and a mixture of Burnt Sienna and Ultramarine Blue, with a little Payne's Gray in the darkest areas.

Visit artistsnetwork.com/Painting-Nature-Cathy-Johnson for a FREE bonus portrait demonstration.

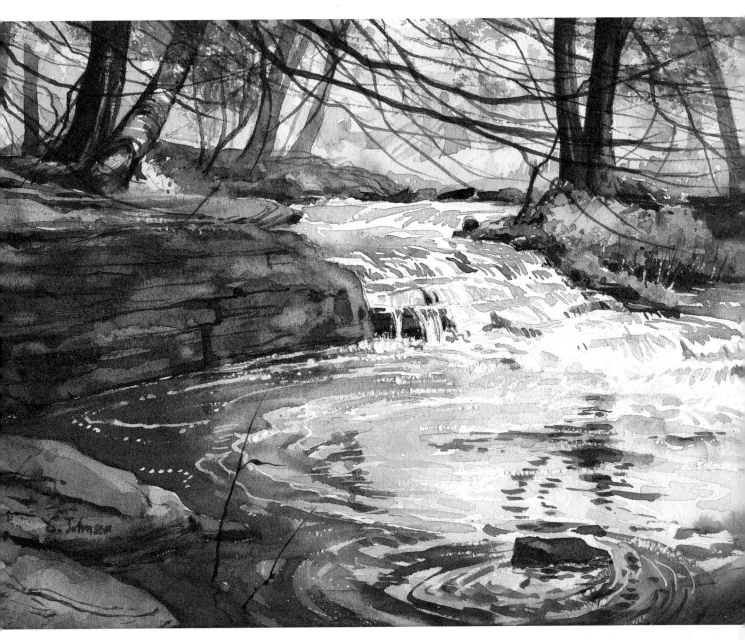

Hidden Falls, Poconos
Watercolor on Fabriano cold-pressed watercolor paper
9" × 12" (23cm × 30cm)

4 Check Shadows and Reflections

I referred to my photo resource to check shadows and reflections in the water and added them where needed. Using the deepest value I could mix, I applied the rest of the branches with the end of a sharpened stick. I painted the darker foliage at top with a natural sponge dipped into a deep green mixture comprised of Phthalo Blue and Burnt Sienna. I used a light touch so the rough, varied texture of the sponge would act as my painting tool.

Ocean Habitat—Tidal Zones and the Seashore

Sketch whatever catches your eye—seashells, coral, seabirds. These elements capture the essence of this unique habitat. They may or may not find their way into your painting, but they will enhance your understanding of the big picture.

Ocean-Side Plants

Pay attention to the unusual plants that are unique to this habitat. A quick sketch will suffice.

Sketching on the Spot

These waves were at California's Ocean Beach. I did the quick ink drawing in my journal by observing the repeated patterns of the waves rather than trying to do a portrait of a specific set of breakers as you might when working from a photograph. I added the color later, from memory.

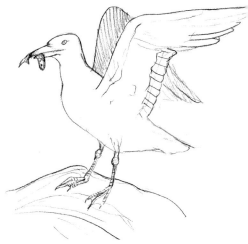

Ubiquitous Flyers

Near the ocean, gulls of one sort or another are everywhere. (They also congregate on inland waters. I see them on the lake near my home in the Midwest.)

Watercolor Pencil Benefits

Watercolor pencils are great for working on the spot—very portable, non-messy and no worries about getting sand in your palette! Just draw the basic subject and wet carefully with clear water, on the spot or later when it's more convenient. I love the subtlety of a limited palette and a variety of shapes. Here I used Cobalt Blue, Ultramarine Blue, Yellow Ochre and Burnt Sienna.

Tidepool
Watercolor pencil on
hot-pressed watercolor paper
3" × 4" (8cm × 10cm)

Visit artistsnetwork.com/Painting-Nature-Cathy-Johnson for a FREE bonus portrait demonstration.

Painting the Sea

You could spend a lifetime painting the ocean and never capture all of its moods. Even if you never left the place where you began, the sunrises, sunsets, storms, crashing gales, gentle overcast days, high tide, low tide, grand vistas and intimate close-ups would provide you with more painting opportunities than you would ever be able to explore.

Even if you are painting a stormy sea and want to give the impression of the danger involved with towering waves and madly foaming whitecaps, the horizon line is almost always level. Winslow Homer's *The Life Line* demonstrates this well. Even though the foreground waves are extremely tilted to suggest great peril during a sea rescue, the small vignette of distant horizon that shows between the two huge waves is still quite level. In some rare cases, the entire horizon might be tipped either slightly or at an extreme angle, but that is almost always intended to suggest instability or imminent disaster.

Calm, Distant Sea

Here, I used long horizontal strokes to suggest the calm, distant sea. I used three colors, a cool blue pencil and two cool greens. I've wet them on the right side of the sample to show how the colors blend.

Gentle Waves

Here, the waves are gentle, without white breakers. To achieve this look, I simply drew peaks of color with my blues and greens and blended judiciously. At left, the pencil marks still are untouched by water, showing the loose strokes.

Rolling Surf

Here, I wanted to show the rolling surf, the white breakers curling and foaming as they rolled into shore. I used the same two greens with Prussian Blue, paying attention to the way the leading edges of the foam follow the rules of perspective, becoming higher and somewhat simpler as they receded from the viewer. I used the blue only in the breakers themselves and left most of that area as white paper, blending, again, on the right side. Where the spray rose skyward, I washed back the pigment while it was still wet using a bristle brush and clear water, blotting often to remove loosened pigment.

Sea-Foam

The waves have spent themselves on the sandy shore in pale blue-green sea-foam. I used squiggly lines and some smooth areas of color, remembering to let my lines continue to follow the perspective up the coastline a bit in the finished painting. Again I left some white paper to suggest this foaminess.

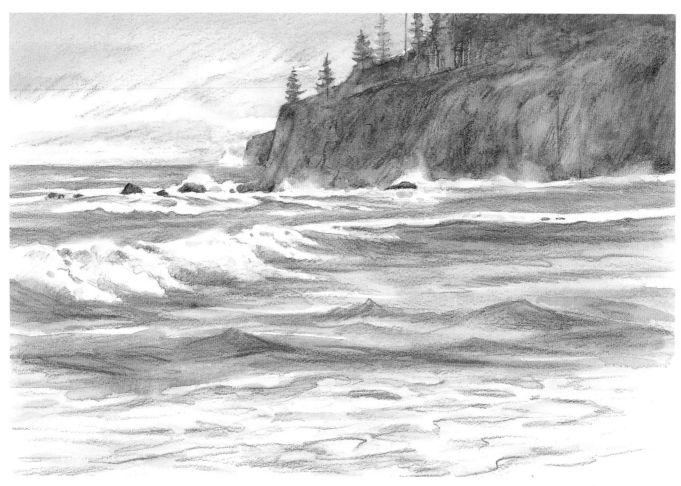

Coastal Scene

In the finished painting, I kept the sky fairly simple, leaving some white paper to suggest low clouds and blending to keep this area soft. I made sure to leave white paper to suggest the distant waves crashing against the headlands. Off the near cliff, I drew in dark rocks in the surf itself and blended them with clear water, keeping the bottom side more level than the jutting tops of the rocks. Here and there I lifted color from the cliffs with a bristle brush and clear water to suggest the waves crashing against them.

Oregon Surf
Watercolor pencil on Arches
hot-pressed watercolor paper
7" × 10" (18cm × 25cm)

Visit artistsnetwork.com/Painting-Nature-Cathy-Johnson for a FREE bonus portrait demonstration.

Strokework for Gentle Waves

This example shows the basic pencil strokes needed to suggest these gentler waves. The colors used are tropical: a turquoise blue, a sea green and a few sandy browns and tans. For the standing wave, I kept my strokes vertical or diagonal—some of that, to good advantage, will show through when wet. Because the sand shows through the sea-foam, I layered a warm tan and the turquoise blue close to the wave and drew in the front edge of the advancing foam with a lacy line.

Blending for Foamy Look

This is what happened when those lacy lines were wet and somewhat blended with clear water. I did use a very light touch in places, though, because I wanted the lines to show through, rather than loosening all the pigment from the paper—that's what gives this area the broken, foamy look.

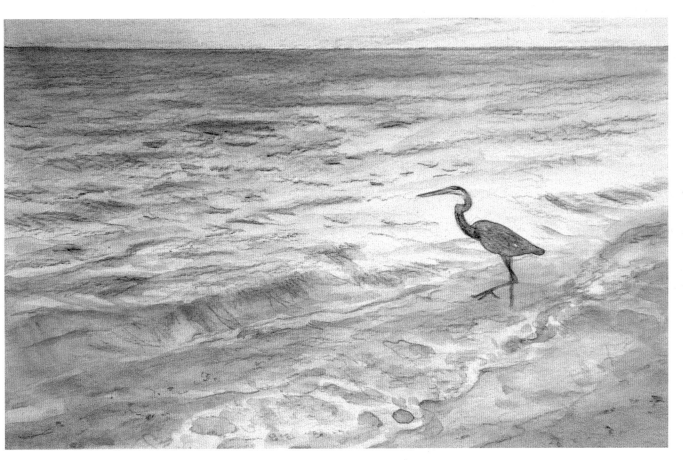

View From Shore

On the finished piece, I handled the near waves and the advancing foam by adding just a bit more detail to suggest wrack on the sand and bubbles in the foam. The distant horizon is very high in the picture plane and unbroken by landfall. Out to sea the water is darker on this brightly overcast day, and in the distance the waves are almost unnoticeable. Closer in, they follow the rules of perspective, more detailed in the foreground and less so as they recede into the distance on the right.

Florida Heron
Watercolor pencil on
Arches hot-press water-
color paper
7" × 10" (18cm × 25cm)

Painting the Light of Sunrise and Sunset

Capturing a glowing sunrise or sunset can be very tricky. It's easy to go too garish if you are not careful. Keep the cool colors predominant, and reserve the warm reds, oranges and yellows for a small but intense impact. Often the temptation when painting a sunrise or sunset is to use too much contrast. Look instead for the subtleties of shade, and enjoy the controlled layering possible with watercolor pencils.

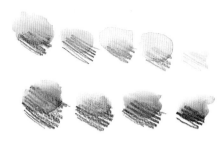

Sunrise and Sunset Palette
Although the colors used for painting sunrises and sunsets are fairly bright, try to keep everything on the subtle side on the painting itself.

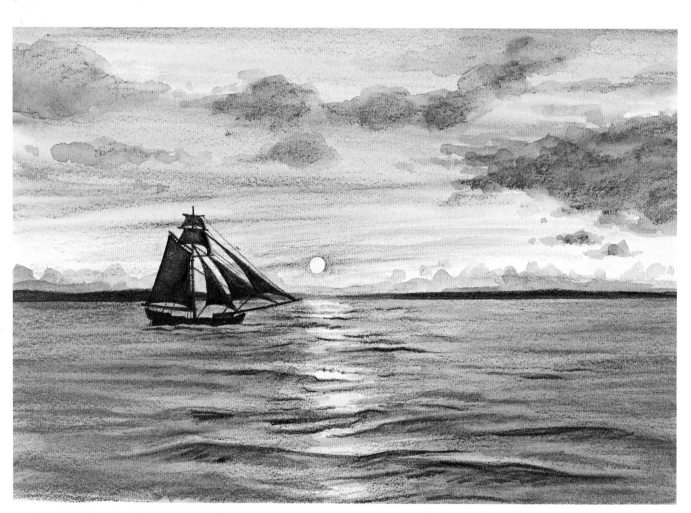

Using Sunrise and Sunset Palette
For this seascape, I used Cobalt Blue, Glue Grey, Gunmetal and Indigo for most of the painting. For the clouds and water, I applied my colors in several steps, allowing each to dry in between. Adding the darker values to the clouds at right really seemed to give them dimension and pull them forward in the picture plane. Note the variety of cloud shapes. The softer, puffier ones look closer than the long striations near the sun, but another, simpler line of soft clouds hugs the distant horizon. Where they are closest to the sun, they are warmed by its light.

The Black Rose at Sunrise
Watercolor pencil on Arches
hot-pressed watercolor paper
7" x 10" (18cm × 25cm)

Visit artistsnetwork.com/Painting-Nature-Cathy-Johnson for a FREE bonus portrait demonstration.

Cliff House

Sometimes a painting grows out of sketches and photos—we may wait days, months, even years to recreate the magic. Here, I'd been fortunate enough and had time to do a fairly detailed sketch, then took a resource photo or two before having to leave.

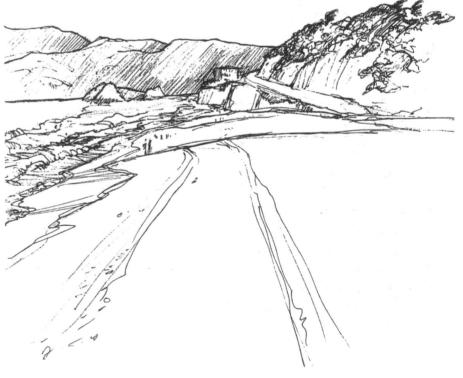

MATERIALS

SURFACE
Strathmore cold-pressed watercolor paper

WATERCOLORS
Burnt Sienna, Cobalt Blue, Phthalo Blue, Raw Sienna, Ultramarine Blue, Yellow Ochre

BRUSHES
1-inch (25mm) and ½-inch (13mm) flats
nos. 6 and 8 round
stencil brush
small, inexpensive brush for masking

OTHER MATERIALS
HB pencil, fine-point pen, masking fluid

Reference Photo

When I finished, I snapped a quick photo for later reference. It is from a slightly different angle, but it has most of the basic information. (As you can see, photos seldom offer as much specific or focused detail as you can capture in a sketch.)

I loved the beach near San Francisco and have done several paintings from my sketches, studies and photo references. My sketch of Cliff House is one of my favorites, so I decided to paint it (with the help of the photo I'd snapped that day).

Sketch Quickly

Sketching on the spot allows you to capture the scene in very simple, clean, graphic ways. Concentrate on what interests you most, and then, if there is time, continue to work.

Quick, tight squiggles suggest the rough trees on the hill overlooking Cliff House. I used dancing motions with my pen point to capture the effect of the incoming waves. I had more time to work than I expected, so I was able to add more to the foreground area.

This sketch was done with a fine-point pen. To simplify the scene further, I edited out most of my fellow beach bums.

1 From Sketch to Painting

Plan your composition based closely on your sketch and lay in the main shapes with an HB pencil. Use masking fluid to protect the whites of the waves and buildings, but be sure to wet your brush before dipping it into the masking fluid and wash it immediately afterward, or the masking fluid can ruin it.

When the masking fluid is thoroughly dry, add your first washes. Here, the colors are mostly Cobalt Blue, Burnt Sienna, Raw Sienna and a touch of Phthalo Blue. Keep the latter very diluted or it will take over. It is a strong staining color.

To provide further definition, add a bit of Yellow Ochre to the far hills while the blue is still wet.

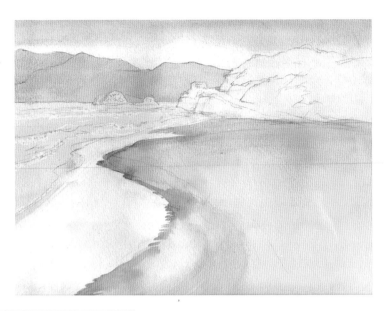

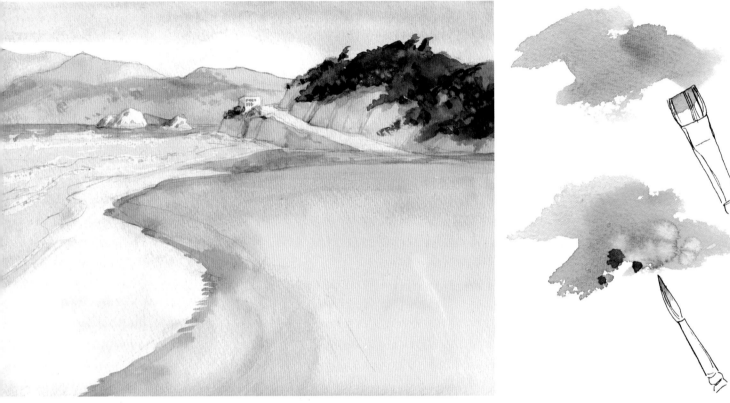

2 Lay In Secondary Washes, Deepen Colors and Add Trees

Lay in secondary washes in the buildings and rocks out in the bay, using a midtone of Ultramarine Blue and Burnt Sienna. The cliffs are warmer, with more Burnt Sienna and Yellow Ochre in the mix. For the road, leave the white paper exposed.

The distant ocean gets a darker wash of Phthalo Blue. Use a hint of green (made with Phthalo Blue and Burnt Sienna) to suggest the trees in the far hills.

Variegated Wash in Action

A strong mix of Phthalo Blue, Cobalt Blue, Burnt Sienna and Raw Sienna form the basis for the near trees, above Cliff House. This is a variegated wash done with a ½-inch (13mm) flat, with colors allowed to mix on the paper as well as the palette. Just as the wash begins to lose its shine, drop in clear water with a small, round brush to make lighter-colored treetops.

Visit artistsnetwork.com/Painting-Nature-Cathy-Johnson for a FREE bonus portrait demonstration.

3 Remove Liquid Mask and Add Final Details

Remove the liquid mask and develop the wave with stronger mixes of Phthalo Blue and Cobalt Blue. Add some spatter to the beach to suggest sand. Add definition with shadows and a bit of detail.

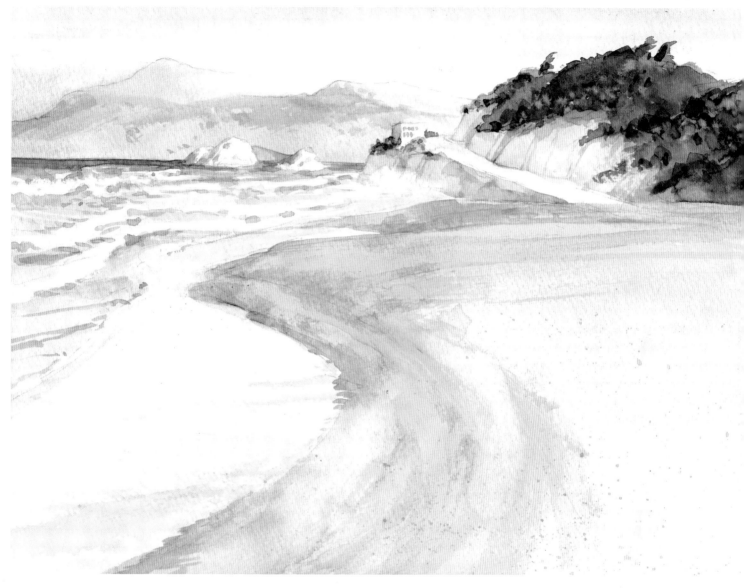

Cliff House
Watercolor on Strathmore
cold-pressed watercolor paper
9" × 12" (23cm × 30cm)

Lift Pigments to Create Misty Clouds

You can get the effect of clouds obscuring the distant hills by lifting the pigment with a bristle or stencil brush and clear water. Blot away the excess. Here, a somewhat stronger wash of green (made from Phthalo Blue and Burnt Sienna) makes it clear how drybrushing can suggest the distant tree-covered hills.

Natural History Sketches—Plants and Wildlife

Zero in on the details that define a particular habitat. Field sketches, nature journals, botanical paintings and even wildlife art focus more on the particular than the general. The larger landscape or seascape may or may not play a part in the finished work, in these cases.

Your field sketches can be little more than quick gesture sketches. Lay in a bit of color or not, as you choose. You may prefer to settle in and do a complete painting of the plants or flowers in the vicinity on a white background. You'll develop a unique relationship with each place.

Take Your Time

Perhaps you've never noticed the flowers on a weeping willow. When you slow down and pay attention, you discover all kinds of small, perfect details.

Touch-Me-Not!

Jewelweed pods are fun. When they are fully ripe, they literally explode when you touch them, throwing their seeds in all directions to assure the widest possible distribution. No wonder this plant's other common name is touch-me-not. A quick, simple sketch like this one, in ink and watercolor, helps capture the sense of motion.

Explore

In moist areas, you often see a variety of wildflowers and plants you don't normally find elsewhere. There may be rich strands of horsetail or equisetum or a bank of colorful jewelweed (illustrated above). Take the time to paint and explore the unique properties of these plants.

Be Flexible

Don't let a great subject get away because you don't have "the proper tools." You can always refine your sketches later. Or, with the help of field guides or photos, you can develop them into more finished works with correct markings and details.

This frog was a lightning-quick sketch in black, wax-based colored pencil, with watercolor washes added later. The turtle at top is a simple ink sketch, and the snapping turtle in the middle is a very quick pencil sketch.

Visit artistsnetwork.com/Painting-Nature-Cathy-Johnson for a FREE bonus portrait demonstration.

On the Move

Birds tend to move frequently, so a pencil sketch may be all you have time for. Remember their markings and add them later, or look them up in a book. Don't feel as though you have to do an illustration worthy of a field guide—you don't have to paint every feather. Getting their essence down with energy and life is at least as important, if not more so.

I used colored pencils on this red-winged blackbird as well as on the duck. I added water-color later to suggest their markings.

Flat Fish

A simple rule of thumb when sketching or painting fish is that they are usually rather flat. That is, they are longer and deeper than they are thick (think of a ribbon shape and flesh it out a bit). The backbone that runs close to the top of the fish defines the motion.

Look Closely

Fish are often very difficult to spot. Usually, you'll only see the rings in the water where they are rising to feed, or perhaps you'll spot one as it leaps out of the water. If they are feeding or spawning near the shore where the water is clear, you may get a better look.

Painting Feathers

The process of painting a feather can be broken down into simple steps that can result in a very beautiful study of one of nature's details. You can paint a single feather as a finished piece or paint a detailed portrait of a bird up close. And, like painting fur, the amount of detail you include depends on the distance of your subject and the type of plumage. In some instances, a great deal of detail may be necessary—think of the mottled markings of an owl or a partridge—and in others the shape or color of the bird itself is much more distinctive than its markings, such as the beautifully colored but simply marked indigo bunting.

MATERIALS

SURFACE
Arches hot-pressed watercolor paper

WATERCOLOR PENCILS
black, blue, gray, greenish blue and reddish brown hues of your choice

BRUSHES
small round

1 Draw In Basic Shapes

To achieve the look of this blue jay feather (which symbolizes friendship), first draw in the basic feather shape on hot-press watercolor paper with a soft gray pencil, and add the first layer of blue as smoothly as possible. Use a bit more gray on the right side as feathers usually are a touch more colorful and have more emphatic patterns on one side than the other.

2 Blend and Add Colors

Carefully wet this layer, following the direction of the feather, and use a very light application of an intense, slightly greenish blue to give a bit of definition to the white tip. Let everything dry, and begin to add the black bars using delicate, light, broken strokes and still following the natural growth of the feather.

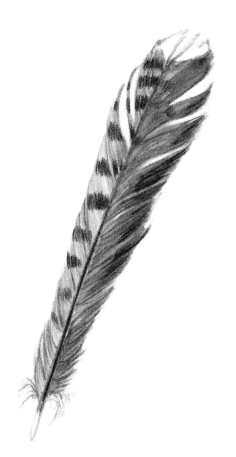

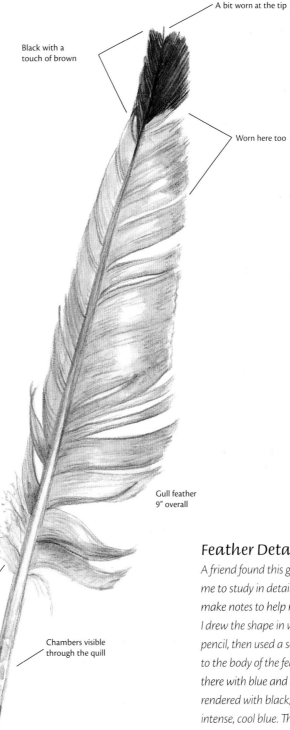

Black with a
touch of brown

A bit worn at the tip

Worn here too

Gull feather
9" overall

Downy

Chambers visible
through the quill

3 Add Final Details

Add a bit more dark to the right side of the feather and finish the dark bars, carefully observing their shape and value. Notice that at the top of the feather, the bars continue across the quill (which they do not do farther down) and that those bars at the bottom become much lighter in value. Use a light stroking motion with a small, barely damp brush for greatest control here.

Feather Details

A friend found this gull feather, which allowed me to study in detail a feather's construction and make notes to help remember the specific points. I drew the shape in with a light blue watercolor pencil, then used a soft gray to give local color to the body of the feather, shading here and there with blue and lavender. The black tip was rendered with black, a reddish brown and an intense, cool blue. Then the whole feather was blended with water and a soft brush.

Painting Flocks of Birds

Unless you are patient enough to paint each bird separately, you will want to find ways to easily suggest birds in such numbers as you find at migration times. I had always wanted to capture something of the spectacle of the thousands of migrating snow geese at Missouri's Squaw Creek and worked from a combination of several photographs and sketches to create the idea of the kinds of numbers sometimes seen there.

Look for the simplified shapes of the rafts of birds on the water that may be made up of several hundred geese. Note the shape and direction of the Vs of flying geese that fill the sky. A few birds close up can help identify the species, but even these can be relatively simple. Color and shape tell the tale.

MATERIALS

SURFACE
Strathmore cold-pressed watercolor paper

WATERCOLOR PENCILS
black, blue, brown, gray and purple hues of your choice

WATERCOLOR CRAYONS
blue hues of your choice

BRUSHES
small round
wide flat

OTHER SUPPLIES
masking fluid

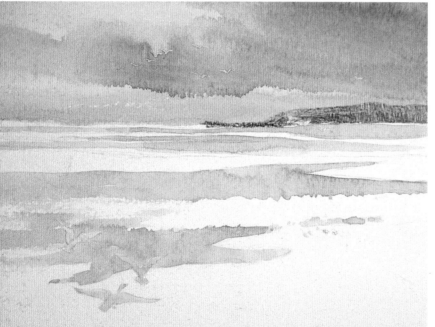

1 Establish Basic Shapes and Colors

Use liquid mask to protect the shapes of the birds in flight and the larger foreground geese. Just paint around the raft of birds on the water. Because you can't see individual geese, simply draw around them as though they are another landmass. When the mask is dry, lay in the sky in successive washes to capture the effect of wintry clouds with a glow in the west, using Lyra Aquacolor crayons to avoid lifting the small spots of mask. Paint the water using rich blues as if they are pans of pigment, having carefully drawn the shapes of these shallow pools that attract millions of migrating geese each year.

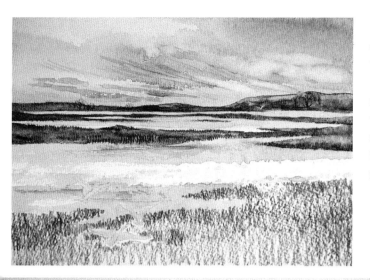

2 Add More Color

Begin to add the landmasses using a variety of watercolor pencils. Do the background hills in shades of blue, purple and several browns, using mostly a short zigzag stroke to apply the colors. Then blend them with a small round and water. Spiky strokes help suggest the reedy plants at the water's edge. Begin to suggest a variety of floating flocks of other water-fowl in the background, drawing them in with quick dots and dashes and blending them with a damp brush. Apply a variety of colors to the plants in the foreground, then blend with a wide brush and clear water.

3 Add Final Details

When everything is dry, remove the mask from the geese landing in the foreground and use blue, gray and black pencils to define their bodies and dark-tipped wings. Continue to finish the details and make adjustments over the whole painting until satisfied with the result.

Squaw Creek Migration
Watercolor pencil on Strathmore
cold-pressed watercolor paper
9" × 12" (23cm × 30cm)

Creating a Bird's Portrait

You may wish to do an extremely detailed study of a particular bird. I have worked this way to paint great horned owls, screech owls, grouse, crows, egrets, bitterns, orioles and red-tailed hawks and have found the careful study of each very much worth my while. I learned something new each time. Watercolor pencils seem well suited to this kind of study, allowing you to use the pencil point to carefully suggest the linear quality of feathers, then blend with clear water to suggest the softness inherent in most feathers.

One of my favorite creatures is the great blue heron; I study one every chance I get, making sketches and taking roll after roll of film. I combined resources for the portrait in this demo. Most of my photos were of an immature heron my friend Pete Rucker rehabilitated when it was injured and unable to fly, but I wanted to portray an adult bird in breeding plumage instead. I used the shape and pose of my adolescent bird with other references to create this very detailed portrait.

MATERIALS

SURFACE
Arches hot-pressed watercolor paper

WATERCOLOR PENCILS
hues of your choice (see "My Palette" swatches for matching)

BRUSHES
soft round

OTHER SUPPLIES
graphite pencil

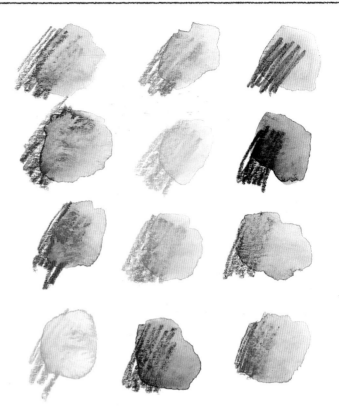

My Palette

For such an elegant and subtly colored bird, it took quite a few surprisingly bright hues to get the effect I wanted. As you might suspect, most of these colors were used sparingly and with a very light touch or layered to make interesting combinations of nearly neutral colors.

1 Draw Basic Shapes

To do a true portrait of this majestic bird, work only from the shoulders up. Draw the basic shape very lightly with a graphite pencil just to get the position and size correct. Then begin to color in the plumage; the long, impressive beak and the brilliant yellow eye that misses nothing.

Visit artistsnetwork.com/Painting-Nature-Cathy-Johnson for a FREE bonus portrait demonstration.

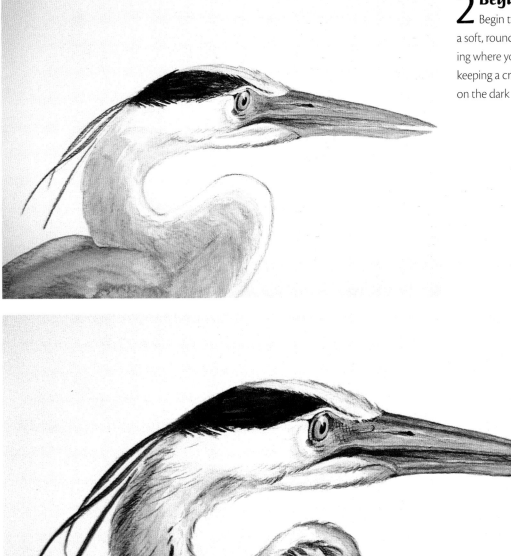

2 Begin Blending

Begin to wet these areas carefully with a soft, round brush and clear water, blending where you want a smooth transition and keeping a crisp, clean edge where needed, as on the dark crown of the heron.

3 Add Final Details

Finish with small, sharp details, blending some and leaving some pencil marks untouched, as in the scaly yellow skin around the heron's eye and some of the small feathers on the back of its long neck.

Pete's Heron
Watercolor pencil on Arches
hot-pressed watercolor paper
7" × 10" (18cm × 25cm)

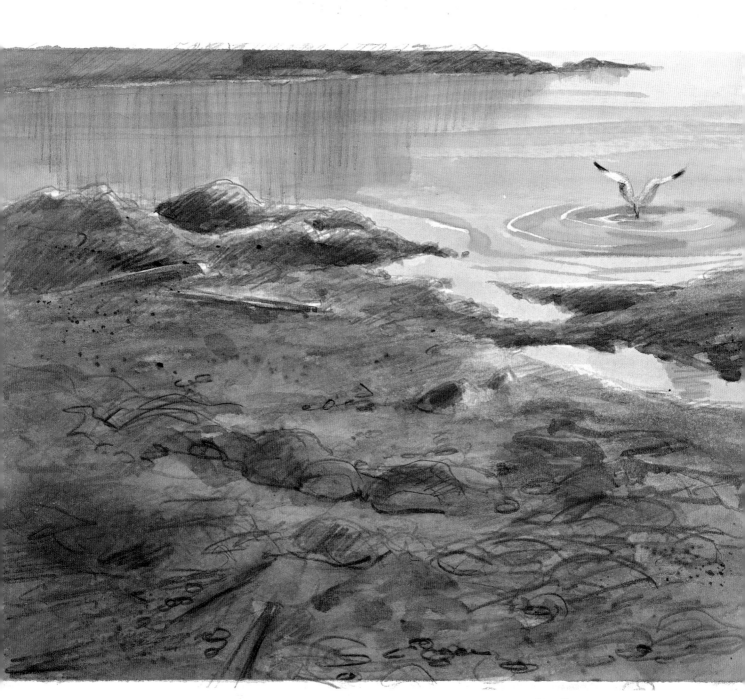

Gull Feeding
Watercolor pencil on Strathmore vellum drawing paper
7" × 10" (18cm × 25cm)

Visit artistsnetwork.com/Painting-Nature-Cathy-Johnson for a FREE bonus portrait demonstration.

Painting Different Types of Clouds

Watercolor pencils work well to capture the many types of clouds; these pencils are capable of very soft, subtle effects and also of great energy. Use them to their potential when you depict skies by utilizing color, direction of stroke and even loose, washy effects. Study the weather as it changes, and set yourself the challenge of trying to capture the various configurations of clouds you notice. You'll find that your work benefits greatly when your clouds exhibit the same kind of variety as that found in nature.

Cumulus Clouds

Cumulus clouds are generally puffy on top and less defined below. They often show reflected light on the undersides. Remember that clouds follow the rules of perspective, too, appearing smaller as they recede from the viewer. Let the sky color between the cloud shapes be darker and more intense at the top, fading to a paler shade nearer the horizon.

Cirrus Clouds

Cirrus clouds are very delicate, often quite linear and sometimes gracefully curved. They also are referred to as mare's tails. Let the direction of your preliminary pencil strokes mirror the direction you want the clouds to take. Then, when you wet them with your brush, maintain that same directional motion with light, deft touches.

Altocumulus Clouds

Altocumulus clouds are often puffy and quite uniform, looking larger as they get higher and smaller as they recede. I used a strong Cobalt Blue to capture the sky, applying the pigment with a more forceful touch at the top of the sky and a lighter touch lower down so that when I touched it with water it would mimic the graded color of nature's own sky.

Nimbostratus Clouds

Nimbostratus clouds are rainmakers, so here I chose Blue-Grey and applied it with firm pressure so plenty of pigment would be deposited on the paper. I mixed the pigment with a generous amount of water to suggest cloud shapes. While that was still wet, I scratched through the lower sky with the end of a pointed stick to suggest rain.

Painting Snow

When painting snow, let cool colors predominate. As with regular watercolor, let the white of the paper stand in for the majority of your snow-covered surface. But remember that the shadows aren't just blue. Don't use a single pencil to create the shadow effects or they can end up looking boring. Look for a variety of blues to capture the shadows and the subject. Note that the shadows are generally sharper close to their subjects and become lighter and more diffuse as they fall away from them. Beginning with the lightest colors, you can suggest the rounded shapes of body shadows on the surface itself and use your sharper, darker accents to depict the shadows of trees and brush.

Falling Snow

Here I laid in a neutral-colored background to suggest the snow clouds, using watercolor and a variegated mixture of Ultramarine Blue, Cobalt Blue and Burnt Sienna. I encouraged cloud shapes to develop by adding more or less water to my wash. When that was completely dry, I used white to dot the paper here and there to suggest flakes.

Blowing Snow

Blowing snow can be suggested with directional strokes blended judiciously with a damp brush. In this sample, I painted a simple house shape and a gray winter sky behind it with watercolor, then used dampened watercolor pencils and crayons with strong diagonal strokes to suggest the blowing snow.

Painting Rain

There are a number of ways to suggest rain, whether you concentrate on the storm itself, wet clouds that hang over a landscape, wonderfully subtle and gray values, lightning that accompanies a storm, the ripples on a pond, or the wet, reflective surfaces that rain creates. You may find that watercolor pencils work well for you for some effects but take concentration for others. That's normal—just practice until all of the techniques come easily.

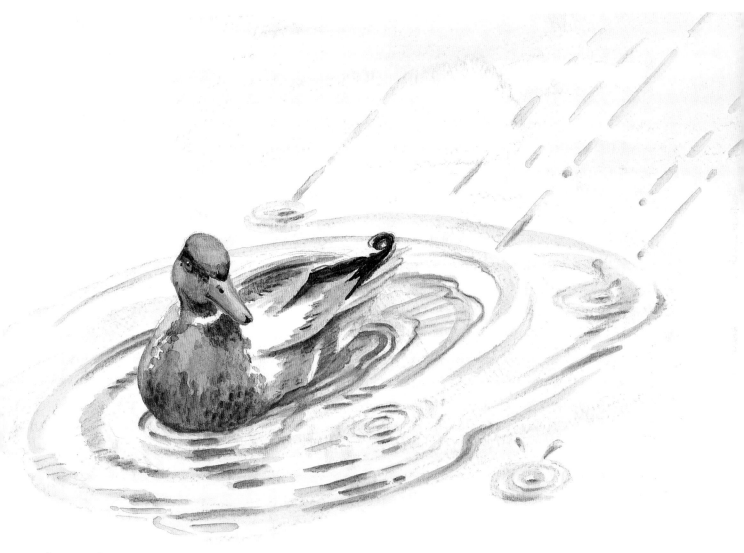

Rain Up Close
Rain striking a wet surface—a lake, a puddle or even a sidewalk—makes lovely rippled patterns. Watch for ways to suggest reflections, falling drops and splashes, but keep in mind that not all raindrops should look like a stereotypical droplet.

Painting Rain Clouds

MATERIALS

SURFACE
Strathmore cold-pressed watercolor paper

WATERCOLOR PENCILS
blue, brown and green hues of your choice

BRUSHES
bristle brush

OTHER SUPPLIES
tissues

1 Establish Basic Shapes
To get the clouds over this red rock formation to remain soft, lay in your colors sketchily all around that area but leave some clean white paper. Allow your pencil strokes to follow the direction of the rock formation, the softly rounded foreground hills and the clouds overhead.

2 Blend and Soften
Soften the pigment with clean water, blending more in some areas than others and blotting up loosened pigment with a clean tissue where the clouds are. Where you need a still more softened or blurred edge, such as where the clouds obscure the mountains, use a bristle brush to loosen pigment, again picking it up with a tissue. On the rocks themselves, use a fairly light touch when blending to maintain the sense of the folds and fissures in the weathered formation.

Visit artistsnetwork.com/Painting-Nature-Cathy-Johnson for a FREE bonus portrait demonstration.

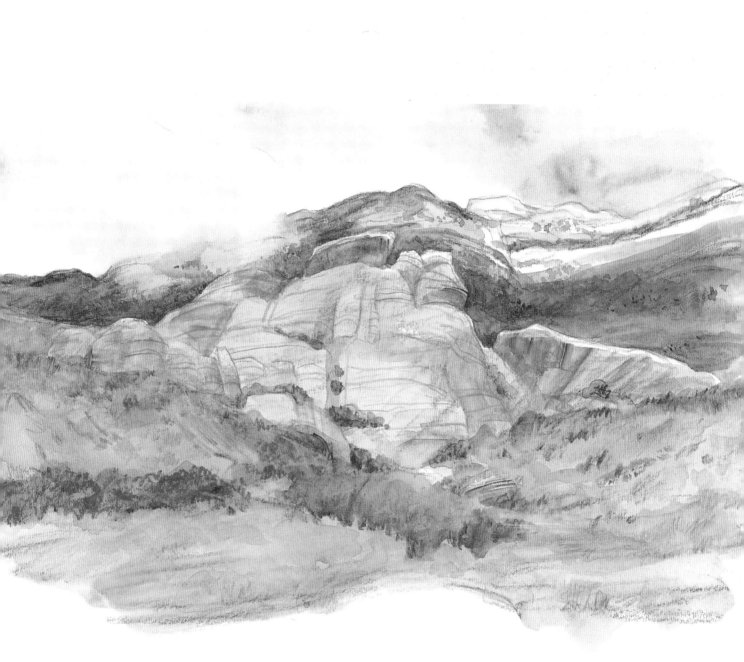

3 Add Final Details

Finally, use additional layers of ultramarine blue in the far mountains to push them back, warm browns in the red rock and a combination of sage and juniper greens for the desert brushes and weeds. Wet those areas carefully, wedding them to the previous layers and making final adjustments here and there. Retain the vignetted effect of the foreground; it draws the viewer into the picture.

Storm Clouds Over Red Rock
Watercolor pencil on Strathmore
cold-pressed watercolor paper
9" × 12" (23cm × 30cm)

CHAPTER SIX
PRAIRIES, MEADOWS AND FIELDS

The prairie is full of life. Hundreds of plant varieties, insects, reptiles, birds and mammals, large and small, offer painting subjects for a lifetime of study. The ever-changing sky, arching from horizon to horizon, and the shifting colors of the land delight the painter's eye.

Tallgrass prairie is an ecosystem unto itself. The mixed grasses can be quite tall and blow in the wind like waves on the ocean. At one time, eastern settlers thought of this vast, open landscape as the great American desert. It is anything but. It is lush and varied and endlessly fascinating.

If you think the classical tallgrass prairie is the only type of prairie there is, think again. In fact, there are four distinct types of grasslands in the United States alone: tallgrass, midgrass and short-grass prairies and the California grasslands. A smaller, similar natural grassland can be found in Washington state. The grasslands extend up into much of Canada and mirror grasslands in other countries, from the South American pampas to the steppes of the Ukraine, Russia and Mongolia to the African veld.

Decide on Format and Focus
Choose your format as well as your focus. You may prefer to direct attention toward that big sky (top sketch), the sea of grass to catch that sense of space and rhythm (middle) or go for the wide-angle effect (bottom). Try out a variety of color schemes and moods, but keep it simple for now. These quick thumbnail sketches were done with a dark gray colored pencil and watercolor washes. The rectangular sketches are no bigger than 2½" × 3½" (6cm × 9cm), a generous size for thumbnail sketches.

Study the Grasses
Try zeroing in on the grasses, either as quick sketches of the silhouettes against the sky or as a more focused and detailed painting. Here, a crisp pencil drawing gives a framework for quick watercolor washes.

Visit artistsnetwork.com/Painting-Nature-Cathy-Johnson for a FREE bonus portrait demonstration.

Trees That Follow the Watershed

In these wide-open spaces, you may notice a line of trees snaking off in the distance. Often, these trees mark a river or stream or even a seasonal watershed that's dry much of the year. Trees sink their roots deep in these low places, seeking moisture where they can. Including them in your landscapes makes for an interesting design element and breaks up an expanse that might otherwise lack definition.

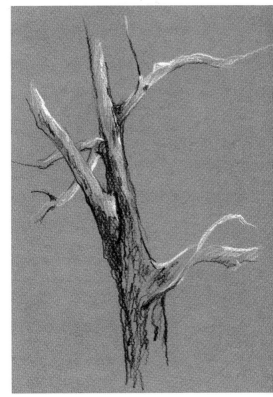

Sycamore Study in Black and White

I used a soft graphite pencil for this simple landscape, using a rolled-paper "stump" to smudge it for subtle values. To suggest the sycamore trees in the gully, I impressed the blunt tip of a nail file into the paper and then ran the pencil point lightly over the paper, leaving the trunks and limbs lighter in value.

Sycamore Sketch

Sycamores are beautiful trees. They have tight, scaly brownish bark below, but they shed that bark on the upper limbs to expose pale, smooth, greenish white. It's fun to sketch them with black and white colored pencils on a toned ground, either in preparation for a more finished painting or as a finished drawing.

Simple Palette

In this little watercolor, painted on the spot on a lovely rainy day, you can see the line of trees that mark the watershed, bisecting the distant field. I used only primary colors for this one— a warm and a cool red, blue and yellow. As you saw in chapter two, you can make almost any color you wish with this simple palette.

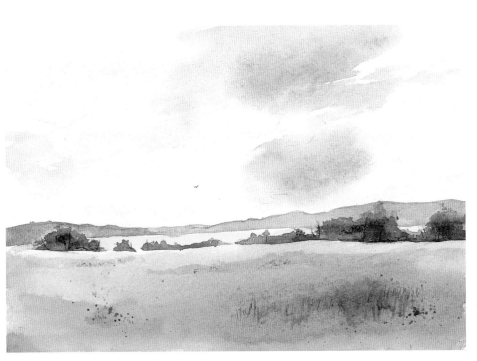

Primary Prairie
Watercolor on Fabriano
cold-pressed watercolor paper
9" × 12" (23cm × 30cm)

Wildflowers

Prairies, meadows and the edges of fields are often full of wildflowers, changing their bright dresses from season to season. You may find yellow wild mustard in the spring; a variety of golden sunflowers, sky-blue chicory, reddish orange Indian paintbrush and creamy-white Queen Anne's lace in midsummer; perhaps clary sage and coneflowers later in the year. Take time to wander a bit, and make field sketches of the flowers you find, as well as any notes that you might find helpful.

Try to discover wildflowers that are characteristic of your location—typically prairie or old-field flowers. Some flowers produce fruit later in the season. Follow the progression from the first blooms to the rich, ripe fruit to get a feel for the place.

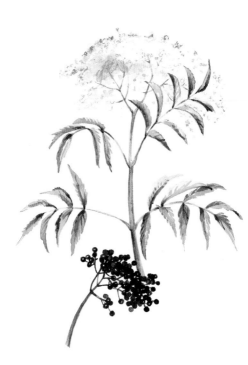

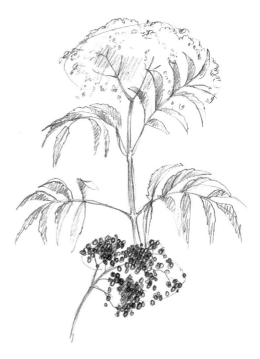

Leave Room to Grow

Reserve a page in your sketchbook to allow space to record changes as the plant matures. Leave room for berries or leaves or any other details you may want to add as the season progresses.

Notice the shape of the flower or, in the case of the elderberry blossoms shown here, of the whole flower head, called an umbel. Use a pencil guideline to capture the overall shape, as I did with the loose oval line you see here. Later, when the plant matures, add the fruit.

White-on-White

Painting a white flower against a white background can be tricky—you'll probably want to suggest some background color or push the color a bit to make it pop.

Vary the rich dark hues in the berries for interest and authenticity, and be sure to leave some untouched white paper to suggest the shine.

Use Reference Photos

Reference photos can be a great help when you don't have time to really stop and paint, particularly if you have a macro lens or macro setting on your camera. It would be difficult to paint all the details you see here (the hairy backs of the chicory petals weren't even visible with the naked eye), but the photo captures shape and color very well.

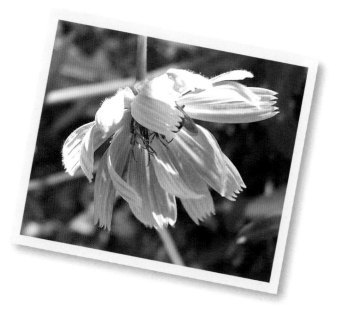

Visit artistsnetwork.com/Painting-Nature-Cathy-Johnson for a FREE bonus portrait demonstration.

Growth Patterns

Pay attention to the growth habits of the plant you want to paint. Chicory has secondary stems that alternate along the main stem, each terminating in bud, flowers and spent flowers.

The Full Picture

An interesting approach from the botanical standpoint is to include the whole plant, from root to flower. Chicory is common enough that this isn't a problem, but be sure you're not uprooting an endangered plant species! A mixture of Cobalt Blue with the barest touch of Phthalo Blue seems to capture that amazing azure.

If the plant is too tall to include on the page, you can always paint two separate parts, as I did here. The slightly creamy color of the paper gives a pleasing antique look.

Include Details and Irregularities

When you're ready to do your finished piece, pay attention to the shape and position of the petals and how they overlap or curl. This will make a much more realistic flower than one that looks too uniform. A few tiny lines will suggest the hairy stems.

Colors used here were Burnt Sienna, Cadmium Red Medium Hue, Cadmium Yellow Medium Hue and Phthalo Blue. A springy no. 7 round lets you paint a leaf or petal almost with a single stroke, and backruns suggest volume.

Painting Flowers in the Distance

MATERIALS

SURFACE
Arches hot-pressed watercolor paper

WATERCOLOR PENCILS
black, blue, pink, red and yellow hues of your choice

BRUSHES
small flat

1 Lay Down Preliminary Colors

Lay in your preliminary colors without sketching the landscape. Add the tall ironweed flower in the foreground to complement the distant flowers and to make a focal point; let it take center stage by placing it just inside the dark area created by the shadows of the trees. Use loose, scribbly applications of color, letting the blues fill in areas needed for sky and for the underwash of green foliage. Be careful to leave a white edge above the ironweed for maximum contrast on the sunstruck flower. The blue in the background is a combination of two cool blue pencils—one a bit lighter than the other. The darker blue will be the undercolor for the foliage while the lighter one will be for the sky.

2 Blend Colors

Blend the colors with clear water and a flat brush—it's necessary to scrub a bit to loosen and lift the dry pigment, but don't worry about making smooth washes since the trees and the prairie in the foreground will get multiple layers of color and detail. Allow this layer to dry thoroughly before moving to the next stage.

3 Add Secondary Washes

Now begin to add secondary washes, layering warm yellow pencil over the blue except where you want to keep the blue of the sky. This makes a nice varied green you can maintain in a few areas where the sun hits the closest masses of foliage.

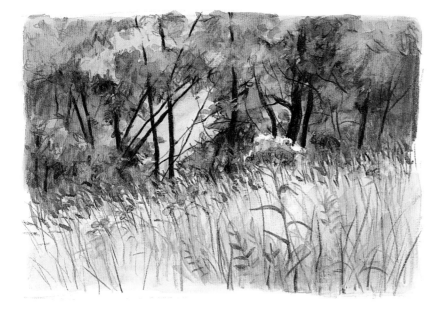

4 Add Final Details

Finally, begin adding details in earnest. Use a flat brush with a light stroke to blend lightly, allowing the rough squiggles to show through and maintain the sense of lacy foliage. Use black for the tree trunks and branches and for a few of the deepest shadows; it sometimes is difficult in this medium to get a dark enough value without black.

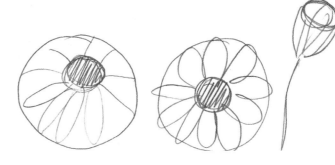

Pay Attention to Shape and Perspective

Notice the apparent shape of the flower head in relation to your eye. It follows the rules of perspective on a small scale. Notice, too, that the pistils and stamens make a kind of open cone shape in the center.

More on Shape and Perspective

You can use geometric shapes to help you correctly draw the shape of your flower. These sunflowers will fit, roughly, in circles and cones, as many wildflowers will. Pay attention to perspective, even on this small scale (as with the chicory seen here). You'll notice that the center of the flower appears higher on the circle. The bud fits roughly in a cone or cup shape, with the dark brown center nestled in the middle.

Mammals of the Grasslands

Most mammals are shy of humans. If you get the chance to sketch a groundhog, prairie dog, rabbit or deer "up close and personal," take advantage of it. Be ready, use whatever's at hand, even if it's not the art supplies you would have preferred, and draw as quickly as possible.

Putting grassland animals into a landscape is more challenging than sketching them by themselves. You may choose to depict them in the distance or as the main subject of your painting, as I did in the bison demonstration. I had the wonderful opportunity to get close enough to an American bison to touch its nose (from the other side of a very stout fence, of course!).

Do What Time Allows

I pulled into the parking lot at Watkins Mill, near the restored nineteenth-century church and the big field nearby, and there, not ten feet from my Jeep, was a cottontail rabbit. I didn't want to lose the moment or startle the little creature with too much scrabbling about through my field kit looking for the "perfect" art supplies. I had only an indigo colored pencil and a few sheets of tinted watercolor paper in a 5" × 7" (13cm × 18cm) pad, so that's what I used.

I had no idea how long the rabbit would stay put, so I did a very quick gesture sketch, then a sketch with simplified shapes for the body parts. I was quiet and nonthreatening, so after the first anxious awareness, the rabbit seemed to accept my presence. It took a quick look at me, then went back to what it was doing. I even had long enough to do a simple wash sketch, capturing the coloring.

Later, using other sketches and resources, I added an ink drawing of a younger rabbit to the page. The point of creating various resources such as these is to provide us with enough information to do a more complete work, such as the little watercolor of the bunny.

Visit artistsnetwork.com/Painting-Nature-Cathy-Johnson for a FREE bonus portrait demonstration.

Groundhogs

Whether you're on the prairie or at the edge of a farm field, you're likely to see groundhogs or their relatives, the prairie dogs. They have very similar body shapes, and both stand firmly planted on their hind feet and fat little bottoms to survey their domain. If you live in close proximity to them, you may see them lounging, grooming or teaching their young. Draw them quickly.

This groundhog or "whistle pig" was at the edge of my yard, looking all around for any sign of danger. A day or two later, when he was sure I meant him no harm, I found him snoozing in my old metal garden chair on the back deck!

I've drawn groundhogs many times before, so practice had allowed me to capture his pose quickly in ink. Later, I added fresh, quick watercolor washes.

Bison

Draw as many sketches as you have time for, from as many angles as you can manage. If it's safe to do so, approach your subject to get more details. If you can't, use binoculars. Use gesture sketches, block in the forms and suggest form and value. You may even want to do some quick color sketches.

Bison

These animals are not tame pets; they can be quite dangerous, so work at a distance or with a strong fence between you. They once covered the prairies in the thousands. If you're fortunate, you may get to see them on some patch of prairie that's managed to escape the plow.

MATERIALS

SURFACE
Strathmore cold-pressed watercolor block

WATERCOLORS
Burnt Sienna, Cadmium Red Medium Hue, Cobalt Blue, Payne's Gray, Ultramarine Blue, Yellow Ochre

BRUSHES
1-inch (25mm) flat
nos. 3, 5 and 7 rounds
small bristle brush
aquarelle brush

OTHER SUPPLIES
mechanical pencil

Reference Photo
If you have the chance, take plenty of reference photos. This close-up was very helpful when I translated my sketches to the watercolor paper.

Experiment With Palettes and Brushes
A limited palette can be very effective when painting wildlife. Here, I made swatches of Burnt Sienna, Cadmium Red Medium Hue, Payne's Gray, Ultramarine Blue and Yellow Ochre to help me plan where I wanted to go. Burnt Sienna and Ultramarine Blue make a lovely variety of neutral grays, and Yellow Ochre and Payne's Gray (or black) make a rich, subtle olive green. Play around with your brushes to see which might work best to suggest the various textures.

1 Apply Underpainting

I knew that Yellow Ochre used as an underpainting would give my big mammals a warm glow, so I just painted right over where I had sketched them in, using mostly Yellow Ochre with a little Burnt Sienna and Cobalt Blue and a 1-inch (25mm) flat. I lifted a bit of the wet color with a clean, damp brush where the light would strike the big cow in the foreground, in case I wanted to go with a lighter value there.

I allowed a little wet-into-wet work with Burnt Sienna and Ultramarine Blue dry till it was just damp. Then I scraped through it with the end of an aquarelle brush to push the pigment out of the way, suggesting the rough grasses around and under the closer animal.

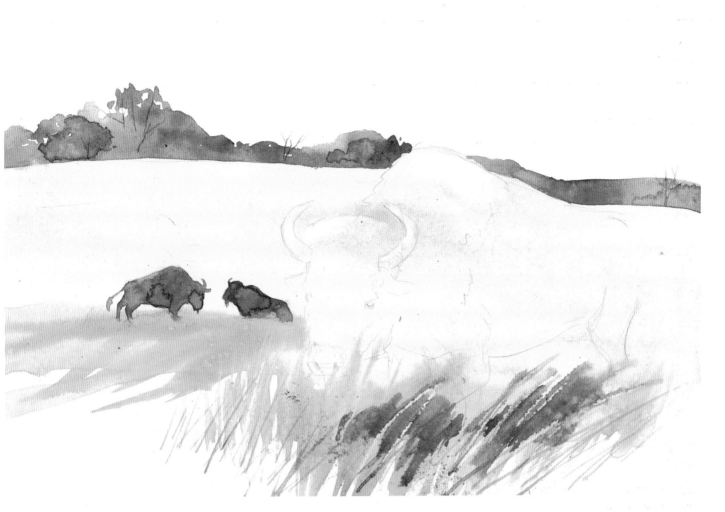

2 Begin to Suggest Foliage, Trees and Hills

Yellow Ochre and Payne's Gray made the soft, subtle green of the distant trees, painted with a no. 7 round. I let the tip dance playfully to suggest loose foliage. Burnt Sienna dropped here and there into the still-wet wash formed hard edges that look as though a few of the distant trees are beginning to change color.

A bit of Ultramarine Blue mixed with Yellow Ochre suggested the blue hills in the distance. I painted the hills while the trees were still wet so the two areas would blend. Then, I painted in the distant bison, relying heavily on my on-the-spot sketches.

Detail

This detail shot shows the lacy edges of the distant tree line. I let the tip of my brush dance to suggest foliage at the top. A little wet-into-wet touch made hard edges that read as individual trees. I drew back into the damp wash with my mechanical pencil to suggest distant tree trunks.

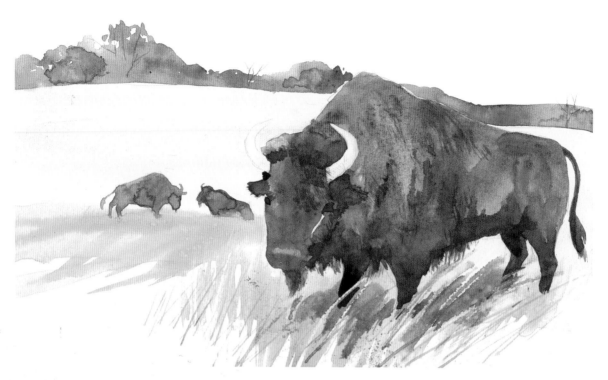

3 Paint Foreground Bison

Next, I painted in the closer animal, mostly wet-into-wet. I pushed the color a bit by adding Cadmium Red Medium Hue to the rough hair of her hump. Otherwise, I mostly used the combination of Ultramarine Blue and Burnt Sienna that I rely on heavily when painting browns and grays. I painted around the horn rather than masking it out. In small, relatively simple areas, this is not difficult to do, if you are patient. While this first strong, intense wash was still wet, I pulled out the paint with my fingertip to suggest the long hairs on the chin and chest.

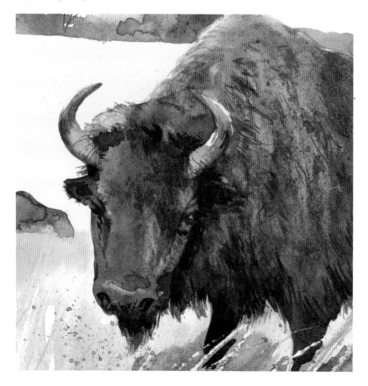

4 Refine Hair and Horns

I used a small, ragged bristle brush to begin modeling the rough hair of the bison's hump. A no. 3 round was great for painting the horns. The close-up photo reference was invaluable for capturing the subtleties of shape and texture.

Visit artistsnetwork.com/Painting-Nature-Cathy-Johnson for a FREE bonus portrait demonstration.

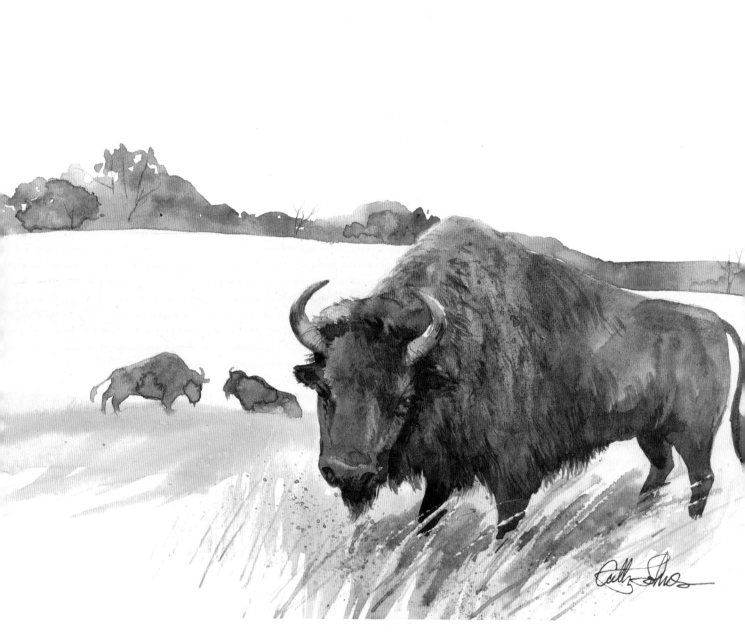

5 Final Touches

I toned down the color in the hair by continuing to add texture with a small brush. I then modeled the face and eyes a bit more until I was happy with the final effect.

Woolly Mammoth
Watercolor on Strathmore cold-pressed watercolor paper
9" × 12" (23cm × 30cm)

Birds of the Grasslands

These open areas with weedy edges are great habitats for birds, particularly if there are the remains of a crop to be gleaned. You're likely to see anything from wild turkeys, hawks and owls to quail, grouse, prairie chickens and pheasant, perhaps even a huge sandhill crane. There also are a variety of small songbirds like sparrows, meadowlarks, bluebirds and more. There's no lack of great avian painting subjects.

Move Fast!

Birds are usually rather wary of people, so you'll want to be prepared to sketch quickly. Have your tools at hand. Use gesture sketches, or block in shapes with a few quick lines. Then develop your impressions further from memory, resource photos or even a published field guide if you need help with the patterns of the feathers.

Fit the shapes into roughly geometrical forms if it helps you. Then you can continue to refine and develop the shape and details at your leisure.

Sketch With Watercolor Pencils

Watercolor pencils are great for quick sketches. Pick up the pencil that most closely approximates the colors you see and scribble in areas of color. Touch them with a damp brush to blend. You can layer colors while the pencil is still dry or add color to a damp wash. Or try letting your sketch dry thoroughly and then add another layer and wet to blend.

In this little sketch of a male prairie chicken in mating display, I made use of Faber-Castell's Albrecht Dürer watercolor pencils in Burnt Ochre, Dark Chrome Yellow, Pale Geranium Lake, Sanguine, Ultramarine and Van Dyck Brown, with just a touch of Black for the eyes and the darkest areas of his plumage. The startling bright orange-gold color is intended to capture milady's attention, and her favor.

Visit artistsnetwork.com/Painting-Nature-Cathy-Johnson for a FREE bonus portrait demonstration.

Use Swatches to Determine Color

Color swatches can help you decide what colors to use. For this Gambel's quail, a Western species with a delightful little headdress, I used Derwent's watercolor pencils in Ivory Black, Blue Grey, Burnt Sienna, Gold and Vandyck Brown. Small sketches like this are sufficient to get you started on a more detailed painting.

Use Shape and Position to Create Specificity

When you want to suggest something besides a generic bird, pay attention to the overall shape and position. This is a red-tailed hawk, sketched first in pencil, much larger than it appeared in the painting.

Birds as Components of a Scene

You may prefer to just include a bird as part of the larger picture to give a sense of life. In this plein air painting, a hunting hawk soars high over nearly ripe soybean fields, hoping to spot a meal.

The Hunter
Watercolor on Cachet cold-pressed sketch journal paper
5" × 7" (13cm × 18cm)

Painting Weeds and Grass

Weeds and grass add texture and interest with their sensuous, linear shapes. They grow, in one form or another, in most natural environments no matter how arid or cold. There are a hundred different kinds of grass, and as we consider the subject as artists, we must keep this in mind. What effect are we after? A carefully trimmed lawn in the middle distance will simply be a nearly featureless expanse accomplished more than likely by laying in an area of closely spaced strokes and then blending softly. If you need more detail, you can add lines of a different color, value and direction while wet and then blend quickly so as not to lift the pigment too much. When everything is thoroughly dry, you can add however much additional detail you wish, then touch it with water on a small round brush or leave it as is.

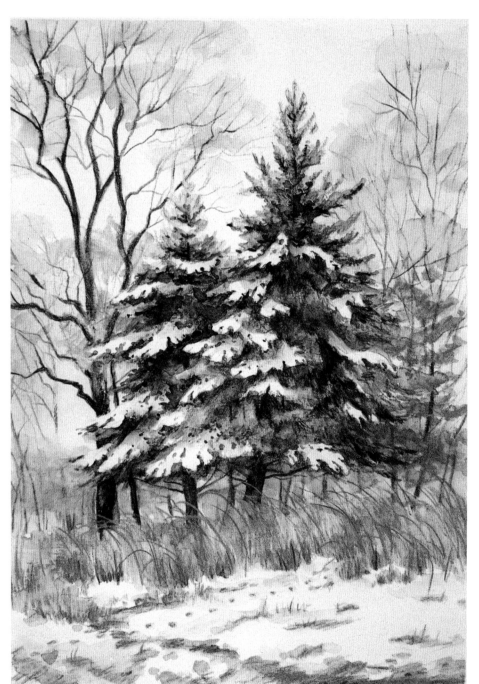

Use Grasses Effectively

I loved the contrast between the warmly colored broomsedge, a grassy plant that turns to red-gold in the fall, and the wintry forest beyond with its chilly blues and lavenders. The deep shadows of the two cedar trees with their soft, lacy coats of snow made another lovely contrast. I used no masking fluid here, just painted around areas I wished to keep light. I used quick, bold, expressive strokes to suggest the leaves of the broomsedge, blending the first layer with water, allowing it to dry and adding more strokes on top. For the bare deciduous trees, I used Blue Grey and Ivory Black for the sharp, calligraphic lines of limb and branch and blended the smaller branches that were drawn in with a very sharp watercolor pencil and an almost dry-brush stroke with a small watercolor brush to suggest the finest twigs. The final touch was to add the tracks of a small forest animal in the foreground, just visible in the cold blue of the snow.

Twins—Winter
Watercolor pencil on Canson Montval
cold-pressed watercolor paper
10" × 7" (25cm × 18cm)

Visit artistsnetwork.com/Painting-Nature-Cathy-Johnson for a FREE bonus portrait demonstration.

Painting Grass

MATERIALS

SURFACE
Arches hot-pressed watercolor paper

WATERCOLOR PENCILS
brown and green hues of your choice

1 Lay In Basic Colors
Lay in an area of soft, spring green using grassy, zigzag strokes, and add a bit of darker green at the base of the shape to suggest shadows. Then blend lightly. On the untouched left side, you can see the kind of strokes to use.

2 Add Grass Blades
Once your work from step 1 is dry, add more quick, upward-jabbing strokes that maintain a grassy taper, and wet them only gently so as not to lose all definition.

3 Add Final Details
Finally, add the broadleaf plants, a few taller grasses with their seed heads and the little brown sapling. These three simple layers suggest the riot of plant growth in a grassy environment.

Grass Up Close

I often enjoy a more botanical approach, doing a close-up study of my subject—here, a single frond of foxgrass, named for its soft, furry seed head. I used only four pencils for the preliminary layers: a warm ochre, a warm brown, Burnt Sienna and Burnt Umber. I carefully observed the shape of the plant and that gorgeous spiral-twisted leaf. The shadows help to define the spiral, so I used Cobalt Blue to add them when everything was thoroughly dry.

Visit artistsnetwork.com/Painting-Nature-Cathy-Johnson for a FREE bonus portrait demonstration.

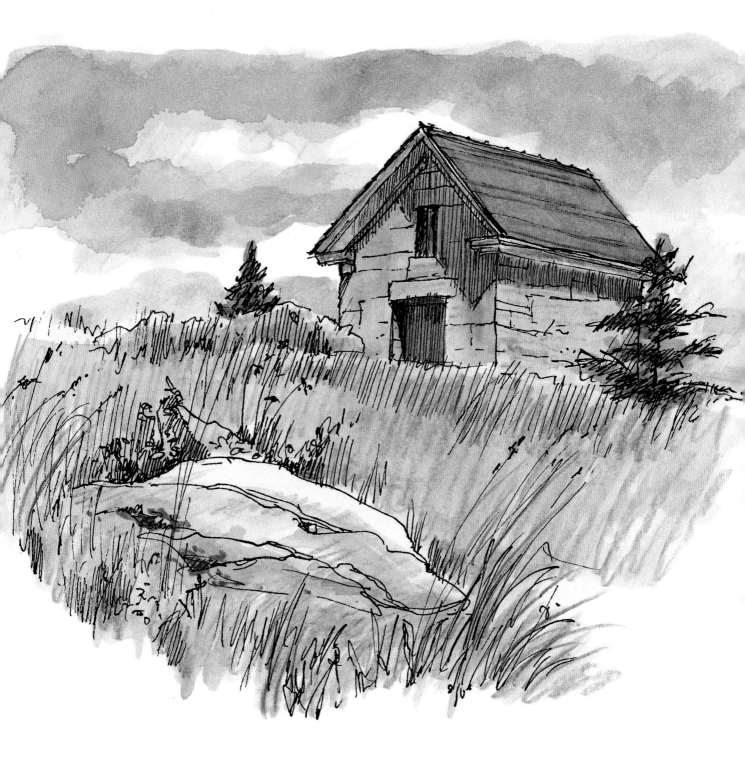

Port Clyde Well House
Pen and ink and watercolor on Strathmore
vellum drawing paper
6¼" × 7½" (16cm × 19cm)

Cultivated Fields

Cultivated fields change their dress from year to year as the farmer rotates his crops—short, round-leafed soybeans one year, tall corn another and occasionally a hay crop. Form a relationship with a specific place, and revisit it in a variety of seasons.

Visitors and Inhabitants

Shy white-tailed deer may feed near the edges of a cultivated field, always aware of nearby cover. Meadowlarks and bluebirds may perch on the fence and nest nearby. Quail are common here, too, and in some areas, you'll see ptarmigan or long-tailed pheasant. In the fall, after the harvest, birds of many types can be found in the grassy areas, feeding on stray seeds or grains. Look for crows, grouse or wild turkey. Overhead, hawks wheel and turn, looking for dinner.

This is the area as it looked in early September, rich with soybeans.

Rainy Day Adjustments

On drizzly days like this, working in the car is a great option, and working small makes everything much easier. This is a Strathmore watercolor sampler pad that comes in a variety of paper surfaces, thicknesses and colors. I was working on a soft gray paper to match the damp gray day.

When I'm working quickly, I like to sketch in the basic forms with a dark gray colored pencil, then lay in washes in a quick, free manner. The light underwashes can extend to cover the places where darker areas will be, as in the distant tree-line.

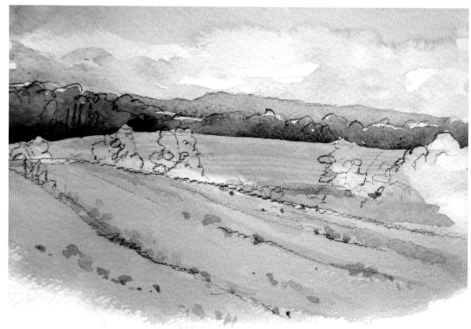

Patterns of Green

The rows themselves make interesting patterns, delineating the lay of the land and providing a sweeping perspective. You can suggest this with just a few lines.

When the first washes are dry (be patient on humid or rainy days), add the next layer, darker and more emphatic than the initial washes. Burnt Sienna and Phthalo Blue, painted wet-into-wet, make lovely varied greens.

Visit artistsnetwork.com/Painting-Nature-Cathy-Johnson for a FREE bonus portrait demonstration.

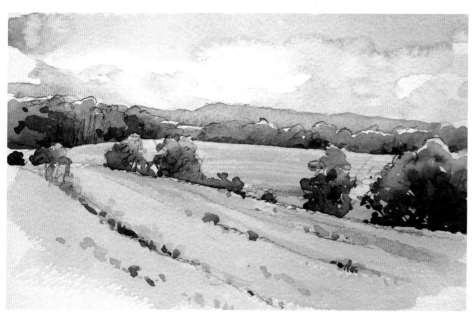

Add Details Later

Wait till the secondary washes are dry, and go back in with additional details: the trees that follow the gully, shadows under distant trees, more detail in the rows. (The color is slightly different here because the first two photos were taken in natural light on that gray rainy day.)

Rainy Day in Mosby
Watercolor on gray toned paper
5" × 7" (13cm × 18cm)

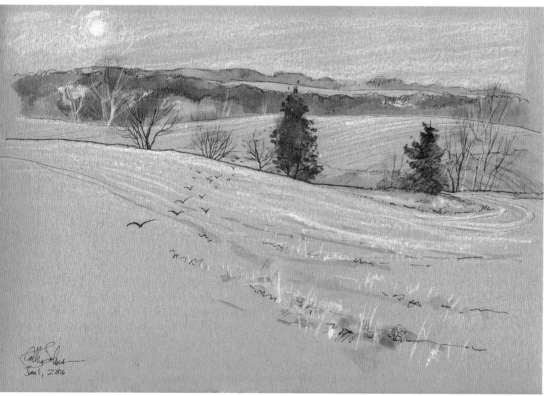

Seasonal Changes

This is the same field, on a winter's day with the stubble of last year's corn crop.

January 1
Ink, colored pencil and gouache on toned paper
9" × 12" (23cm × 30cm)

Fiery Renewal

Part of the natural life cycle of the prairie is the burn. It allows new seeds to mature and germinate and clears off the huge fuel load that can choke the ecosystem. Sometimes nature sets these fires (with lightning). Sometimes humans set the fires in a controlled burn.

Even during a controlled burn, I suggest using a quick sketching technique. You can add color later, as I did with this journal drawing of the burning prairie at the Martha Lafite Thompson Nature Sanctuary in Liberty, Missouri. I worked rapidly with a pen, then added the colored pencil a little later when the fire had passed but the scent of smoke was still in my hair and on my clothes. I used colored pencils here, but I could do a credible watercolor with this much information.

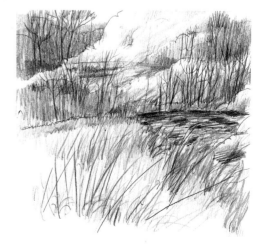

Painting Aerial Perspective

Aerial perspective creates a sense of distance and depth. As objects recede into the background, they appear higher, smaller, simpler and often more blue. Clouds also most often follow the rules of aerial perspective, with the clouds farthest from you closest to the horizon and smaller than those up close.

Aerial perspective most often is seen in natural landscapes as opposed to the perspective of the linear environments of cities and towns. There are few straight lines in nature (though rivers, streams and roads do follow the basic linear perspective). Use a combination of both linear and aerial perspectives to make your landscapes ring true.

MATERIALS

SURFACE
Arches hot-pressed watercolor paper

WATERCOLOR PENCILS
blue, brown and ochre hues of your choice

OTHER SUPPLIES
black wax-based colored pencil, tissues

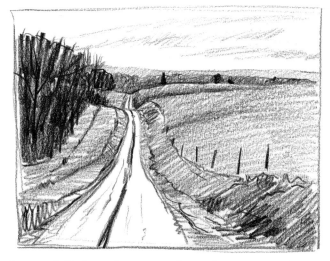

1 Establish Values and Basic Composition
This little sketch is from one of my favorite resource photos of the end of a small road where my friend Alice lived. To begin, use a wax-based colored pencil in black to explore the values and the basic composition and to consider how to handle the problems of perspective.

2 Lay In Preliminary Colors
Lay in the preliminary colors in the sky and background trees, keeping these areas simple and more blue with distance. Paint the sky and the farthest hills partially wet-into-wet, mixing in the lid or a small palette just as you would a normal watercolor wash. Blot out the light clouds with a tissue.

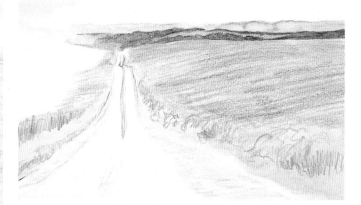

3 Establish Distance and Add More Colors
Where the landforms overlap in the distance, leave one row pale and simple. Add more detail to the next rank of hills, including some green fields. In actuality, the broad Missouri River nestles between those two planes, though it is too far away to see. Begin to lay in the color for the bare winter fields, using a variety of warm ochres and browns, and add the first linear shapes in the muddy gravel road.

4 Add More Details

Here, add the rough pencil marks that stand in for the bare forest to the left of the road. Pay attention to perspective here, too, in your handling of color and in how closely or simply you apply the pencil to the more distant rank of trees. Add the distant evergreens and the bare winter trees beyond the field on the right. Use your cooler colors in the farthest landforms.

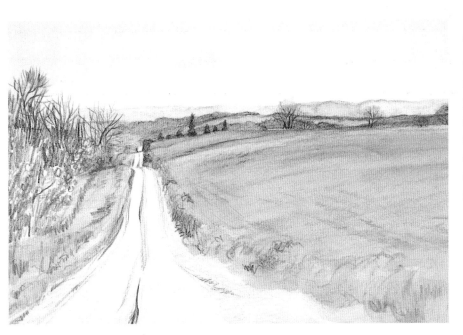

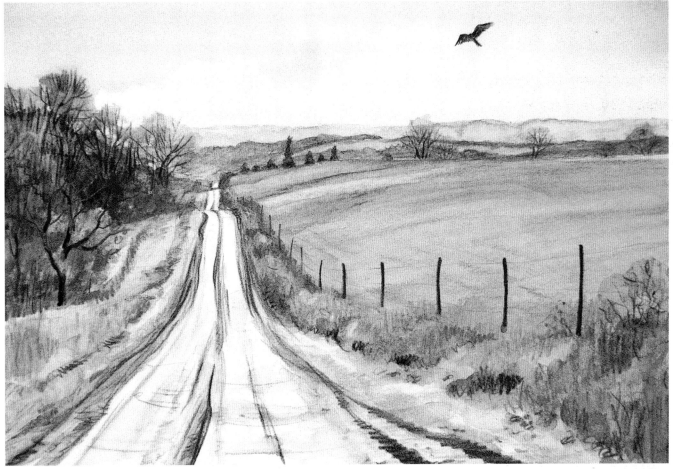

5 Add Finishing Touches

Blend the woods and add the shapes of the leafless trees within the larger shape, making the closer tree darker and more detailed than the ones a bit farther from the viewer. Use a number of things to suggest the receding distance—the blue hills, the narrowing road, the simpler trees on the middle ground hills, the increasingly simple shapes of the weeds in the ditch to the right as they recede into the background, the fence posts that become smaller and higher and the muddy lines in the gravel road. I couldn't resist adding the turkey vulture that hovered over the field, looking for sustenance.

Alice's Road
Watercolor pencil on
Arches hot-pressed
watercolor paper
7" × 10" (18cm × 25cm)

Limestone Fence Posts and Windmills

Rural artifacts connect us to our history in ways big and small. Windmills are fairly common in many rural areas. Limestone fence posts are more often seen where suitable trees don't grow in usable numbers. (These days, though, unlovely steel posts are the norm!)

Fence Posts

In some areas, wood is in very short supply. That's why early settlers in the Great Plains sometimes built sod houses until they could import the lumber to build more permanent homes. Even the fence posts may be limestone. You can see the grooves in these massive posts for holding the wire in place.

Variations on a Theme

This post was just down the line from the one in the photograph; they're marvelously varied in shape. It was done with layers of watercolor pencil, applied dry, wet carefully and allowed to dry again. It needed a bit more punch, so I added another layer and wet it again, then added a little dry pencil work for texture. The tall weeds are Queen Anne's lace, a very common sight along the edges of old fields.

Windmills

In some rural areas, you may see windmills still in use to generate electricity or pump water. The newer windmills are not as picturesque, but many of the old mills are still standing.

Pay attention to what you see: the shapes of the blades, the number of them, the angle from where you sit. It's not necessary to be an engineer or an architect to depict these in an interesting way, but a degree of accuracy lends believability. This quick annotated sketch is in my journal. It was actually a cloudy, gray day, but it's okay to tweak color and mood if you want.

Visit artistsnetwork.com/Painting-Nature-Cathy-Johnson for a FREE bonus portrait demonstration.

Painting Night

It is tricky painting a night scene in almost any medium, particularly a transparent one. Sometimes it is especially difficult to get color saturated enough when using watercolor pencils. We've already talked about the need for a good tough paper you can handle with bold strokes and heavy pressure. Another good solution is to use water-soluble crayons, such as Lyra's, instead of the drier, more delicate pencils. These are soft and buttery and as big as a child's kindergarten crayon. It's difficult to get fine detail with such a large tool, of course, but I often find them useful for covering large areas fast, for first layers of paint in these broader areas and for instances in which I want a very strong, saturated color. For all of those reasons, I chose watercolor crayons to paint this small night sky.

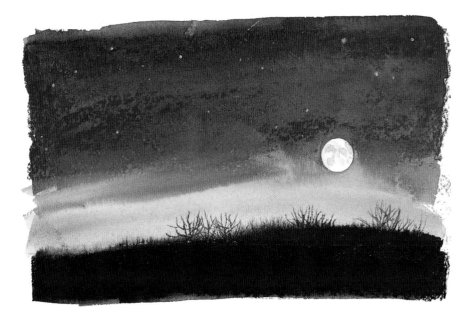

Night Sky/Full Moon

For interest and color variation, I made this small painting depicting that time just before full darkness when the sky retains the loveliest of transparent hues at the horizon, usually in winter. While the sky and the dark landforms below were still damp, I used a sharp watercolor pencil to draw the bare trees back into the luminous sky at the horizon to maintain that delicate, lacy look. Once the sky was thoroughly dry, I wet an opaque white pencil and made dots in the sky for the stars. I carefully modeled the moon with a small wet watercolor brush and color lifted from the end of a yellow-green crayon.

Don't Be Heavy-Handed

You can see from these colors used for this painting (obviously without the addition of any water) that it's not necessary to lay down the preliminary pigments with a heavy hand to achieve results. You'd never be able to work this lightly with dry pencils.

Painting Intimate Landscapes

It is often satisfying to look at a landscape in microcosm. If the larger landscape is daunting to you, if there seem to be too many details or if you just simply enjoy slowing down and paying a kind of Zen-like attention to this more intimate world, you will enjoy this approach.

There are a thousand possibilities when you begin to consider what to paint. Open your eyes and look around you—there is never a shortage of paintable subjects. A single flower growing in the crook of a giant oak's root system, a closeup of a gnarled limb and branches or the indomitable patch of sea grass growing from granite rocks—all of these make perfect subjects for a more intimate approach.

MATERIALS

SURFACE
Arches hot-pressed watercolor paper

WATERCOLOR PENCILS
blue, green and yellow hues of your choice

WATERCOLOR CRAYONS
blue, brown and red-brown hues of your choice

BRUSHES
2-inch (51mm) flat

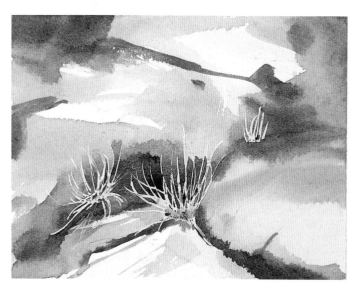

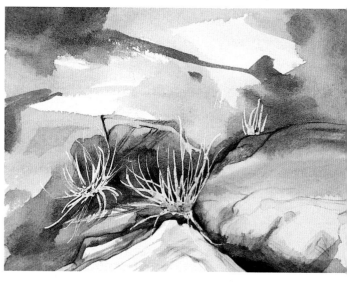

1 Lay Down Foundation

To paint this scene of sea grasses, first sketch in the basic shapes of the rocks. Locate where the grasses will be and protect them with liquid mask applied with the end of an old bamboo pen. Then allow everything to dry before proceeding. Next, mix good strong washes of warm red-brown, dark brown and the deepest blue Lyra watercolor crayon and lay these on your paper with a wide, flat brush to provide a strong, free underwash for the painting. Use some of the darkest darks at the base of the grasses for good, strong contrast. Mixing the three colors will give you strong, dark hues.

2 Add Details

When the first layer is dry, begin to add details—planes, shadows and small sharp cracks, following the interesting linear quality of the rocks. Blend these with clear water and a 2-inch (51mm) watercolor brush.

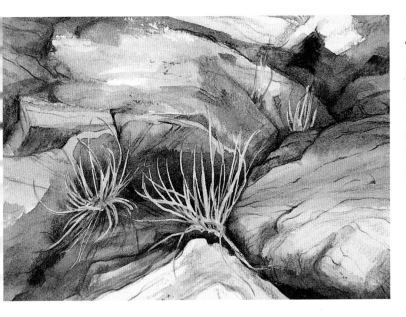

3 Remove Mask
Remove the mask by lifting one edge and pulling it as gently as possible away from the paper so as not to damage the surface. Then begin detailing the grasses, keeping them fairly light shades of green, yellow and blue so they stand out against the shadows. I used a yellowish spring green, a warm light yellow and the same deep cool blue, greatly diluted.

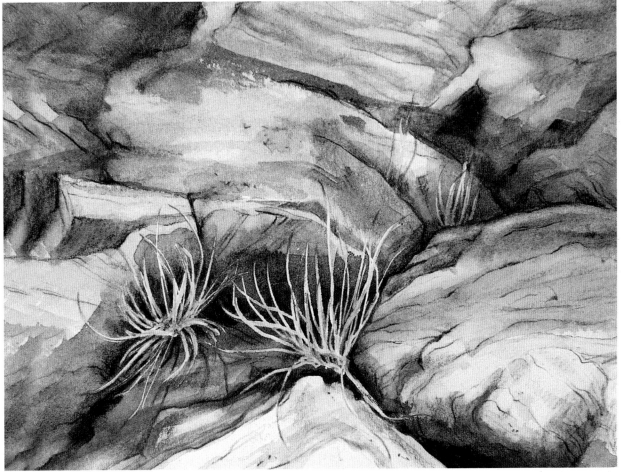

4 Add Final Details
Finally, add the rest of the details, shading the clumps of grass to give them a slight dimensionality, paying attention to the warm brown and reddish tips of the blades, deepening the shadows behind them. Add more texture to the rocks as well. Wet some of this detail to blend and allow some to remain dry and very linear until you are satisfied that the painting is complete.

Sea Grass
Watercolor and watercolor pencil on Arches hot-pressed watercolor paper
7" × 10" (18cm × 25cm)

MOUNTAINS

S omeone I knew once said, "If you've seen one mountain, you've seen 'em all." Nothing could be farther from the truth. I've traveled from the Ozarks of my home state to the Appalachians and Great Smokies to the Adirondacks, from the Rockies to Nevada's Black Mountains to the San Gabriels in California. The variety is staggering and beautiful.

Ancient mountain ranges like the Ozarks and Great Smokies are often rounded and worn down, covered with enough soil to support an amazing variety of flora and fauna, including some very large trees. Newer ranges are rugged and raw, virtually bare outcroppings, supporting a few plants at lower elevations. Or, like the Rockies, they are treeless and snow-capped above the tree line and clothed with evergreens and aspens below.

They are definitely not all the same. They are a delight to the eye and a wonderful challenge to paint.

Don't Oversimplify

Kids tend to think of mountains as a simple series of saw-toothed lines, zig-zagging across the page. Resist the urge to create these stereotypical forms and your work will instantly become more interesting.

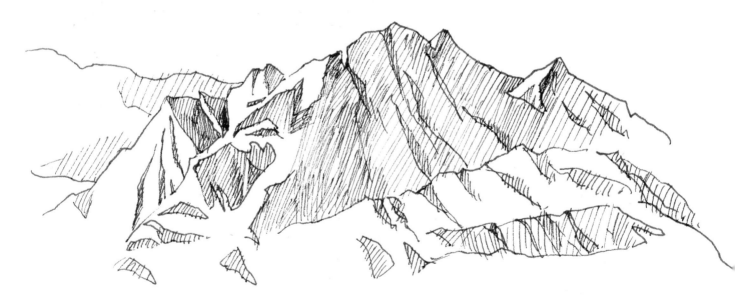

Map the Mountains

Take your time and "map" the shapes you see, drawing the major forms and looking for how they relate to one another, how they fit together. Use an ink or pencil line, and fill in the shaded areas with tone or hatched lines. Keep it relatively simple. You'll soon see just how complex and interesting and specific these shapes are.

By the way, this is Frenchman Mountain, just outside Henderson, Nevada. As I sat looking out toward the distant mountains, I drew them in my journal, using an art pen with sepia ink.

Visit artistsnetwork.com/Painting-Nature-Cathy-Johnson for a FREE bonus portrait demonstration.

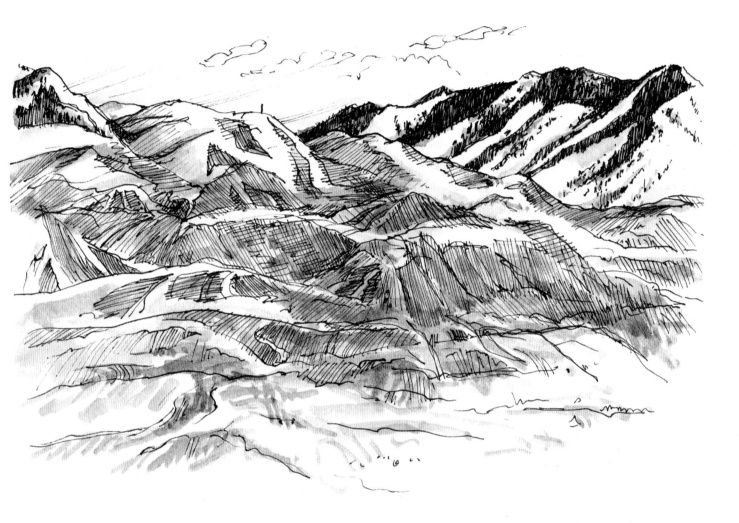

Time for Details

If you find yourself with more time, you can carry the mapping as far as you like. Here, my plane was delayed at the Salt Lake City airport, and I passed the time by drawing the view with a fine-point pen, using the mapping process. When it became obvious we'd be delayed even longer, I got out my travel set of watercolors and painted right over the ink sketch. (Actually, this is just one panel of what turned out to be a three-page journal spread. It was a long wait.)

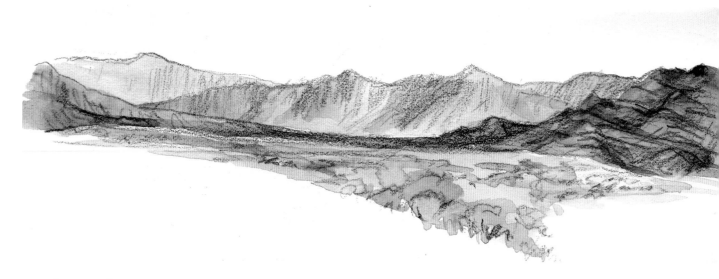

On the Road

Sometimes there's not a good place or time to stop to sketch. If you're not the driver and you're not bothered by motion sickness, you can get in a quick pencil sketch on the road and add color later.

Let your impressions of the place fix themselves in your memory, and the color will be representative of your subject.

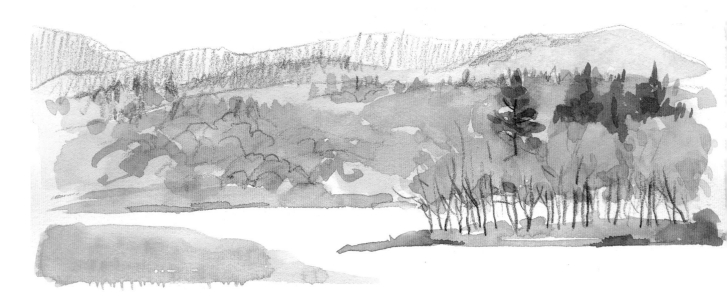

Use What You've Got

I hurried to complete this rough sketch before the downpour could drench us. The indigo colored pencil was near the top of my field bag, and I didn't have time to dig for a different tool.

Visit artistsnetwork.com/Painting-Nature-Cathy-Johnson for a FREE bonus portrait demonstration.

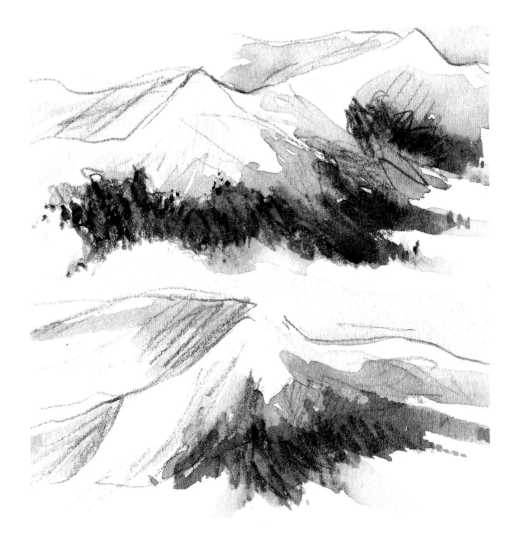

Above the Timber Line

It makes an interesting contrast to include both the green trees and the bony, bare rocks above them, particularly if the mountains are snow-capped. Your practice in mapping the shapes will help you see accurately and place the snow fields and fingers of forest in a believable way. (Of course, it helps to have a sketch, a photo reference or the luxury of working on site.) Take every opportunity to sketch mountains. You can even sketch them out the window of a plane at 27,000 feet (8,230m), as I did here.

If you were on a level with these mountains instead of having a sky-high view, the tree line would look more uniform, but it's still not a straight line of green. Because of the tendency for soil to form more readily where it's protected, the trees will reach higher in the mountain valleys and between the ridges.

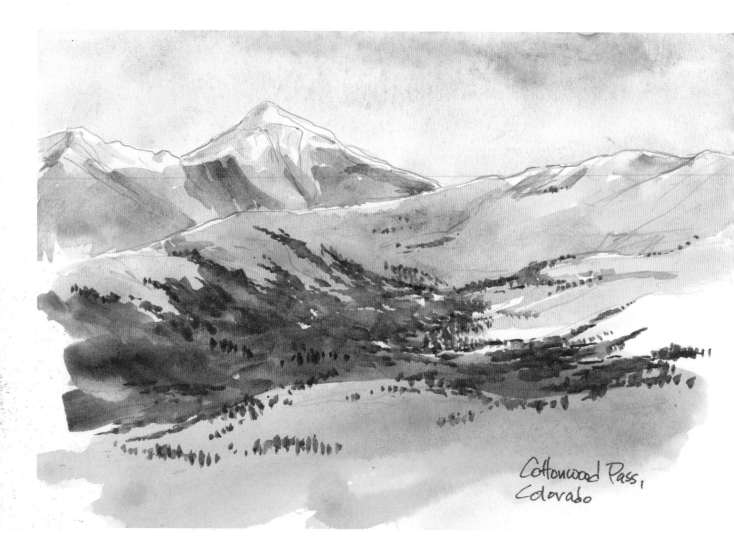

Cottonwood Pass,
Colorado

Elevated Sketching

Way above the tree line, you're liable to see snow even in the summer. The trees reach up as far as they can find soil and a foothold.

This was a simple pencil sketch with washes laid in with only two brushes, a ½-inch (13mm) flat and a no. 6 round for the details of the trees. I pounced the edge of the flat on the paper to suggest some of the trees, then painted a few individual ones at the edges and in the meadow in the foreground with the tip of a round brush.

Cottonwood Pass, Colorado
Watercolor on Fabriano hot-pressed watercolor paper
5" × 7" (13cm × 18cm)

Back to Basics

Painting at home or on the spot can be extremely simple. I did this painting with a box of rich, granulating Kremer Pigments watercolors, a little watercolor block, a ½-inch (13mm) flat, a no. 6 round and my small water container made from a pair of travel-size spray bottles (one was cut to form a water cup).

Visit artistsnetwork.com/Painting-Nature-Cathy-Johnson for a FREE bonus portrait demonstration.

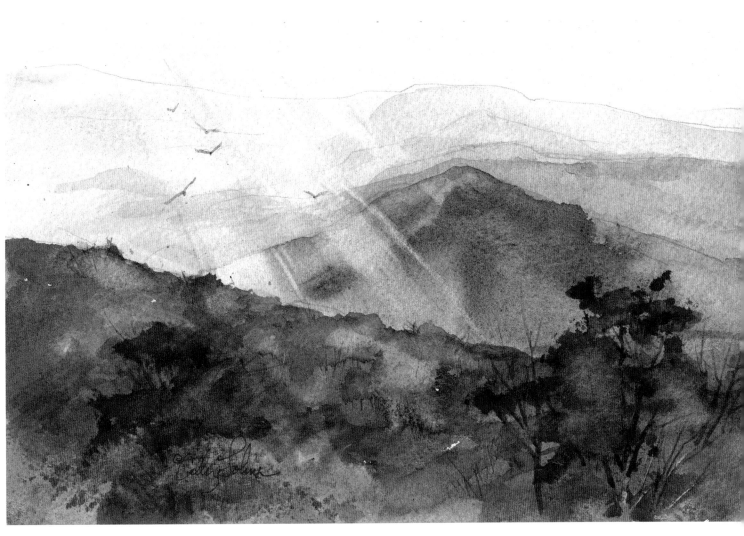

Dickey Ridge
Watercolor on Strathmore rough paper
5½" × 9" (14cm × 23cm)

Keep Records

I shot this photo after sketching so I would have a photographic record of the place. You can see how much I edited out for the painting.

Simple Mapping

Mapping mountain ranges can be very simple when the haze shrouds them, as it so often does in the eastern mountains. Here, you see the soft blues, gray-blues and lavenders of the Shenandoah Mountains. I pushed the colors in the foreground a bit, but they were already very rich on that early November day.

Granulating colors like Ultramarine Blue and Burnt Sienna worked well to suggest the mountains in the middle distance, and a mixture of a very pale wash of Phthalo Blue and Cobalt Blue suggested those in the distance. Each receding mountain looks paler and paler, suggesting greater distance.

After everything dried, I lifted the shafts of light that pierced the haze by loosening pigment with a clean, wet bristle brush and then blotting with a tissue.

In Virginia, the vultures stay year-round, riding the warmer thermals of air. A gathering like this is a common sight, and we always greet "Buzzard" and appreciate his grace as well as his work as cleanup crew!

Trees of the Eastern and Western Mountains

As usual, the subject you choose to paint depends on where you are and what season it is. In the Ozarks in early spring, you can't help but notice the beautiful pale glow of dogwood blossoms or the hot pink of redbuds, also common in the Shenandoahs and Great Smokies.

Paint the entire tree, a stand of trees or focus on the details, field-guide style, as I have here.

Balsam Fir
This cold-loving tree is mostly found in Canada and in the eastern half of the United States. It can also be found in West Virginia and Virginia, but it is much more likely to grow in the Adirondacks than the Appalachians. Ink and watercolor work well to capture the delicately colored immature cones and short, dense needles.

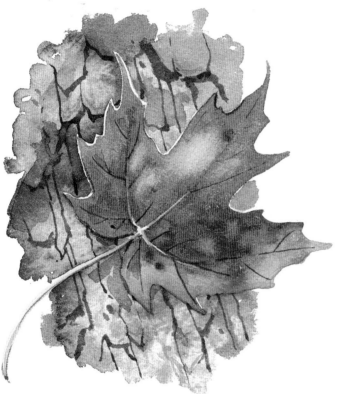

Sugarbush
If you're fortunate enough to be in the mountains when the sugarbush (sugar maple) takes on fall's palette, you'll delight in painting these gorgeous details.

Tree Silhouettes
Pay attention to the different tree silhouettes here. A Douglas fir of the western forests (left) is very different from the dense, shorter balsam fir (right).

Visit artistsnetwork.com/Painting-Nature-Cathy-Johnson for a FREE bonus portrait demonstration.

Douglas Firs

Douglas fir trees are so ubiquitous, the building industry calls this type of tree "Doug fir," as if it were a guy you'd meet for a beer! They are grown in huge tree farms for lumber and paper pulp. They also still grow wild in the Western mountains. They've got interesting fringed cones, as this detail shows.

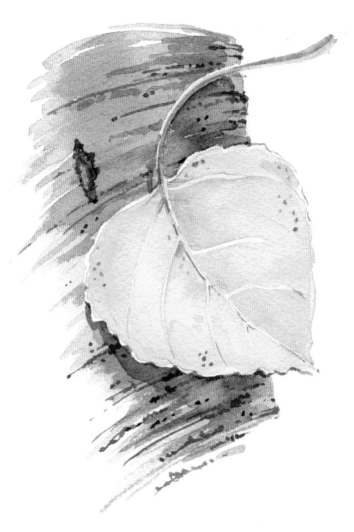

Quaking Aspen

These graceful trees have bright yellow leaves in the fall. The leaves' long stems make them wave madly in the wind, shimmering with highlights.

a flotilla of ducks visits camp several times a day — once with tiny, fluffy babies

Curl of Birchbark

Paper Birch

Balsam fir often grows in concert with this tree, the paper birch, as well as with aspen, white cedar, eastern hemlock and sugar maple.

Mountain Wildflowers

What flowers you are able to draw or paint depends entirely on where you are and what season it is. In Colorado's summer mountains, you're liable to see huge blue columbines. In the Adirondacks in June, you'll find bunchberry, lady's slipper orchids and more. In the Ozarks, spring brings lovely ground-hugging birdsfoot violets, with their lacy, fern-like foliage. The drier mountains of California in early fall are a tapestry of dried wildflower heads in many rich shades and colors, along with the bright coral red of California fuschia or Zauschneria. In another season, the foothills are golden with fields of California poppy.

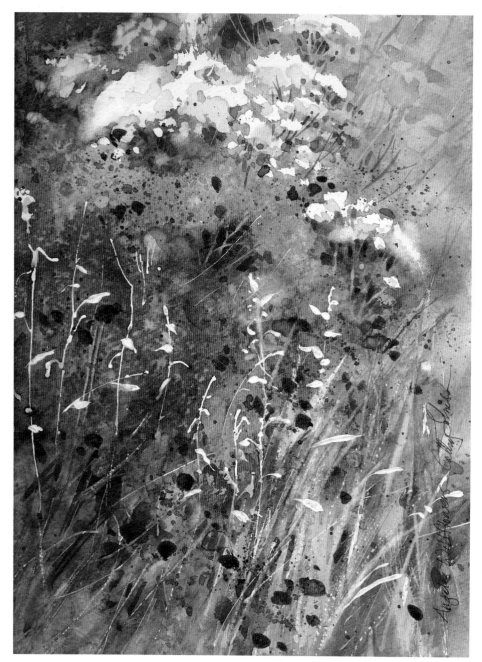

Collect Samples

Collect (if it is legal and safe to do so) a few flowers or seed heads to paint in detail. Otherwise, paint on the spot with as much detail as you can. You may enjoy trying to identify them or simply delight in their shapes and colors.

These varied flowers were thick along State Highway 39 through the Angeles National Forest at the end of September. The Angeles National Forest is in the San Gabriel Mountains.

Enliven With Watercolor

A quick pencil sketch can be brought to life with a little water- color or a wash.

Abstract Complexity

A complex subject may work well with a some- what abstracted approach. Acrylic, gouache or other opaque medium may help, or try masking fluid to retain the lights.

Angeles Wildflowers
Watercolor on Strathmore
cold-pressed watercolor paper
12" × 9" (30cm × 23cm)

Visit artistsnetwork.com/Painting-Nature-Cathy-Johnson for a FREE bonus portrait demonstration.

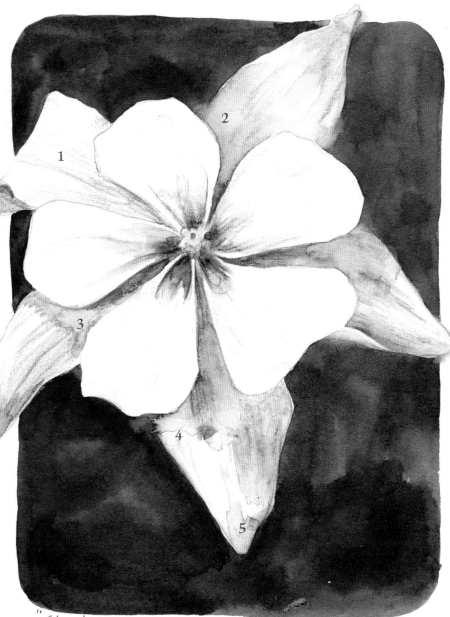

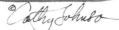

"Colorado Columbine"

© Cathy Johnson

Colorado Columbine
Watercolor pencil and watercolor on Fabriano
hot-pressed watercolor paper
7" × 5" (18cm × 13cm)

Focus on the Specific

Focus on a single flower. If you have the opportunity, columbine makes a beautiful contrast against a dark green background. Notice the large secondary petal at upper left. I left the watercolor pencil untouched there to show the pencil strokes.

Don't let your work become too uniform or it will look as if it were pasted on. This is sometimes a danger with a light subject on a dark background. Try these variations:

1. Leave some pencil work untouched—the linear effect is pleasing.
2. Lost and found edges integrate subject with background. Here, a damp brush blends colors softly.
3. A bit more water creates lovely puddles. I like the fresh, juicy hard edges that form when the puddles dry.
4. Keep other areas crisp and clean like this, instead of soft.
5. Subtle color or temperature variations are nice, too. The tip of this petal is warmer than some of the other shadowed areas.

Artistic Detective Work

In the Adirondacks in June, bunchberry hides under the trees. I drew these in my journal and was able to use my sketch to identify them later (another great use for your artwork).

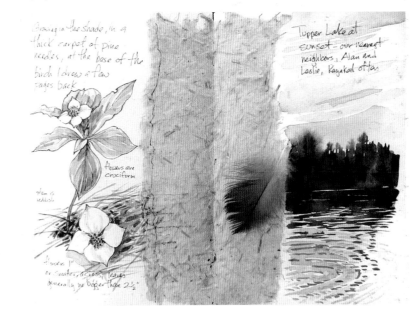

Birds of the Mountains

Some birds just seem to make us think of mountains, though you will also find them elsewhere. The bald eagle is really much more common than we might think since the insecticide DDT was banned and nesting is more successful. I've seen them a few miles from my home in the Midwest, fishing on the Missouri River.

Migration does affect bird populations. You may see songbirds from spring to fall, but by winter many of those have gone south.

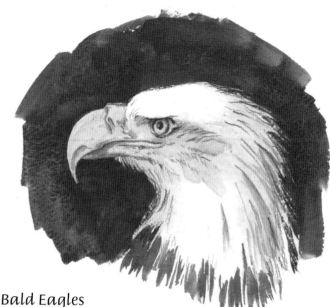

Bald Eagles

You probably won't get close enough to a bald eagle to sketch it in this detail, but, if you have a telescope or good telephoto lens, it's possible. Working from a photo makes the impossible doable.

Horned Owls

In the Great Smokies and elsewhere, great horned owls are common year-round. You may find evidence of their nocturnal hunt in the snow by morning's light or find one drowsing in a tree near the trail. Colored pencils are wonderful for quick sketches under winter conditions since no water or other medium is necessary, though you can add a wash later (when you're someplace warm!).

Hummingbirds

These little guys don't often stay still long enough to sketch them, eve[n] a rough sketch like this one. Do some [o]f gesture sketches, then flesh out the de[tail] and color with help from a photo or [a] guide drawing.

Visit artistsnetwork.com/Painting-Nature-Cathy-Johnson for a FREE bonus portrait demonstration.

Mountain Wildlife

You may not be lucky enough to get close to wildlife. One solution is to take a camera with a telephoto lens, a pair of good binoculars or a terrestrial telescope with you. It's a bit difficult to draw when using binoculars or a telescope, of course, but it can be done. Resource photos are a big help.

Stuffed mounts can be another useful resource. Some mounts are just ghastly, like stuffed toy animals, certainly not like anything that once had breath! Hold out for ones that look real and, more importantly, alive. Often, a natural history museum will have very good mounts, as will national parks' visitor centers.

Interestingly, places like Bass Pro Shop or Cabela's may also have very high-quality mounts. It's not the same as working from life, of course. If at all possible, you need to put in your time in the field so you have an understanding of the natural behavior and characteristic poses of your subject. But for close work, mounts may be the best solution you can manage.

Up Close and Personal

You're more likely to see wildlife at a distance. These female bighorn sheep (you can identify females by the smaller, straighter horns) were amazingly close. Quick sketches with your brush, a pencil or pen will give you enough information to use later in a painting.

Dall Sheep

This magnificent example of a Dall sheep was in the offices of the Nevada Fish and Wildlife Commission. I got to sit and sketch and paint to my heart's content. The wonderful people who work there were helpful, interested and supportive. I'm glad I found the place, because I didn't see a single live sheep while we explored the area on this trip.

I used a cool dark gray Prismacolor pencil and quick watercolor washes, just as I would have chosen in the wild. It's a combination that allows for quick sketching and maximum liveliness!

Grizzly Footprints

Sometimes this is as close as you want to come to wildlife. Look at the size of those prints!

Mountain Sheep

The sheep were very far away, up on a mountain ridge, so I decided to paint them as tiny as they looked on a more abstracted, bold mountain. The contrast of the large, abstracted landscape and the carefully delineated sheep lets the viewer realize how vast this scene is.

MATERIALS

SURFACE
Fabriano cold-pressed watercolor block

WATERCOLORS
Burnt Sienna, Cadmium Yellow Medium Hue, Phthalo Blue, Quinacridone Burnt Scarlet, Quinacridone Gold, Ultramarine Blue, Yellow Ochre

WATERCOLOR PENCIL
Olive Green

BRUSHES
½-inch (13mm) and 1-inch (25mm) flats
no. 1 round

1 Begin With a Sketch and Add a Wash

I sketched the shape of the ridge with an Olive Green watercolor pencil, then added a graded wash for the sky, from Cadmium Yellow Medium Hue on the right to Phthalo Blue on the left.

2 Lay In Darker Colors

I mixed a strong wash of Ultramarine Blue, Burnt Sienna and Quinacridone Burnt Scarlet and laid it in quickly, following the shape of the ridge. Then while that was still wet, I dropped and spattered in Yellow Ochre and Quinacridone Gold to suggest the desert plants, with a bit of scratching or scraping into the damp wash here and there to ground the plants with branches.

Visit artistsnetwork.com/Painting-Nature-Cathy-Johnson for a FREE bonus portrait demonstration.

3 Add Details and Shadows
Finally, I added details and shadows to the mountains and painted those tiny, tiny sheep with a no. 1 round and a mix of the same colors used previously.

Mountain Sheep
Watercolor on Fabriano
cold-pressed watercolor paper
9" × 12" (23cm × 30cm)

Mountain Painting

Adding the suggestion of a bird or birds in the sky gives life to your paintings. It's a very strange day when you see no birds at all.

Wherever you are in the mountains, take a good look to see what makes that particular place unique. What captures its spirit? Mountains and mountain ranges are different. What is it that captures your eye about this particular place?

MATERIALS

SURFACE
Fabriano cold-pressed watercolor block

WATERCOLORS
Burnt Sienna, Cadmium Orange, Cadmium Yellow Deep, Manganese Blue Hue, Olive Green, Permanent Rose, Phthalo Blue, Ultramarine Blue, Yellow Ochre

BRUSHES
¾-inch (19mm) flat
no. 8 round
old, moth-eaten ½-inch (13mm) flat
small bristle brush

Reference Photo
This is Nevada's Mt. Charleston, where there is a great range of flora and fauna, as you'll often find below the tree line. The mountains provide a backdrop to trees, wildflowers and wildlife, making a colorful tapestry. It just cries out to be painted.

Plein Air Sketches
Here is a selection of quick paintings that I did on the spot this past year. From the top: the bare red mountains near Henderson, Nevada; the amazing steep grassy foothills in California, dotted with live oak; the thickly wooded Adirondacks near Lake Durant, New York; and the rugged brown mountains and distant blue vista in the Angeles National Forest, California. Each one is very different from the others.

Brushes
Consider the interesting textures to be created with a variety of brushes, old and new. For this painting I chose, from the left, a ¾-inch (19mm) flat, a small bristle brush intended for oil paints, a no. 8 round and a moth-eaten ½-inch (13mm) flat that's great for textures. I'm glad I didn't throw the old moth-eaten brush away!

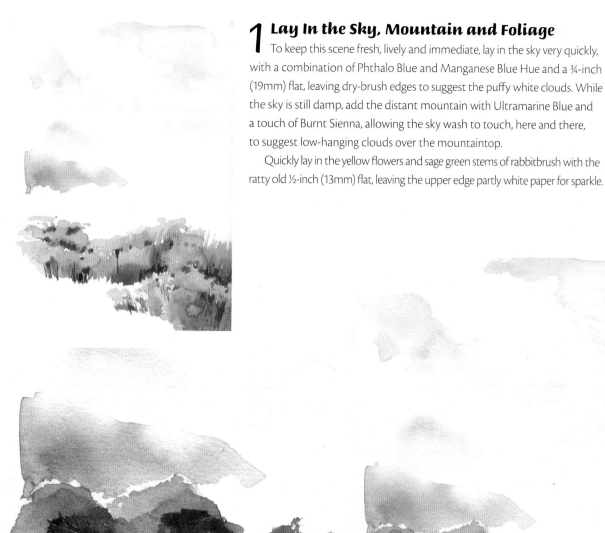

1 Lay In the Sky, Mountain and Foliage

To keep this scene fresh, lively and immediate, lay in the sky very quickly, with a combination of Phthalo Blue and Manganese Blue Hue and a ¾-inch (19mm) flat, leaving dry-brush edges to suggest the puffy white clouds. While the sky is still damp, add the distant mountain with Ultramarine Blue and a touch of Burnt Sienna, allowing the sky wash to touch, here and there, to suggest low-hanging clouds over the mountaintop.

Quickly lay in the yellow flowers and sage green stems of rabbitbrush with the ratty old ½-inch (13mm) flat, leaving the upper edge partly white paper for sparkle.

Step 1 Detail
This detail shows the blending between mountain and sky.

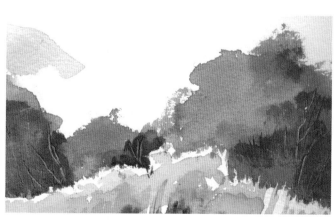

Step 2 Detail
While the trees are still wet, scratch in darker lines to suggest trunks and limbs. Allowing the green washes to dry a bit more will let you scrape the paint back out of the way to look like lighter trunks. Timing is important here, so you may want to practice on scrap paper to get a feel for it.

2 Differentiate the Deciduous Trees

A warmer mixture of Yellow Ochre and Phthalo Blue with a bit of Olive Green differentiates the deciduous trees behind the rabbitbrush.

3 Lay In Wash and Spatter

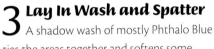

A shadow wash of mostly Phthalo Blue ties the areas together and softens some parts. The mountain on the right is Ultramarine Blue with Yellow Ochre and a little Phthalo Blue, kept very simple but varied a bit to suggest the trees that cling to the slopes.

Some spatter, some more pouncing strokes with that little bristle brush and a few detailed stems painted with the tip of the no. 8 round finish the flowers and foreground.

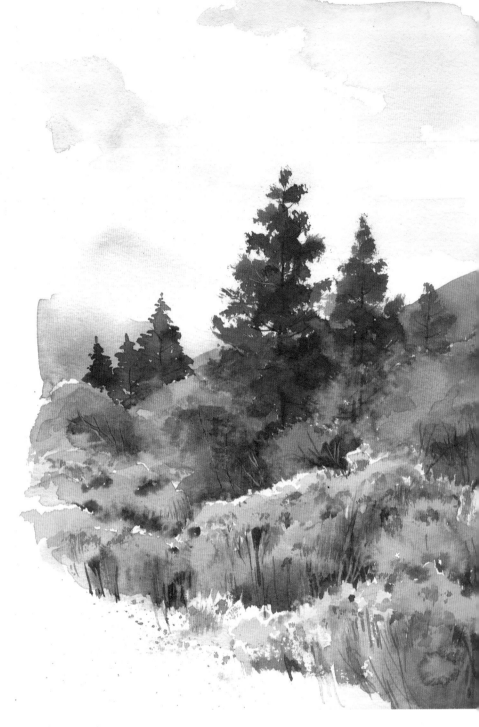

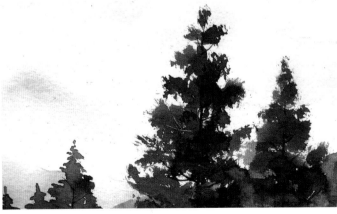

Step 3 Detail

Paint in the lacy evergreens mostly using that handy old bristle brush. Use a pouncing and sometimes scratching motion and a strong mixture of Phthalo Blue and Burnt Sienna, again scraping and scratching through the damp paint to suggest limbs.

With the no. 8 round, paint the more distant trees to the left using a dancing motion of the tip. Keep them a bit lighter and cooler in value to push them into the distance.

Visit artistsnetwork.com/Painting-Nature-Cathy-Johnson for a FREE bonus portrait demonstration.

Painting Rocks and Boulders

If you approach rocks and boulders logically, you can handle them in a simple manner. Just as with trees, there are no generic rocks. I can't say, "Choose this color pencil for the body and that for the shadow," because rocks have many different hues. You'll find a great variety of shapes and textures with rocks as well.

For example, red rock sandstone in the desert often is smoothed by endless desert winds. A rocky coastline still may show the effects of cooling lava in the striations of rock layers. On the English coast, the cliffs of Dover are made white with chalk deposits. The weathered stone walls of European castles provide inviting textures. In my part of the U.S., we find smooth, pink, glacial erratics of granite, feldspar and limestone. Each rock has its own personality, and your landscapes will ring true if you can capture some of that variety.

This demonstration is based on the big granite boulders in Missouri's Elephant Rocks State Park. They're hard, smooth and rounded, very different from some of the more angular, sharp-edged rocks found elsewhere.

MATERIALS

SURFACE
Arches hot-pressed watercolor paper

WATERCOLOR PENCILS
blue and brown hues of your choice

BRUSHES
small round

1 Establish Basics
Lay in the colors loosely, with bold, repetitive strokes, using a cool blue for the shadows and burnt sienna for the body of the rock.

2 Wet and Blend
Wet and blend the colors carefully and let them dry thoroughly. Then add some modeling of the rock shape itself—planes, cracks and angles—using warm and cool colors to describe which part was in the sun and which was shaded.

3 Add Final Details
After wetting the modeling layers, add the final details of cast shadows and body shadows and suggest a bit of texture with dots and dashes, both with the pencil tip and with the end of the small round watercolor brush.

Using Rocks in Landscapes

If you paint much at all, you will find a dozen places to incorporate rocks and boulders into your work. They poke from grassy meadows and moors; they stand guard in mountain passes; they reach bony fingers out into the sea. The variety of shapes, sizes, colors and textures offers challenges that intrigue us, giving an almost architectural quality to a landscape.

Don't be daunted by their sheer numbers when faced with a subject like the one here, a scene from Port Clyde, Maine, just before the fog lifted. Simplify. Find a way to suggest what you want to say rather than spelling it all out; that helps involve your viewer into the picture. Look at the big picture. Use light and shadow to stand in for minute detail.

MATERIALS

SURFACE
Arches hot-pressed watercolor paper

WATERCOLOR PENCILS
Blue Grey, Burnt Sienna, Cobalt Blue, Indigo, Olive Green, Ultramarine

1 Establish Basics

Sketch in the rocky point in the middle ground with its tall, lacy evergreens and the shapes of the foreground rocks. Then mix up a good moody fog color using cool light blues and grays. Paint this area wet-into-wet to suggest the low-hanging clouds and the fog that obscures the distant shoreline, blotting where you need to on the pale blue-gray landfall on the horizon to maintain the idea of its being partially obscured by the fog.

2 Add More Color and Details

Once dry, lay in the rocky middle ground point using a mixture of Blue Grey and slightly warmer Ultramarine and Cobalt Blue. Under and just beyond the trees, use yellow and a light spring green to show the sunlight on the grass. Sparingly use Olive Green on the point itself to suggest moss and seaweed. On the middle rank of coastline rocks, begin to suggest more detail and differentiation between rock forms, but still keep that area relatively simple. Paint the trees with a combination of strokes—loose zigzags in the larger areas and delicate, dancing strokes to create lacy edges. Because of the distance and the foggy morning light, ignore local color and paint with soft blues and blue-grays. Carefully blend, encouraging variation in tone and value. Paint some of the limbs and trunks with a sharp pencil and no blending at all. Keep the sea still and calm, reflecting the pale morning sky.

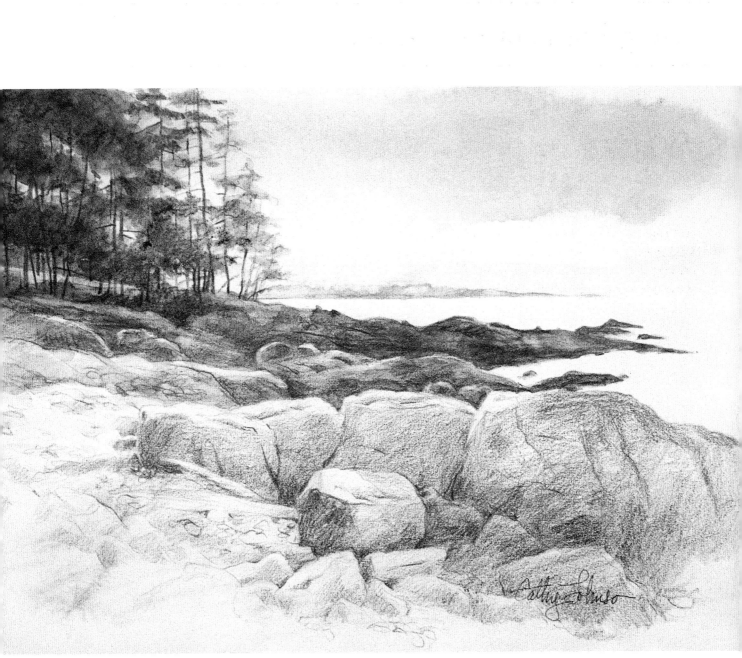

3 Add Foreground Rocks

Now comes the exciting part of this painting, the place where your work speaks to you! Do the foreground rocks with smooth layers of color, carefully delineating the rock forms, using Burnt Sienna, Ultramarine, Blue Grey and Indigo. I found the area as it stood, untouched with my brush, to be very exciting in contrast to the wetly painted area beyond. For once I listened to that voice inside my head that says "stop!" This painting is a keeper, as the vibration between the wet and dry areas engages my imagination.

Maine Coast Fog
Watercolor pencil on Arches
hot-pressed watercolor paper
7" × 10" (18cm × 25cm)

DESERTS

Here, in the earth's driest areas, we discover a beautiful, austere landscape that can change as often and as rapidly as the passing hours. In shadow or sunlight, in spring or fall or winter, or after the all too infrequent rains, the desert shows us her changing face. A distance of a scant few miles can mean the difference between a brown, serene landscape and one of flaming reds and golds, as in Nevada's Valley of Fire. After a rain, the desert bursts almost ecstatically into bloom, hurrying to put on her best dress before the water evaporates again.

Deep blue, lavender and purple shadows paint the rock shapes, and soft gray-green or desert gold plants blanket the hills. Never imagine that there isn't a great deal to paint here. There is!

Take care when entering this harsh land, even to do a quick sketch. Take plenty of water and wear protective clothing. A wide-brimmed hat will shade you and block the glare from your drawing or watercolor paper. Good walking shoes will help a lot, and watch where you put your feet.

As they say in the desert, "Whatever moves will bite you; whatever doesn't will stick you!"

SEEING DESERT COLORS

We may think of the colors of the desert as rather simple sand, rock and "cactus green." Throw in a blue for that big sky arching overhead, and your palette is complete, right?

Wrong! Sit back, take your time, and look more closely. Name the colors to yourself, and be as descriptive as you like. Don't feel you have to stick with official pigment names, straight from the tube. Compare with the pigments you normally keep on your palette, and see what's close as is and what needs subtle mixing to approximate the myriad hues of the desert.

You may even want to experiment with some of the new mineral colors, such as those from Daniel Smith.

Desert Colors

The earth colors and the blues may be fairly close. Traditional earth pigments are, after all, taken right from the dirt, either as their native color or "burnt" for a richer, darker and usually warmer color. Think of the difference between Raw Sienna and Burnt Sienna. The greens are another matter, unless you've bought some fairly obscure ones. I like to use the warm blues to mix desert greens. These mixtures result in a grayer range that's typical of many of these plants. Cobalt Blue and Ultramarine Blue can be handy here.

Here you see Phthalo Blue and Manganese Blue Hue at upper left, with a shadowy purple made of Ultramarine Blue and Cobalt Blue at right. At center left is Quinacridone Gold (a new synthetic color), Burnt Sienna and Quinacridone Burnt Scarlet. At the bottom is a variety of soft mixed greens, some tending more to the yellow, some to the blue, but all softer than most straight from the tube.

Visit artistsnetwork.com/Painting-Nature-Cathy-Johnson for a FREE bonus portrait demonstration.

Desert Wildlife

Depending on where you find yourself, you may see pronghorn antelope, jackrabbits, spotted skunks, coyotes, kit fox or ground squirrel. Ravens are among the most common birds, but roadrunners have earned a place in our folklore as well. You may be surprised to find a house finch or to hear the sweet, liquid song of a canyon wren.

Desert Montage

This montage was originally an illustration I created for Country Living magazine. I like the contrast between the canyon wren and the roadrunner. These are common desert sights, from the red sandstone rock formations to the ubiquitous roadrunner. Jackrabbits, black widow spiders, coyotes and canyon wrens all populate the desert. The plant seen here is a sunray. These flowers grow on top of dead plant matter.

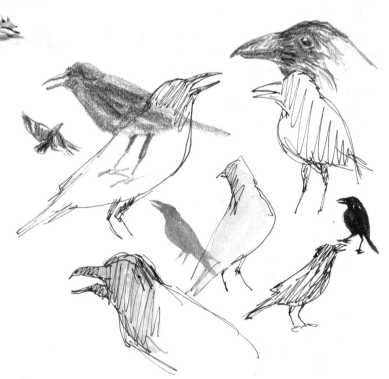

Hungry Ravens

It's hard to get close enough to birds to sketch them. But, as usual, food will work as bait. Every time I tried to get close enough to the ubiquitous desert ravens, they flew away with great indignant squawks. But, at a rest stop in the Mojave, they literally swarmed the big semis. The drivers must habitually share their food. We parked next to one of the semis so I could sketch, up close and personal.

Here, stick graphite, fine-tipped marker, indigo colored pencil and quick watercolor washes caught something of the ravens' poses and personalities.

Antelope

Like the Dall sheep in the previous chapter, the opportunity to draw an antelope this close presented itself at the Nevada Department of Fish and Wildlife. This is Strathmore watercolor paper with warm dark gray colored pencil and watercolor washes. Take any opportunity you can to draw these creatures at close range.

nose "patch" loose on sides

very large, dark eye

Western Patchnose Snake – gray and yellow ?

dark dorsolateral stripe

yellowish

relative of the whipsnake

Reptiles

Sometimes it appears that reptiles are best adapted to desert life. All kinds of lizards and snakes make their way in the desert, from the little tan lizard I saw skitter under a rock, to sidewinders (also called horned rattlesnakes) and the docile, nonpoisonous patchnose snake seen in this graphite field sketch.

Reptiles can regulate their body temperature more easily than a mammal can. That's why you see so many of them in desert climes.

Speedy Lizards

To capture a zebra-tailed lizard on paper, you'd better be quick. This was done with an artist pen in brown, with very simple watercolor washes. A "stick figure" like the one at top may help you to capture the pose. Then flesh it out as you have time. A field guide may help with the markings.

Visit artistsnetwork.com/Painting-Nature-Cathy-Johnson for a FREE bonus portrait demonstration.

Ground Squirrel

Much less shy than the bigger mammals, cheeky ground squirrels are found any place where they might get a handout! They were everywhere near the Valley of Fire State Park visitor center. These were near a picnic shelter at White Domes, a cul-de-sac at the park.

MATERIALS

SURFACE
Fabriano hot-pressed watercolor paper

WATERCOLORS
Burnt Scarlet, Burnt Sienna, Hematite, Minnesota Pipestone, Sedona Genuine, Ultramarine Blue, Vivianite (Blue Ochre)

OTHER SUPPLIES
4B Pentalic woodless graphite pencil

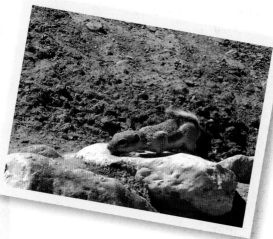

Initial Sketches
I sketched as quickly as I could. Although they were curious, they were also quick!

Reference Photo
To supplement your sketches, try to catch these fast-moving little rodents with your camera. My niece offered this one a drink of water in a little depression in the rock, and we suddenly became much less frightening. Two of them vied for drinks, giving me great photo ops.

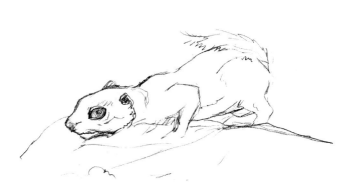

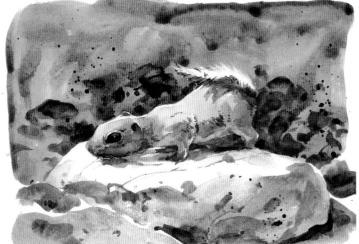

1 Block In the Basic Shapes
Block in the animal's shape with your pencil. I emphasized the shape here with a rather bold drawing so it would show up in print, but you probably won't want to draw such dark lines.

2 Add Color
I was trying out some new PrimaTek mineral colors from Daniel Smith. The background is a mixture of Minnesota Pipestone and Sedona Genuine with Hematite Burnt Scarlet—nice, earthy desert colors. I added Vivianite (Blue Ochre) in the rocks but chose regular transparent watercolors (Burnt Sienna and Ultramarine Blue) for the squirrel itself.

Trying Out Desert-Toned Paper

You may want to choose a tan, sienna, gold or other "desert-toned" paper to work on. Then use some opaque watercolors or gouache, or mix a little white in with each of your colors. The Old Masters used toned papers frequently. It's a technique that's gotten short shrift in more recent times.

The really interesting thing about this technique is that if you choose a mid-toned paper, you can add darker darks and lighter highlights to achieve an almost three-dimensional effect.

MATERIALS

SURFACE
toned warm tan drawing paper

WATERCOLORS
Burnt Sienna, Phthalo Blue, Raw Sienna, Titanium White

BRUSHES
no. 7 round
½-inch (13mm) flat

OTHER SUPPLIES
black and white colored pencil,
gouache paint

Reference Photo
I cropped the foreground, simplified the plants and emphasized the height of the mountains. Never feel that you have to copy a photo exactly; it's a tool like any other, and you're the boss.

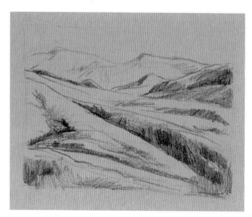

1 Start Boldly
Do your preliminary drawing more emphatically than usual. I used a black colored pencil. Go as deep and intense as you like with your darks; they form the bones of your painting with this technique.

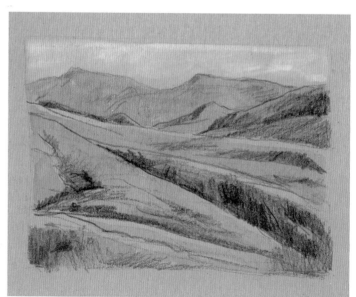

2 Add Lighter Tones
Start to add your lighter tones with local color. You can alter them later in either direction, going lighter or darker. I used a combination of gouache paints and Titanium White added to my regular watercolors.

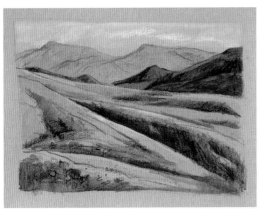

Study Plants

When you get the opportunity, do close-up sketches of landscape elements. Though the plants in my toned paper demo might almost be generic, it helps me to know what they look like close up.

3 Apply Stronger Washes

Mix stronger washes with less white in them for the mid- and darker tones. Here, I used Phthalo Blue with a little Raw Sienna for the mountain that's mostly in shadow, and a stronger mix of Raw Sienna and a little Burnt Sienna for the foreground gullies. See how rounded it's beginning to look?

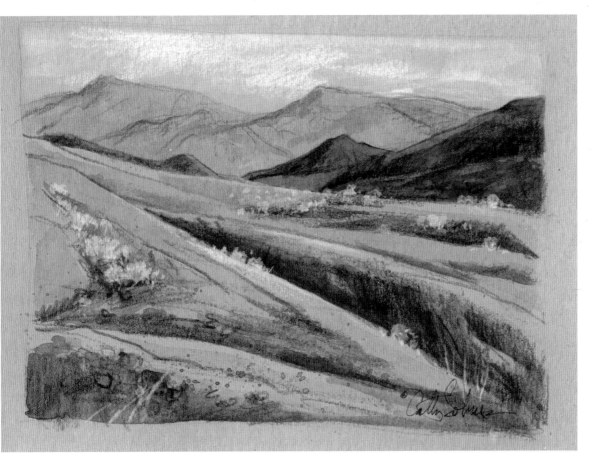

Desert Erosion
Watercolor, gouache and colored pencil on toned drawing paper
5" × 7" (13cm × 18cm)

4 Lighten and Darken the Details

Keep adding lighter lights for the sagebrush and other desert plants with quick, lacy strokes. Add deeper darks where needed. I used a little white colored pencil in the sky and restated some of the dark lines with my black colored pencil.

Signs of Early Occupation

Ghost towns, old ranches and claim shacks are common in the Southwest desert. At one time, all you had to do was build some sort of structure on a piece of desert to claim it as your own. You can still see many of these shacks, shanties and cabins as you drive through the Mojave and Sonoran deserts between California and Nevada. In some areas, there are whole towns, now abandoned, full of picturesque and evocative buildings to paint.

Even earlier marks of human settlement are graven in the rocks in many areas. Petroglyphs, scratched through the dark "desert varnish" hundreds of years ago, still speak to us in mysterious whispers. For 1,000 to 1,500 years, the Anasazi, the Hohokam and other peoples made their homes here. It seems they communicated with one another or commemorated great events of their lives with these markings, or maybe they were just an earlier version of graffiti! You may see images of bighorn sheep and other animals, hands, ladders, lightning shapes, humans, concentric circles and even spirals virtually identical to those at Newgrange, in Ireland.

The petroglyphs on Atlatl Rock in the Valley of Fire State Park are believed to be 3,000 to 4,000 years old, but those at Mouse's Tank, not far from the visitors center, are thought to be Puebloan in age, approximately 1,800 to 2,000 years old. There are subtle differences to study here.

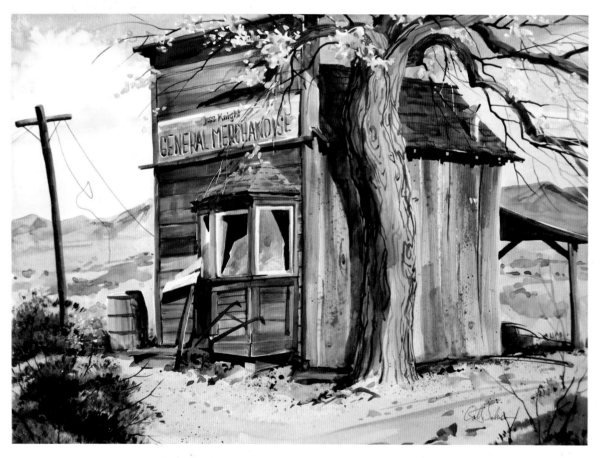

General Merchandise
Watercolor and ink on hot-p
watercolor paper
11" × 22" (28cm × 56cm)

Desert Stress

You may find yourself working more quickly in the desert. You must hurry to beat the dry air that sucks the moisture out of your washes and dries your paper unevenly, and you'll put on the speed to finish when it's uncomfortably hot. This painting of one of the abandoned buildings in the desert was done rapidly, with a very strong, calligraphic feel. Happily, it worked well with the subject.

This is very smooth hot-pressed paper. It lends itself to some wonderful texturing effects. Notice the sagebrush at lower left that was done with a bristle fan brush, trimmed to a jagged "hairdo" for interesting, spiky textures.

A technical ink pen with a fine nib worked wonders for the broken wires, drawn smoothly on the hot-pressed paper.

Visit artistsnetwork.com/Painting-Nature-Cathy-Johnson for a FREE bonus portrait demonstration.

Work Light to Dark

When painting this type of subject matter, one of the best approaches is just the opposite of the way the original petroglyphs were made: Work light to dark, rather than scratching or pecking through a dark layer. Try laying down a reddish underwash, allowing it to dry. Then, use a resist-like wax or masking fluid before painting on a much darker, cooler shade to represent the desert varnish.

Here, the spiral was done with a little white birthday candle. The ladder was drawn with a white colored pencil, and the hand petroglyph was done with masking fluid, painted on and allowed to dry before adding a second wash of Burnt Sienna, Phthalo Blue and Ultramarine Blue. All three give very different effects, as you can see. Remove the masking fluid when this wash is dry and finish up with spatter or fine lines to suggest the cracks in the rock. You'll be amazed at the effect.

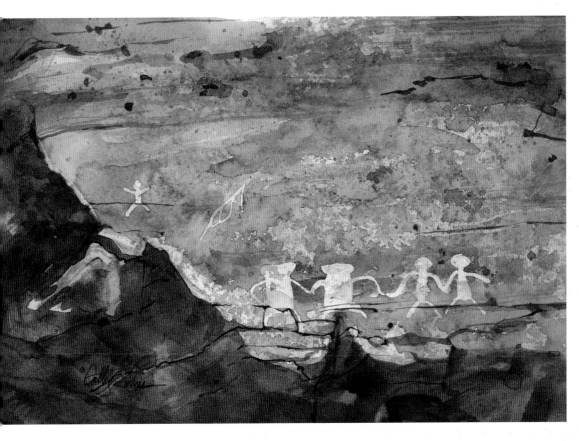

Petroglyphs

These are some of the Puebloan petroglyphs near Mouse's Tank in Nevada, done with much the same progression as above.

Petroglyphs
Watercolor on Fabriano
cold-pressed watercolor paper
5" × 7" (13cm × 18cm)

Receive free downloadable bonus materials at www.artistsnetwork.com/Newsletter_Thanks.

191

Desert Plants

You may picture little more than cactus and sage when you think of the desert—but wait! When you look with fresh, unbiased eyes, you'll see a great variety of plants, colors and shapes.

After a rare rain, the desert bursts into bloom. Yellow, white or pink flowers may be seen. Even the Joshua tree blooms, as do the ancient saguaro cacti. Mojave yucca stands tall on the debris of years past, raising a staff of beautiful white flowers. Even when it hasn't rained, you may still see a variety of interesting and beautiful plants to capture your painter's eye.

Elf Owl in Saguaro Cactus

Saguaros are not as common as they once were, but elf owls still find them a wonderful place for nesting. If you get a chance, sketch one of these tiny nocturnal denizens at home. Binoculars may be necessary to get a close enough view. I did a quick pencil sketch, then added watercolor later.

Mojave Yucca

Watch for distinctive shapes and growing habits. The Mojave yucca looks very different from the yucca plant in my Midwestern yard.

Desert Shapes

Look at the variety of shapes around you. The many-branched Joshua tree contrasts dramatically with the upright spires of juniper. Try a fine-pointed pen and a quick emphatic line to capture these shapes.

Visit artistsnetwork.com/Painting-Nature-Cathy-Johnson for a FREE bonus portrait demonstration.

| Quinacridone Burnt Scarlet | Burnt Sienna | Yellow Ochre | Raw Sienna | Quinacridone Gold | Phthalo Blue | Cobalt Blue |

Palette Peek

You might have guessed that I used a fairly limited palette for Desert Plants (below), but look how many colors went into the mixtures. Be careful with your choices, and don't try to mix too many pigments into any one wash. Don't be afraid to use bold colors, even to achieve subtle effects.

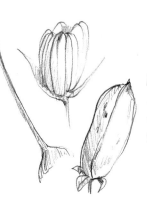

Look at Details

Notice the interesting jointed shape of the Mormon tea in this close-up. I love to pay attention to details like this.

Close-Up Study

If you get the chance, do a field sketch of the details. You get a much better idea of the life cycle of the plant if you can study it up close. Here you can see detailed studies of the flower, fruit and leaf of a Joshua tree.

Compare and Contrast

If you have the luxury of time and a comfortable place to work, consider a detailed study of the plants you find in a given habitat. These were clustered at the base of a Joshua tree near Hesperia, California.

Here, one of the buckwheats is on the left, with a composite in the center and Mormon tea on the right. The large sword-shaped leaf is from the Joshua tree.

Desert Plants
Watercolor on Fabriano
hot-pressed watercolor paper
9" × 12" (23cm × 30cm)

Receive free downloadable bonus materials at www.artistsnetwork.com/Newsletter_Thanks.

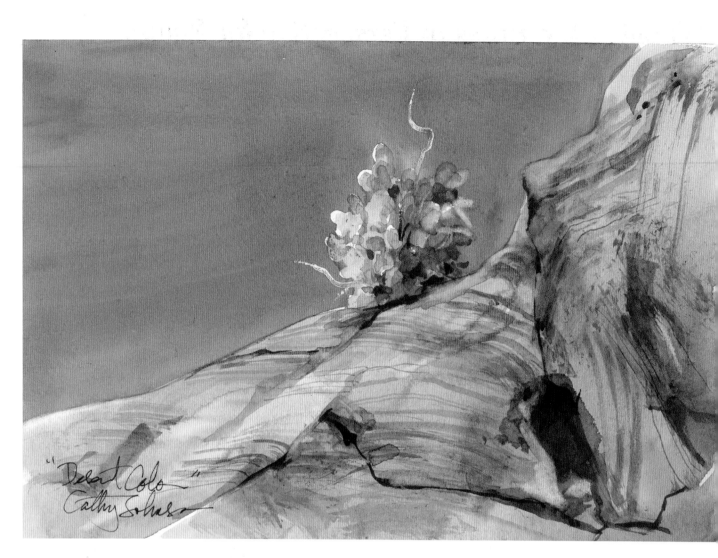

Desert Color
Watercolor on Fabriano
hot-pressed watercolor paper
5" × 7" (13cm × 18cm)
Collection of Laura Murphy Frankstone

Survival Tactics

In the desert, everything must adjust. There's little rainfall, and plants have evolved to be able to find water in the low spots and gullies and hoard the water they have found. They may have furry leaves, dry woody stems or succulent bodies. They make use of any number of survival tactics, but survive they do and under amazingly harsh circumstances!

This little plant, silhouetted against an impossibly blue sky, was growing from a tiny crack in the rock, high above any source of dependable water.

Palm Trees

Palms really do grow in a desert oasis or where they're watered regularly. There are many different kinds to draw and paint, some native, some imported and all interesting. The large one here is in watercolor. The other small ink studies are for comparison.

Visit artistsnetwork.com/Painting-Nature-Cathy-Johnson for a FREE bonus portrait demonstration.

Following the Rules of Perspective for Plants

Even plants follow rules of perspective. Think of the individual flowers in a bunch of daisies. When you observe carefully, you notice that the flower facing you looks round but those turned away appear to be ovals or even acute ellipses. This principle applies no matter what your subject. If it helps you to visualize perspective on this small scale, draw a schematic in black and white to plan your work before beginning to paint.

Use Shadows to Suggest Perspective

This cactus, painted in Nevada, follows the rules of perspective. Each pad is, in fact, roughly oval, but the way the pads connect to one another is often at an angle, changing the apparent shape if not the actual one. Notice how the shadows help suggest that depth—both body shadows (A) and cast shadows (B) add to the illusion.

Yvonne's Cactus
Watercolor pencil on Arches hot-pressed watercolor paper
10" × 7" (25cm × 18cm)

Raven's Hole

Remember, when painting in the desert the light is often intense. (So is the heat, of course, during a large portion of the year.) Shade is at a premium. There are few large trees to find shelter under, but it is cooler in the shade of a large rock.

The strong, clear light may make it difficult to judge color or value, especially if your paper or palette is in the sun. Try to keep them both in the shade to have a better idea of what you're mixing. Sometimes all you have to shade your work is your own body. In that case, you're probably going to be working really fast!

MATERIALS

SURFACE
Strathmore cold-pressed watercolor block

WATERCOLORS
Burnt Sienna, Manganese Blue Hue, Quinacridone Burnt Scarlet, Raw Sienna, Ultramarine Blue, Yellow Ochre

BRUSHES
barbered fan brush
old, moth-eaten ½-inch (13mm) flat
small stencil brush

OTHER MATERIALS
Tuscan Red colored pencil, Venetian Red watercolor pencil, tissues

Value Sketch

There's no need to use black for a value sketch if another color is at hand or suits your subject better. In this case, the dark Tuscan Red colored pencil seemed to fit my proposed subject. I made a small value scale to the right of the thumbnail sketch to help firm my awareness of the values I intended to use in the painting.

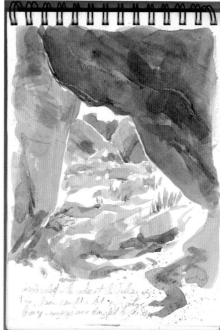

Quick Sketch

You may want to work smaller or use small washes (barely larger than a stroke) to beat that drying speed as I did in my second attempt. This one is in my 10" × 7" (25cm × 18cm) Strathmore watercolor sketch journal.

Later, when the light was more moderate, I adjusted the values so you get the feeling of looking out from a shaded place into that bright desert light. I used mostly Ultramarine Blue, Quinacridone Burnt Scarlet and Burnt Sienna for the shadowed rock, texture and spatter.

Harsh Sunlight

I was in a tiny patch of shade where there wasn't room for both my palette and my small watercolor block. Looking back and forth between them and the brightly lit scene made it almost impossible to judge colors or values, but, just the same, there's something here that catches the spirit of the place. It's a small painting, 7" × 5" (18cm × 13cm), but even so the washes dried very rapidly.

1 Sketch With Watercolor Pencil

I decided to use watercolor pencil for the preliminary drawing on watercolor paper so the lines would disappear, unlike pencil lines. The color I chose (Venetian Red) really didn't lift that well when wet, but it blended in better than graphite. (Slightly off-white paper is difficult to reproduce, so the paper looks darker than it is.)

2 Work on Values

Getting the values right is extremely important with a subject like this. You need strong contrasts to depict hot desert sunlight. Keeping those first washes light enough is difficult but necessary. I used Yellow Ochre with just a touch of Quinacridone Burnt Scarlet in a very high-keyed wash.

3 Deepen the Colors

To make sure I had the shadowed value dark enough, I did a swatch on a piece of scrap paper. Then I went ahead with a mix of Burnt Sienna, Quinacridone Burnt Scarlet and a little Ultramarine Blue, keeping the edge closest to the light in deep shadow.

While that was still wet, I dashed in some almost full-strength Quinacridone Burnt Scarlet and Ultramarine Blue, and let it dry until it began to lose its shine. Then I sprayed it lightly with clear water and blotted with a tissue, just to give the wash some sandy texture. I lifted a few highlights with the folded edge of a tissue to define the rock shape.

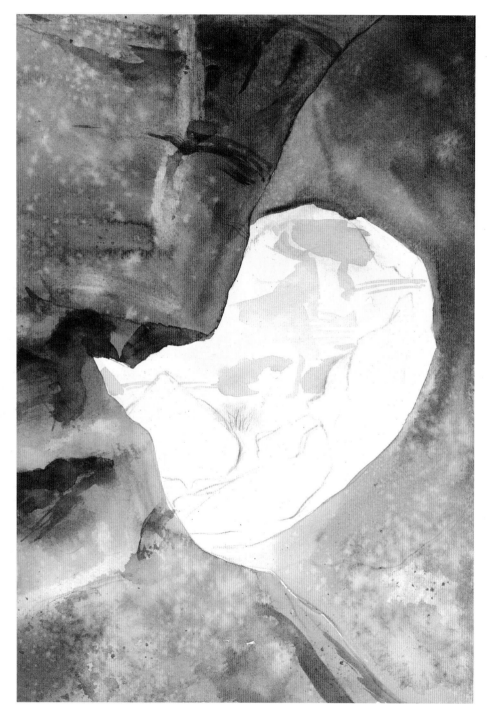

4 Adjust the Values at the Top

It was getting a little tricky by the time I got to this step. The top needed to be a darker value than the closer rock on the left or the lower part of the opening. To make sure things went relatively smoothly, I wet that whole section with clear water twice to more or less soak the paper. I then allowed it to begin to lose its shine and added a strong wash, using the same colors as before.

I began at the top with a stronger mix of Quinacridone Burnt Scarlet and a lot of Ultramarine Blue. I then added more water and less blue as I proceeded down the page. Some wet-into-wet variation was introduced for interest, and I tipped the paper this way and that to encourage the colors to flow together.

I added the clear water spatter again, this time concentrated at the bottom. Since the top was really quite shadowed, not much detail was needed there.

A bit of Manganese Blue Hue and Raw Sienna made a nice lichen color, which I spattered on with a small stencil brush.

I also began adding dry-brush details on the left side, following the direction of the rock's striations. A barbered fan brush and my favorite old moth-eaten brush worked well for most of this.

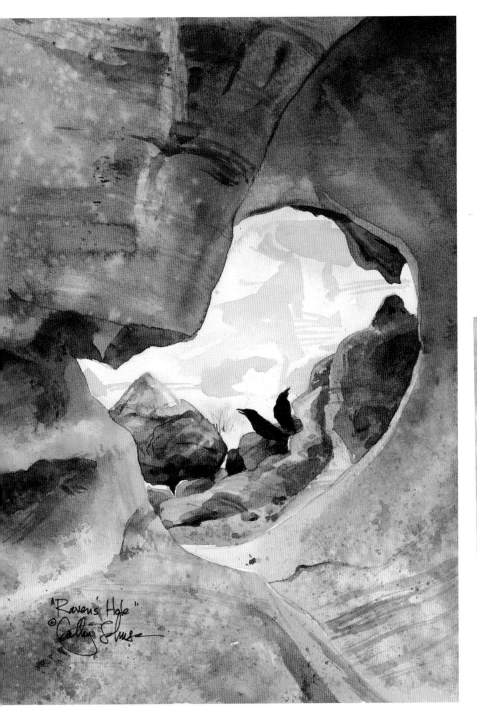

5 Add the Final Details

I added more detail to the walls and added the jumble of rocks in the opening, paying attention to where the light fell on them and modeling them with shadows and highlights.

A bit more warm and dark spatter added texture. I used a photograph I had taken of a pair of desert ravens, perched on the side of a canyon wall, as a resource photo. They offer a focal point where the lightest lights and darkest darks meet, emphasizing the effect of strong desert light beyond them.

TIPS

In the desert the paint on your palette and in your wash wells dries more quickly, too, so you'll learn to mix more than you think you'll need. And, again, work quickly. Be sure you have sufficient water with you, both for drinking and for painting.

Raven's Hole
Watercolor on Strathmore
cold-pressed watercolor paper
9" × 12" (23cm × 30cm)

CHAPTER NINE
PEOPLE IN THE LANDSCAPE

It's a delightful challenge to include people in our paintings. If not literally the human form, then sometimes the marks of our presence is enough—a discarded fishing lure, an old bridge or a heart with initials carved into a tree, as lovers used to do.

Including the human in one way or another can make nature more accessible, less primal or austere. (Of course, that can be good or bad, depending on your viewpoint.) It can also offer a sense of scale—you'd never know how big some natural objects are without the human form to measure them against.

Lost Lures
It's funny how often fishermen lose their lures, snagging them on unseen obstructions. I've found all kinds.

Graham Cave
Evidence of human use dating back 10,000 years has been found in Missouri's Graham Cave, near Interstate 70. It may have provided shelter for an entire village who found the nearby Loutre River a rich source of food—the small human figure gives an idea of scale. I created this sketch with sepia ink.

Heart Tree
It took me a full day to notice this heart, carved long ago in the tree by our campsite. Since it was our first camping trip together, I found it rather romantic.

Visit artistsnetwork.com/Painting-Nature-Cathy-Johnson for a FREE bonus portrait demonstration.

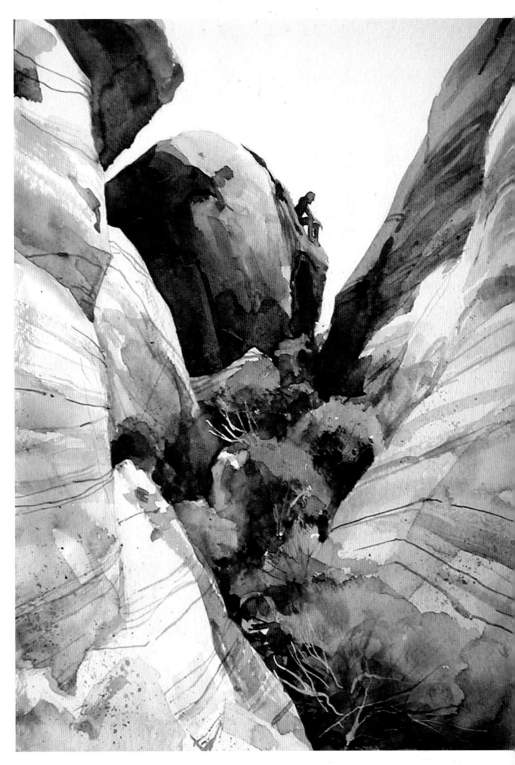

Relative Size

If you have trouble judging the relative size or proportion of the human you want to include in your landscape, take its measure.

Keep it simple! Use any handy tool, like a pencil. Align the tip with your subject's head, then move your thumb down so it's on a line with the feet.

Now compare that measurement with others in the scene you're drawing, still using your thumb and the pencil. How much smaller is the human figure than that rock, tree or whatever? Transfer those proportions to your art.

Ascent
Watercolor on Fabriano
cold-pressed watercolor paper
14" × 11" (36cm × 28cm)

On a Grand Scale

Would you realize how huge these boulders are if not for the climber perched high on the distant rocks?

Small-Scale People

Some artists are intimidated by painting people, but figures can be kept quite simple. Often, we're not trying to do a portrait of a specific human—we just feel our landscape needs something more dynamic.

Take it from the ground up. Even if you're a pro, it's fun to practice with little stick figures. Try out different positions. You can always flesh them out and dress them up however you want later.

Stick Figure Fun

Remember how much fun stick figures were when you were a kid? They still are! See how much action or attitude you can give them. Flesh them out with geometric forms, or dress them up and give them work to do. Next thing you know, you've got people to populate your paintings.

Geometric Shape Figure

If you want to work closer or try a pose that's a bit more complex, you may want to sketch it out first. Visualize the figure as a series of ovals, rectangles and cylinders. I dressed her up a little with colored washes, but you can see the construction lines underneath.

Visit artistsnetwork.com/Painting-Nature-Cathy-Johnson for a FREE bonus portrait demonstration.

Drawing a Crowd

You don't even have to sketch your figures first, just jump right in with water-color. You can achieve a distant crowd scene with fairly simple dashes. Vary your colors, add arms and legs on some of the figures at the edge, dress them with spots of color and there you have it—a crowd.

Tone Figures

If you prefer, make simple forms using tone. Use a graphite stick, a rolled-paper stump or tortillon, or even a watercolor wash to suggest little people shapes. No features or other details are necessary.

People Shapes

Your people can be neat little silhouettes with fairly accurate proportions (see the three in the upper left) or more colorful, freer silhouettes like the young dancers at right. You probably won't see little green women out on your rambles! Try a more subtle hue and place your figure in shadow and it'll look fine.

The middle ground might have more fully realized figures, like those on the bottom left, but they're still very simple.

Painting People in Watercolor Pencil

Watercolor pencils are a wonderfully versatile medium for painting or drawing people. You can color in an ink or graphite sketch you scribbled down in your sketchbook, bringing it suddenly to life. You can do a sketch with these pencils alone, wetting and blending it a little or a lot. Capture a crowd scene with a few quick dots and dashes, then blend to create the illusion of a group of people. Or you may choose a more contemplative approach, carefully building tone on tone for a truly fine art approach to portraiture.

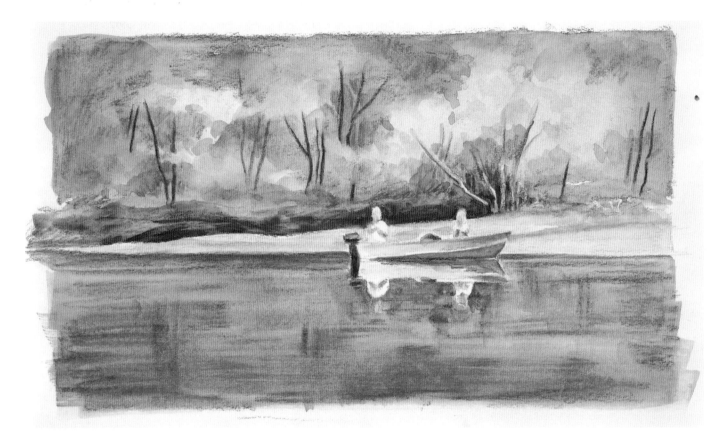

Fishing
Watercolor pencil on Arches hot-press watercolor paper
4¾" × 8" (12cm × 20cm)

Visit artistsnetwork.com/Painting-Nature-Cathy-Johnson for a FREE bonus portrait demonstration.

Creating Skin Tones

I find most premixed "flesh" tones to be too pale and uninteresting—we have more variety in a single face than that and certainly more from person to person, ethnic considerations aside! Some people have fresh, lively coloring; some, cool and bluish; some are very highly colored. Some have skin the color of warm honey; some are tan; some almost black. Flesh color is anything but homogenous.

Some variation of the primaries, even if very intense, may work for the particular and very individual face you need to paint. Try several combinations of pigments, both light and dark. Vermilions work in many instances. You may want to combine orange, red and blue for lighter, more delicate skin, but raw umber, a crimson and a deeper blue for dark skin. Sometimes a burnt sienna-like color will be the best answer. Try putting down several combinations and blending them a little or a lot to find which you prefer for the task at hand.

Put down all three colors at once and blend with water, or do them one at a time for greater control. You can model with each layer as you go.

Consider that racial differences will affect the colors you choose. One size definitely doesn't fit all when painting people!

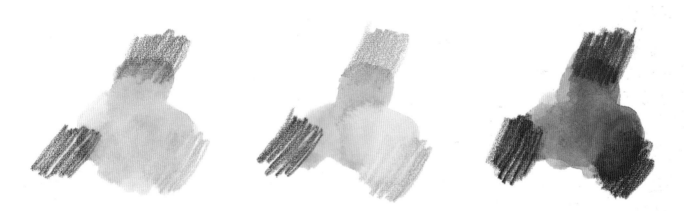

Watercolor Pencil Skin Tone Samples
These are just three of the many possibilities for skin tones.

Painting Hair in Watercolor Pencil

Watercolor pencils can suggest hair in a number of ways depending on the color and texture. Long, straight, shiny hair is relatively simple while crisp, curly hair requires more planning. Leave white paper in spots where light strikes the hair to capture the effect of highlights, and use your pencil point or brush to indicate strands or even individual hairs. Blend depending on the effect you are after.

Don't forget to look for and depict reflected lights. You may see a faint hint of blue within the highlight that suggests the color of the sky overhead or an orange glow if your subject is in firelight.

Hair Details
You can see that some areas are best left unblended, especially if done with a pencil with a good, fresh point.

Different Types of Hair

For long hair, let your pencil strokes follow the direction of the hair itself, then blend. Leave white paper for highlights. "Marry" the areas with a few pencil strokes that bridge the gap and that tie the highlighted areas to the rest of the hair. For short hair, look at the overall shape. Plan highlights where you need them—there may be more than with straight hair. Let your pencil strokes follow the direction of the hair with curly, squiggly strokes, and blend carefully. A few individual strokes to suggest loose ringlets at the edges will keep the head of hair from looking like a cap. Wavy hair is a combination of these effects—your strokes are curved but not so tightly as for curly hair. Watch for the color variations that help suggest light and shadow.

Visit artistsnetwork.com/Painting-Nature-Cathy-Johnson for a FREE bonus portrait demonstration.

Landscape With Figure

Now, try a landscape with a figure in it. Here, I got to paint my niece Jenny in the Nevada desert. It was hot, hot, hot, so I pushed the colors somewhat to get that blazing, bleached idea across.

MATERIALS

SURFACE
Strathmore cold-pressed watercolor paper

WATERCOLORS
Burnt Sienna, Phthalo Blue, Quinacridone Burnt Scarlet, Ultramarine Blue

BRUSHES
no. 5 round
½-inch (13mm) and ¾-inch (19mm) flats

Resource Photo
I took the photo after Jenny had already retreated to the shade. The perspective is a little different from my sketch, but it still serves as a reminder of the landscape.

Thumbnail Sketch
A very quick thumbnail sketch helps me decide on composition, position and values.

1 Lay Down Initial Washes
I didn't have any masking agent with me, so I just had to sketch in her figure and paint around it—needless to say I was working at top speed, both because of the heat and because of the way washes dry fast in the desert! Working wet-into-wet isn't easy when the arid desert air sucks up any "wet" you have.

This first step consists of getting the initial washes down. I used Phthalo Blue in the sky, plus Burnt Sienna, Ultramarine Blue and a bit of Quinacridone Burnt Scarlet. Details and values can be adjusted as we go along.

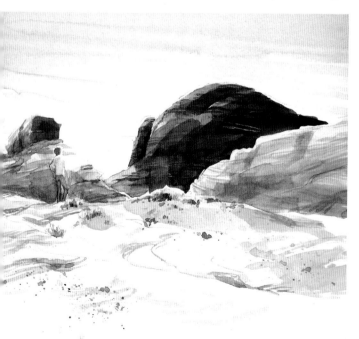

2 Add Details
When those first washes were dry, I completed the figure with simple, expressive shapes and continued to define the linear forms in the rocks. In this step I used stronger mixes of the same colors that I used in step 1. A little spatter in varied warm tones suggested the small rocks and gravel of the desert floor.

Jenny in the Desert Sun
Watercolor on Strathmore
cold-pressed watercolor paper
7" × 10" (18cm × 25cm)

Going Camping

Whether you camp in a huge RV, a tiny travel trailer, a tent or just out under the stars, there's nothing like leaving your cares behind and settling into a different, slower and more natural rhythm. Exploring the area, sitting by a campfire at night, cooking over the coals, sleeping surrounded by the sounds of the wind in the trees or owls on the hunt—it all puts us in touch with an older, simpler part of our nature. And as has been noted, humans are the only animals who use fire—to cook, to give us comfort, to harden our pottery, to let us dream, to drive back the darkness. It speaks to us.

Camping in a tent is becoming relatively rare as more and more people opt for RVs and travel trailers. Still, almost any large campground will offer tents in a variety of shapes and styles, from a simple wedge-shaped pup tent to a geodesic dome to a marvelous construction with a couple of rooms, including a screened "porch"!

There's something magical about camping in a tent, with only a thin layer of fabric between you and the night and the weather. It's both atavistic and intimate—you're aware of changes in the weather in ways you never are under more emphatic cover.

When you walk through the campground at night as people are preparing to turn in, flashlights and other light sources inside the tents make the structures glow like huge Chinese lanterns. It's an enchanting sight.

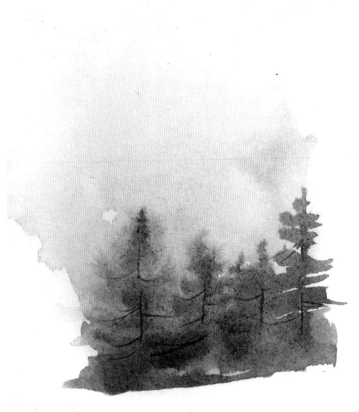

Fiery Sunset

This is the first layer in a little sketch of fire against a New York sunset. I was waiting for my love when I noticed the lovely, simple scene and held it in my memory till I could get back to camp and paint it in my journal.

Teardrop Trailer, Ink and Watercolor

I sketched my love's little home-built teardrop trailer in my journal one summer when we camped in the Adirondacks at a gathering of teardrop owners. It was a lovely shelter, with a delightful cross-breeze, shade and the whisper of rain on the aluminum roof.

Visit artistsnetwork.com/Painting-Nature-Cathy-Johnson for a FREE bonus portrait demonstration.

Evening Campfire, Fish Creek

If you're not satisfied with your first effort, analyze what you didn't seem to capture and try again, either directly on the original or on another sheet of paper. Initially, this sketch was too pale and wimpy, and didn't catch the drama. Months later, I could still see those dark trees and the glow of the fire in my mind's eye, so I went back and darkened it considerably.

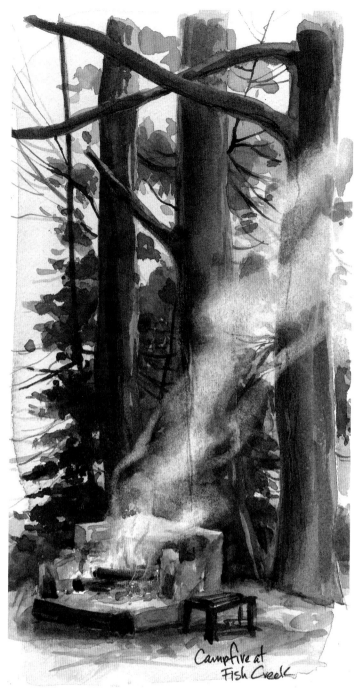

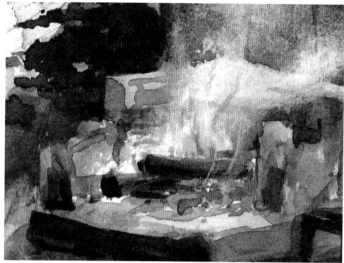

Campfire Detail

I lifted back the smoke with a dampened bristle brush and blotted the loosened pigment with a tissue, then added a bit of sparkle and life with colored pencils to suggest the warm light on the trees.

Campfire at Fish Creek
Watercolor on Cartiera Magnani
cold-pressed watercolor paper
7" × 4" (18cm × 10cm)

Tent Shapes

From the classic wedge shape to the more complicated models with internal or external frames, the basic technology is the same. Just a layer of fabric between you and the great outdoors. Try sketching the various shapes you find.

Tent Camp, Watkins Mill

If there's a campground near where you live or vacation, you can often find any number of subjects. I liked the shape of this large tent—almost like a canvas "house."

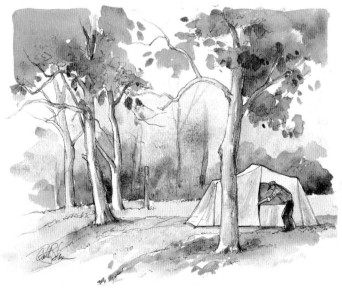

Capturing Firelight

Firelight, like candlelight and to a lesser degree incandescent light, makes colors warmer, more intense and more dramatic. Local color may be altered by the light of a night fire until it is very different from the way it might appear under daylight circumstances. Believe your eyes and be bold when painting these more challenging light sources.

If you want to, try your colors on a separate piece of paper to see if they'll work. Pay special attention to the effect of the direction of the light on the planes of your subject. When doing a portrait, you may find those planes accentuated or even distorted.

MATERIALS

SURFACE
Strathmore rough watercolor paper

WATERCOLOR PENCILS
strong, warm hues of your choice

BRUSHES
soft brush
fine watercolor brush

1 Lay In Initial Colors
Lay in fairly strong and very warm colors to capture a likeness as best as possible. Don't worry about detail at this stage; just place the basic shapes and planes.

2 Blend
Begin to blend with clear water and a soft brush, modeling the young man's face and shirt as you go but still paying attention only to overall shape and the major planes where the light defines his features.

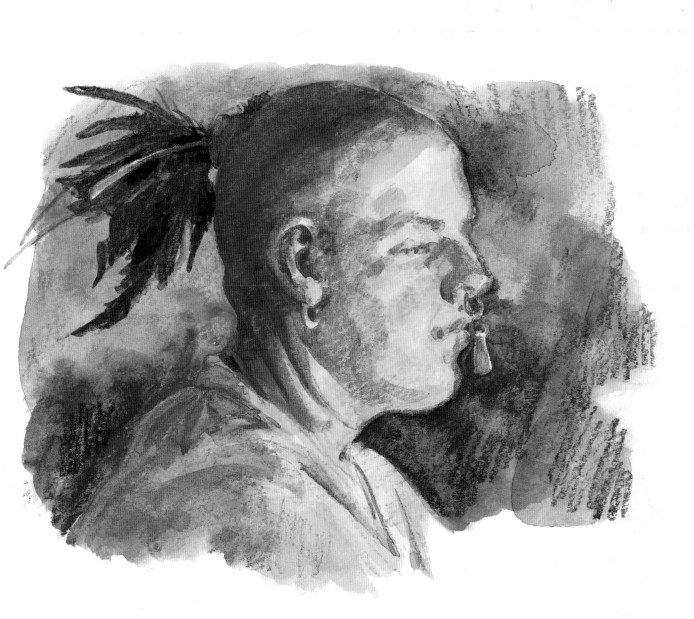

3 Apply Final Details and Contrasts

Work with strong contrasts between light and shadow, including the cool, blue background. Keep the background loose and varied to keep it interesting. Work slowly and carefully to correctly model the shape of ears, nose, lips and other features, restating where necessary but being careful not to touch a damp area with a watercolor pencil point as the pigment tends to go on too heavily and can't be moved.

For the small spaces of dark background color between the nose, lip and nose ring, paint directly by touching the tip of a fine watercolor brush to the tip of your pencil in order to pick up sufficient color, then model those shapes on your paper. Once the background is thoroughly dry, restate the warm color at the right of his profile and paint the dark feathers twined in his scalp lock with Black and Indigo.

White Deer; Portrait of a Young Man
Watercolor pencil on Strathmore rough
watercolor paper
5" × 6" (13cm × 15cm)

Canoes, Kayaks, Dories and Jon Boats

Watercraft are wonderfully satisfying—to watch, to travel in and to paint. They're marvelous to paint from as well. They act almost as a kind of blind (or "hide," as they say in Europe) to wildlife, which are much less likely to pay attention to you gliding by in a nearly silent canoe than if you approach on foot. Something about our tell-tale two-leggedness makes most creatures wary!

In the coastal regions, you're liable to see boats everywhere—up on scaffolds, beached, bobbing in the water, on top of your neighbor's car. Their shapes are endlessly fascinating. These forms look deceptively simple, but, in fact, they're subtle, elegant and rather complex. When my love and I were at the Adirondack Museum, we visited the display of canoes and guideboats, and were blown out of the water (if you'll excuse the pun!) by the delicate subtleties of shape that make all the difference in how a watercraft handles and what it's intended to do. Even in the subcategory of "canoe," you have whitewater craft, canoes for relatively still water, canoes stable enough for families and canoes for adventurous individuals—and more. Catch those shapes accurately, and your work will ring true!

Maine Fishing Boat

Notice the sweep of the bow on this fishing boat and the follow-through indicated by the dotted line. That was very difficult to catch properly, but the shape makes it much more believable than if I hadn't shown the tip of the bow rising above the gunwales.

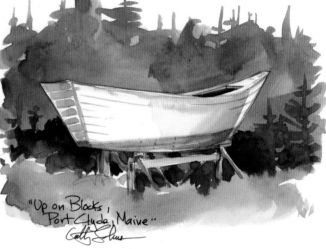

"Up on Blocks, Port Clyde, Maine"

Dry Dock

I drew the shape of the boat and scaffolding as carefully as possible in pencil, then painted the negative shapes around it, first the trees in the background and the grass underneath. The background was a bold, varied mix of Phthalo Blue, Burnt Sienna and a bit of Yellow Ochre in the lighter green areas; the foreground leaned more heavily on Yellow Ochre and Cadmium Yellow Medium Hue in the mix.

Then I added the details of the scaffold, paying attention to lights and darks, and finally the shape of the boat itself. I tried to capture the roundness at the bow, especially, keeping values mostly light so the boat would stand out from the dark evergreens behind it. The deep dark shadow inside the boat gave it dimension.

You can use boats as smaller elements in your landscape or seascape. If they're in the middle ground or distance, their shapes can be greatly simplified. Be aware, though, that the eye will be drawn directly to them, so do try to get those silhouettes right.

In the Distance

If the boat is far enough away, you can barely see the people—in this case represented by the red dot of the windbreaker the sailor wore.

Sailboat at Watkins
Watercolor on Fabriano
cold-pressed watercolor paper
9" × 12" (23cm × 30cm)

Up on Blocks, Port Clyde, Maine
Watercolor on hot-pressed watercolor paper
5" × 7" (13cm × 18cm)

Sunset Canoes

Our local state park closes at sunset to all but those camping there, so I hurried to capture my impressions of the scene as evening fell. I was far from the parking lot, so working fast was a necessity.

1 Apply Wash and Capture Reflections

Here, I laid in a single variegated wash for the sky and the water and allowed it to dry thoroughly. I used mostly Ultramarine Blue, Burnt Sienna and Quinacridone Burnt Scarlet for the far hillside. While it was still wet, I used the tip of a mechanical pencil to scratch fine lines in it to represent limbs. As it began to lose its shine, the end of an aquarelle brush pushed lighter lines out of the dark wash.

I used a cool, broken wash on the distant water. Then I re-wet the right foreground and stroked in the reflections, using the same colors as above, in a more neutral mixture.

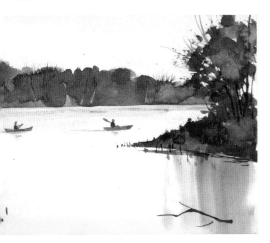

2 Add the Details

I used a stronger, darker mixture of the same colors to add the bank and trees on the right. The extra detail shows that it's closer to the viewer. Using a no. 2 round, I painted in the two canoeists. Letting color flow wet-into-wet gave them dimension without too much detail.

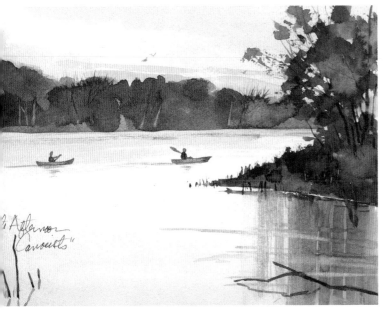

3 Lift and Soften

Finally, I lifted and softened the reflections and the side of the trailing canoe with a bristle brush and clean water, blotting up the loosened pigment with a tissue. Then I added a few more sticks, water weeds and their reflections.

Sunset Canoes
Watercolor on Fabriano hot-pressed watercolor paper
5" × 7" (13cm × 18cm)

MATERIALS

SURFACE
Fabriano hot-pressed watercolor block

WATERCOLORS
Burnt Sienna, Quinacridone Burnt Scarlet, Ultramarine Blue

BRUSHES
no. 2 round
small flat
bristle brush
aquarelle brush

OTHER MATERIALS
mechanical pencil
tissues

Fishing

I was raised by a dedicated fisherman. Year-round, my dad was out there, rod in hand. My sister tells me that whenever he'd visit her out West, they'd go for a drive and he'd invariably say, as they crossed a river, "A man could catch a fish in that stream..." Knowing my dad, he probably could.

Consequently, I have a soft spot in my heart for the sight of a person fishing. Childhood fish fries nourished more than my body.

Dominating Hard Edges

This little guy's cute, with his hard-edged colorful washes, but he'd really take over this little painting.

Overcast Day

This fellow was fishing from an aluminum Jon boat at Watkins Mill State Park. It was an overcast day and the fish seemed to be biting like mad.

I used the tip of a round brush and a lacy, dancing stroke to suggest the foliage at left as well as the tops of the trees on the far shore. A bit of scratching with the tip of a sharp craft knife augmented the dry-brush sparkle of the water.

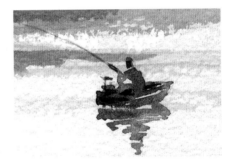

Fishing
Watercolor on rough paper
3" × 4" (8cm × 10cm)

Detail

I introduced a bit of brighter color here and there while the wash was still wet and let the color spread naturally. This works better than hard, sharp washes when you want the figure to complement your painting. When the washes were dry, I refined the details a little with dark shadows in the figure and the boat.

Fly Fishing

We pulled into a rest stop with a glorious view so I could paint and my fiancé Joseph could try fly fishing in the Hudson River. I didn't know how long we'd be there, or how long he'd be in one place; like most fishermen, he tends to try out different holes. So, I used one of my favorite techniques, sketching with a fine-tipped marker with waterproof ink, then adding watercolor washes until I ran out of time.

Visit artistsnetwork.com/Painting-Nature-Cathy-Johnson for a FREE bonus portrait demonstration.

Hiking or Walking in All Weather

Human beings on a walk is a common sight for most of us. We see them alone, in pairs or in family groups—even gaggles! It's fun to include a person or two in your landscape—again, it offers a sense of scale and accessibility, as well as a focus for your composition.

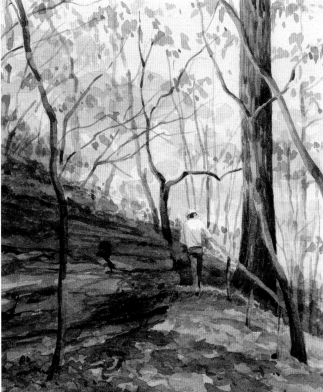

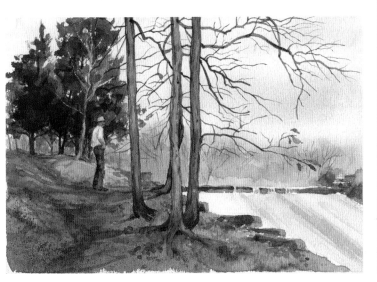

Waiting

My late husband made such a great subject. I loved the focal point his tall, skinny figure made in this landscape near a little Ozark dam. He seems to be waiting for us to catch up with him and discover what's over that little rise.

Harris by the Dam
Watercolor on Fabriano
cold-pressed watercolor paper
9" × 12" (23cm × 30cm)

Nature Hike

I was inspired by Thomas Aquinas Daly's beautiful, atmospheric watercolors and just had to try his layered approach.

Harris Hike
Watercolor on Fabriano
cold-pressed watercolor paper
12" × 10" (30cm × 25cm)

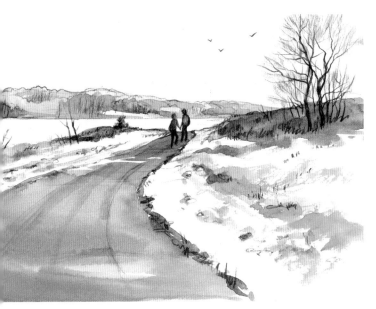

Winter Walk With Watercolor

This wintry landscape is warmed and humanized by the addition of the two walkers just at the crest of the hill. I sketched them with a warm, dark gray colored pencil on Fabriano cold-pressed watercolor paper.

The bold colored-pencil sketch provides a framework that frees me to loosely splash on the watercolor. I use wet-into-wet blending and paint just outside the lines on purpose to avoid the coloring book effect. The people are drawn with few lines and then painted just as simply.

Winter Walk
Colored pencil and watercolor on Fabriano
cold-pressed watercolor paper
9" × 12" (23cm × 30cm)

Implied Humans

You don't actually have to see the human beings in a painting to sense their presence. This idea bothers some who prefer nature untouched, but it speaks to me. In Nevada's Valley of Fire stand a number of tiny rock cairns, placed there perhaps to say, "I was here." Ten thousand years ago, in this same place, humans left their evocative marks on the rocks themselves.

Most often, our human marks are less mysterious: an old fence, a derelict barn, a lighthouse or a log cabin in the mountains with a thin finger of smoke rising from the chimney. These things provide a focus for our souls as well as our art.

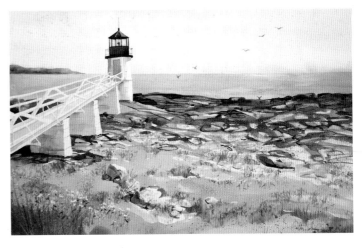

Marshall Lighthouse
Watercolor on Fabriano
cold-pressed watercolor paper
15" × 22" (38cm × 56cm)

Walkway
The human presence is implied in the lighthouse and catwalk.

Cabin
The cabin is in Elizabeth Furnace State Park, Virginia. In reality, no one lives there and there was no smoke rising into the November sky. I painted it on the spot as the skies threatened to open up and rain. I imagined how welcoming a cabin with a warm fire would be.

Elizabeth Furnace Cabin
Watercolor on Strathmore rough paper
9" × 12" (23cm × 30cm)

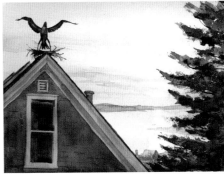

Roof Sculpture
Here, the roof in Port Clyde, Maine, where I taught one summer is not the only hint of the human—the gull on the nest is in fact a man-made metal sculpture.

Maine Roof
Watercolor on Strathmore rough paper
11" × 14" (28cm × 36cm)

Barn Sketches
If you have spent much time in the country, you know how integral barns are to rural life, the backbone of our heritage. Animals and people share these simple, rugged forms. They have a special ambience, inside and out. They are a vanishing sight, as the countryside becomes the new suburbia. I try to preserve a record of as many of them as I can find.

Watkins Barn
Ink and watercolor on Cartiera Magnani
cold-pressed watercolor paper
7" × 10" (18cm × 25cm)

Visit artistsnetwork.com/Painting-Nature-Cathy-Johnson for a FREE bonus portrait demonstration.

Variations on a Theme

Sometimes a painting seems to need some preplanning and "what-ifs" before you can decide how you want to proceed with the finished work, especially if you are working after the fact rather than on the spot.

It was evening on Fourth Lake in New York, and Potash Mountain caught the last warm rays of the sun at the summer solstice. My love cast his line into the lake nearby. I hurried to catch the image in my journal. Since we didn't have the luxury of another sunset in that location, I shot a quick resource photo as well. The sketch is in a vertical format, the photo is a horizontal one. Which to choose, and what colors? I did some preliminary sketches to help me decide.

MATERIALS

SURFACE
Strathmore cold-pressed watercolor paper

WATERCOLORS
Burnt Sienna, Cadmium Red Medium, Cobalt Blue, Dragon's Blood, Phthalo Blue, Quinacridone Burnt Scarlet, Transparent Yellow, Ultramarine Blue

BRUSHES
nos. 5 and 8 rounds

½-inch (13mm) and ¾-inch (19mm) flats

small, inexpensive brush for masking fluid

OTHER SUPPLIES
indigo colored pencil, craft knife, palette knife, masking fluid, Sunset watercolor pencil

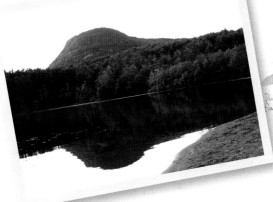

Resource Photo
Joseph had already left to go start the fire for dinner, but I stayed a bit, enjoying the peace and shooting resource photos.

Journal Sketch
This is the initial, hurried sketch— the light was fading rapidly!

Format Sketches
I used indigo colored pencil to explore portrait and landscape formats. Both would work well.

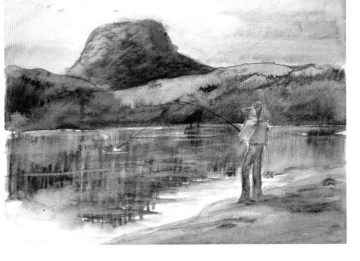

Watercolor Pencil Sketch
In this quick watercolor pencil sketch, I explored the horizontal format as well as a more colorful possibility, pushing what I saw just a bit toward an earlier time of day. Though the format has possibilities, I decided the vertical is more exciting, focusing the attention on that odd mountain in the background.

1 Apply the Mask and Initial Washes

For the sky, I used a graded wash from a warm sunset hue made up of Cadmium Red Medium Hue and Transparent Yellow, to a cooler blue mixed with Cobalt Blue and Phthalo Blue. I applied these colors with a ¾-inch (19mm) flat.

I protected the figure of the fisherman with masking fluid, applied with a small, inexpensive brush. The masking fluid on the fishing line was laid in with the edge of a palette knife. I used a no. 8 round to paint in the mountain, using the same colors as the sky, with the addition of a bit of green, letting the lower edge of the mountain fade into the trees in the middle distance. Then I repeated some of the warm color in the foreground water.

When that was completely dry, I was ready to paint the middle ground. Strong, variegated washes of Phthalo Blue, Ultramarine Blue, Burnt Sienna and Transparent Yellow suggest the distant shoreline. I paid close attention to the location of the shadows and the lightstruck areas. The ½-inch (13mm) flat worked well for most of these additions.

Notice the clean horizontal where the far shore meets the water. A distant lake shore will almost always look straight and flat.

2 Paint the Water

Using mostly a strong Phthalo Blue, Ultramarine Blue and Burnt Sienna mixture, I painted in the water, leaving a bright sparkle of white at the distant shore and trying for broken ripples in the mountain's reflection. A bit of lighter green introduced while that bold wash was still wet suggested the reflections of the lightstruck trees. The ½-inch (13mm) flat gave me the most control for these details.

I was nervous about how protected the figure actually was. Notice how dark the blue looks over his face—I wasn't sure I'd put the masking fluid on thick enough.

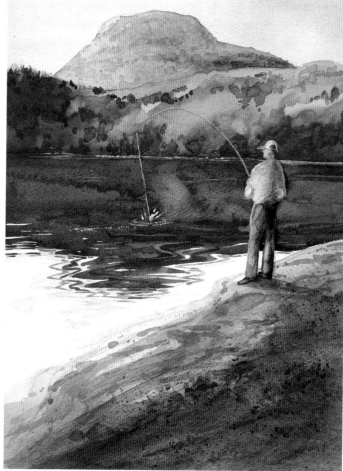

3 Add Beach Sand

The foreground beach was very fine sand. I painted it with a ¾-inch (19mm) flat and a varied mixture of Cobalt Blue, Ultramarine Blue and Dragon's Blood, which is a very warm Burnt Sienna-like color. Quinacridone Burnt Scarlet will work as well.

I added clear water spatter as well as spatter in stronger mixtures used for the sand itself. The mountain and tree-lined shore got some detail now, too.

4 Alter the Values

Hurray for computers and photo-editing software! I wasn't quite happy with the value of the beach, the mountain or the figure (they were a bit too pale and delicate), so I pulled the image into a photo-editing program and did a little preliminary tweaking with the burn tool, just to see how it would look if the beach and figure were darker, as well as the shadowed side of the mountain. I liked it, so I went ahead and altered the painting's values as well.

Figure Detail

I was relieved to find that the masking fluid over the figure had leaked only a little, and it lifted and blended into shadow areas with a brush and clear water.

The fishing rod was carefully cut from the top layer of paper with the tip of a very sharp craft knife. I cut two lines, closer together at the tip and widening slightly closer to the figure, then peeled away the thin layer of paper to expose the white underneath. With a bit of color added, the rod looks fairly natural against the dark hillside.

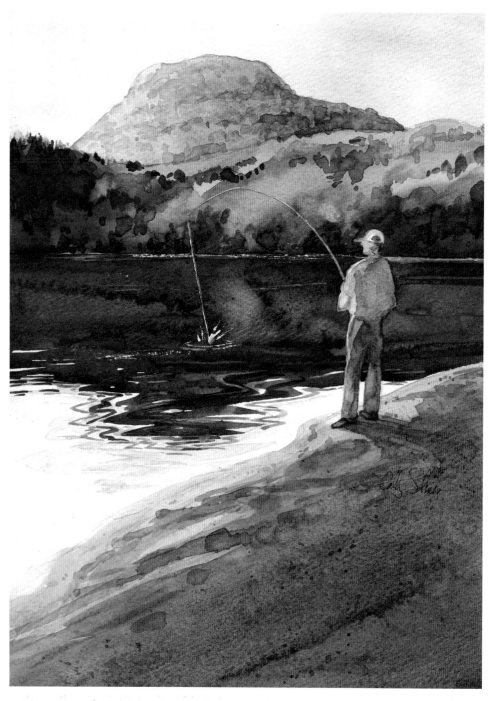

Detail

Lost and found edges soften the figure and keep it from looking pasted on. As usual, I let the colors run into one another to keep this from being too harsh or cartoonish. A bit of sunset-colored watercolor pencil makes him look lightstruck as well.

Joseph at Sunset
Watercolor on Strathmore cold-pressed watercolor paper
12" × 9" (30cm × 23cm)

5 Add Finishing Touches to Water

This is the finished painting—a bit more work on the closer edge of the water and some sparkles scratched out with a sharp knife suggest light on water.

I'm still thinking of cropping the foreground a bit, even though there's a good flow through the painting. As you can see, the eye travels from lower left to right, up the figure and along the rod, then up to the shadowed side of the mountain and back down the V of shadow on the far shore to the man himself.

Visit artistsnetwork.com/Painting-Nature-Cathy-Johnson for a FREE bonus portrait demonstration.

Conclusion

I love it when a new world opens up . . . and, as you've discovered, that's just what happens when we take a sketchbook, journal or watercolor block outside and begin to explore the world around us with an artist's eye. All sorts of things we'd never have noticed while whizzing by in a car—or even on a bicycle—suddenly capture our attention with their everyday magic.

Taking photos is great for later reference, and, if you're a pro, it can take as much time, concentration and pure artistry as most of us muster for our paintings and drawings. For the rest of us, they're just snapshots, with the emphasis here being "snap." We take one quick shot and move on to the next photo op. We can miss a lot.

When we stop and take time to respond, with pencil or pen or brush in hand, we see more than we could have imagined in our normal surroundings. We've formed a relationship. As my friend, fellow writer and artist Hannah Hinchman says, we have "won a moment in the unfolding universe" that can nourish us for years.

I hope you've tried out the exercises found in these pages and put together your own field kit with your favorite art supplies. I hope you've experimented with a variety of techniques to capture the wonderful differences we find in nature, from the desert to the mountains, from prairies to ocean breakers. Some subjects are more challenging than others, but all will keep us on our toes. We have to think about how we might capture that red-winged blackbird or fleeting sunset, carefully considering just which pigments would give us the effect we want. When we nail it—or even come close to the neighborhood—it's a kick!

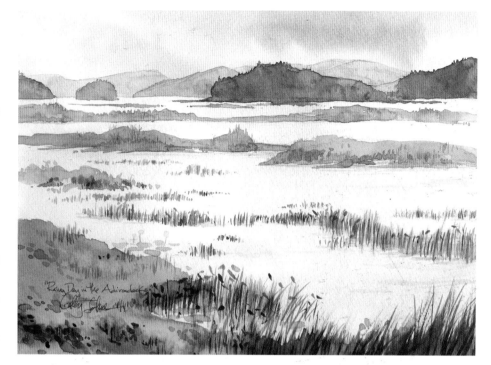

Rainy Day in the Adirondacks
Watercolor on Strathmore
cold-pressed watercolor paper
11" × 14" (28cm × 36cm)

Cut yourself some slack, and give yourself room to grow and develop. No one expects to play a Bach fugue the first time he or she sits down to an organ. It takes practice and attention.

Remember that the practice can be fun. It's play. New art supplies tempt us to splash around with color, try new things and stretch—relax and enjoy it! Practice isn't a chore; it's a lifelong delight. If you learn to love it as I do, you'll never be bored again.

You'll find yourself discovering more and more about nature, particularly if you form a relationship with nature, revisiting the same landscape through the seasons. If you choose a single tree as your focus, you'll learn to think of it as a friend.

When we take our painting kit on a trip with us, we bring the experience back to life. These memories last forever. Each time you look through your travel journal or at one of the *plein air* paintings you created in an unfamiliar locale, you'll find yourself recapturing the moments of your life. It will come back to you with startling clarity.

So enjoy the trip. The adventure has just begun.

ABOUT THE AUTHOR

Cathy Johnson has written more than thirty-five books, many on art. She has been a contributing editor, writer and illustrator for *Watercolor Artist* for over a decade and has written regular columns for that magazine and *The Artist's Magazine*. She started the popular group blog Sketching in Nature (naturesketchers.blogspot.com). She also teaches online warkshops at www.cathyjohnson.info and runs the blogs The Quicksilver Workaholic (katequicksilvr.livejournal.com) and Cathy Johnson Fine Art Galleries (cathyjohnsonart.blogspot.com). Johnson lives and works in Excelsior Springs, Missouri, with her husband and cats.

Painting Nature in Watercolor with Cathy Johnson. Copyright © 2014 by Cathy Johnson. Manufactured in China. All rights reserved. No part of this book may be reproduced in any form or by any electronic or mechanical means including information storage and retrieval systems without permission in writing from the publisher, except by a reviewer who may quote brief passages in a review. Published by North Light Books an imprint of F+W Media, Inc., 10151 Carver Road, Suite 200, Blue Ash, Ohio, 45242. (800) 289-0963. First Edition.

Other fine North Light Books are available from your favorite bookstore, art supply store or online supplier. Visit our website at fwmedia.com.

18 17 16 15 14 5 4 3 2 1

DISTRIBUTED IN CANADA BY FRASER DIRECT
100 Armstrong Avenue
Georgetown, ON, Canada L7G 5S4
Tel: (905) 877-4411

DISTRIBUTED IN THE U.K. AND EUROPE
BY F&W MEDIA INTERNATIONAL LTD
Brunel House, Forde Close, Newton Abbot, TQ12 4PU, UK
Tel: (+44) 1626 323200, Fax: (+44) 1626 323319
Email: enquiries@fwmedia.com

DISTRIBUTED IN AUSTRALIA BY CAPRICORN LINK
P.O. Box 704, S. Windsor NSW, 2756 Australia
Tel: (02) 4560-1600; Fax: (02) 4577 5288
Email: books@capricornlink.com.au

ISBN 13: 978-1-4403-2883-1

The material in this book appeared in the following previously published North Light Books:
Johnson, Cathy. *Watercolor Pencil Magic* © 2002.
Johnson, Cathy. *Creating Nature in Watercolor* © 2007.

Production Edited by Mary Burzlaff Bostic
Designed by Bethany Rainbolt
Production coordinated by Mark Griffin

METRIC CONVERSION CHART

to convert	to	multiply by
inches	centimeters	2.54
centimeters	inches	0.4
feet	centimeters	30.5
centimeters	feet	0.03
yards	meters	0.9
meters	yards	1.1

Visit artistsnetwork.com/Painting-Nature-Cathy-Johnson for a FREE bonus portrait demonstration.

Index

Ideas. Instruction. Inspiration.

Receive FREE downloadable bonus materials when you sign up for our free newsletter at artistsnetwork.com/Newsletter_Thanks.

Find the latest issues of *Watercolor Artist* on newsstands, or visit artistsnetwork.com.

These and other fine North Light products are available at your favorite art & craft retailer, bookstore or online supplier. Visit our websites at artistsnetwork.com and artistsnetwork.tv.

 Follow North Light Books for the latest news, free wallpapers, free demos and chances to win FREE BOOKS!

Get your art in print!

Visit **artistsnetwork.com/splashwatercolor** for up-to-date information on *Splash* and other North Light competitions.